DRAW FROM YOUR HEAD

DRAW FROM YOUR HEAD

A STEP-BY-STEP SYSTEM FOR DRAWING THE HUMAN FIGURE WITHOUT A MODEL
DOUG JAMIESON

WATSON-GUPTILL PUBLICATIONS/NEW YORK

For my wife, Pat,
without whose encouragement,
confidence, support, and help
this project would not
have been possible.

First published in 1991 by Watson-Guptill Publications,
a division of BPI Communications, Inc.,
1515 Broadway, New York, N.Y. 10036

Library of Congress Cataloging-in-Publication Data
Jamieson, Doug
 Draw from your head : a step-by-step system for drawing
the human figure without a model / Doug Jamieson.
 p. cm.
 Includes index.
 ISBN 0–8230–1374–X
 1. Anatomy, Artistic. 2. Human figure in art. 3. Drawing—
Technique. I. Title.
 NC760.J34 1991 91–8119
 743′.49—dc20 CIP

Manufactured in the United States of America

Acknowledgments

A number of people made this project possible and I owe them my thanks and appreciation: the many students over the years who encouraged and convinced me that the system I had developed and taught should be translated to book form; Bill Gibbons, Bruce Solotoff, Steve Sanford, Ann Gibbons, and Susan Rotolo, who took the time to look at portions of the manuscript and drawings in progress and gave me encouragement and helpful criticism; Candace Raney, senior editor at Watson-Guptill, who got the ball rolling; and Carl Rosen, associate editor at Watson-Guptill, who knocked the manuscript into a concise, readable form.

CONTENTS

INTRODUCTION

This book shows you a system for drawing the human figure in a systematic, step-by-step application of anatomy and measurement. From the first line applied you will learn to construct a simplified skeleton, which is the foundation of the system. When the simplified skeleton is mastered, the muscles are added to the drawings one by one.

The system's unique feature is its use of schematics, its thorough isolation and examination of muscles, and its gradual connection of all the parts. The "fleshed-out" figure, along with an 8-head measure schematic of the body, begins each chapter on particular body parts to provide an overview of the material covered thereafter. The particulars of constructing the individual parts are presented in each chapter with numbered instructions. The schematic instructions are usually followed by a section called "Refinements," which complements the rules for creating a simplified figure with tips on fleshing out the forms. The schematics themselves are concise sets of drawings with simplified directives that illustrate the system. In the schematics, the often great complexity of the subject has been reduced to such simple geometric forms as ovoids, triangles, teardrops, and so forth. This makes the system immediately translatable to

figure drawing. The corresponding anatomical refinements will help you to use the system in any professional capacity.

There is no other anatomy drawing system that has this book's visual completeness and simplicity. Each muscle, or muscle group, that contributes to external form is isolated and examined, allowing you to literally put a figure together one muscle at a time and to draw the figure in action. Each chapter is a complete unit, incorporating the information presented to that point. You will draw the master drawings in the final chapter, establishing a set of seven after chapter 2. Thereafter, as you develop the figure in each chapter, you can trace the progress of the construction in the final chapter, entitled "Draw from Your Head," which shows the step-by-step progress achieved by following this system for adding the parts of the body to the schematic one by one. The master drawings in the final chapter should be used as a self-check. Thus, at the end of each chapter, turn to the final chapter and compare your results with the master drawings, which consist of a walking, running, three-quarter back view, three-quarter front view, and various actions. When you have mastered the system, you will be able to draw the same figures in any variation of the actions presented.

1 THE SIMPLIFIED SKELETON

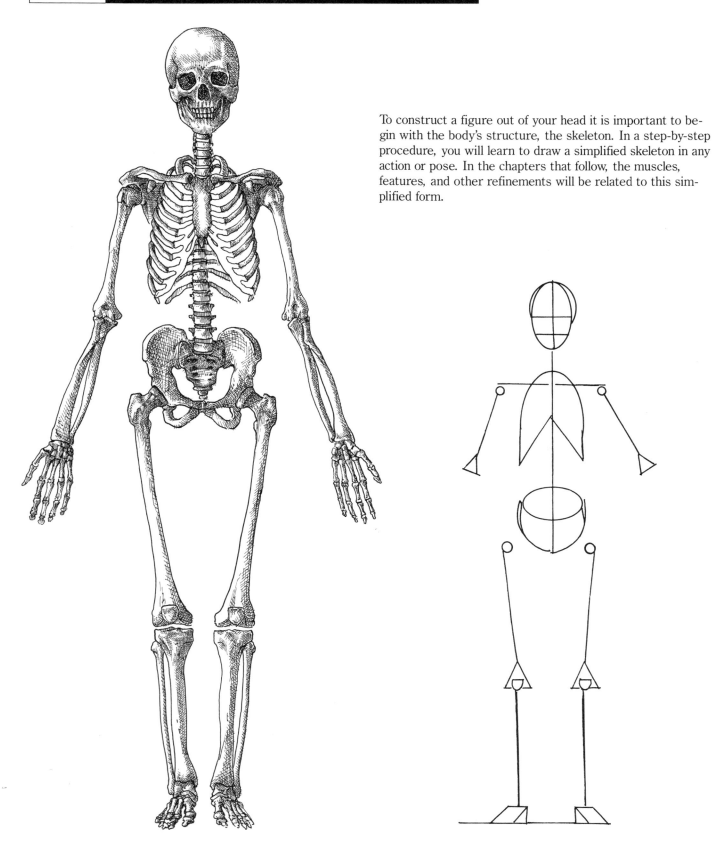

To construct a figure out of your head it is important to begin with the body's structure, the skeleton. In a step-by-step procedure, you will learn to draw a simplified skeleton in any action or pose. In the chapters that follow, the muscles, features, and other refinements will be related to this simplified form.

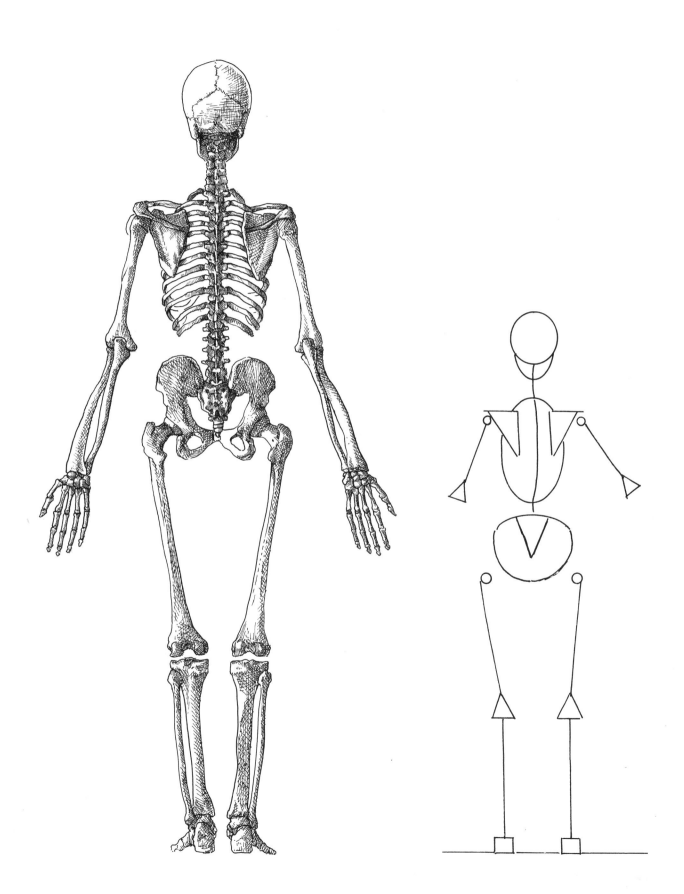

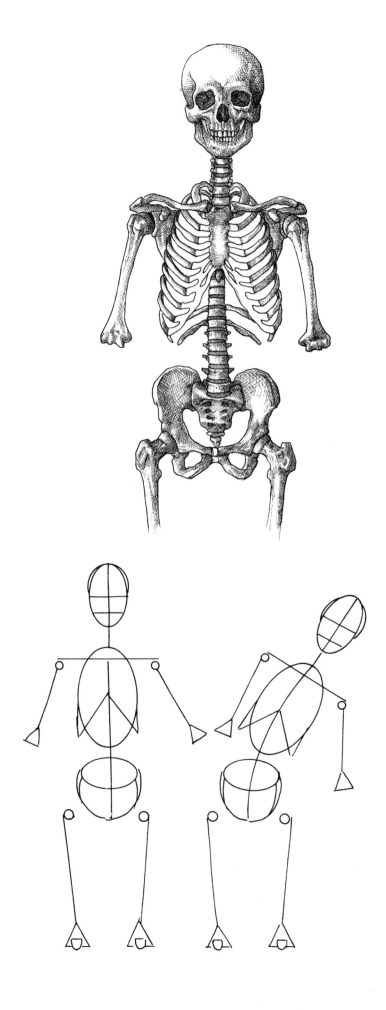

Thrust lines are the most basic directional lines in the figure. These lines precede all fleshing out of forms or detail. Thrust lines give the most basic information about the figure you will learn to draw and the relationship of that figure to gravity and basic movement. Later on, you will add refinements to basic thrusts, leading up to a simplified skeleton that can be filled out with such details as features.

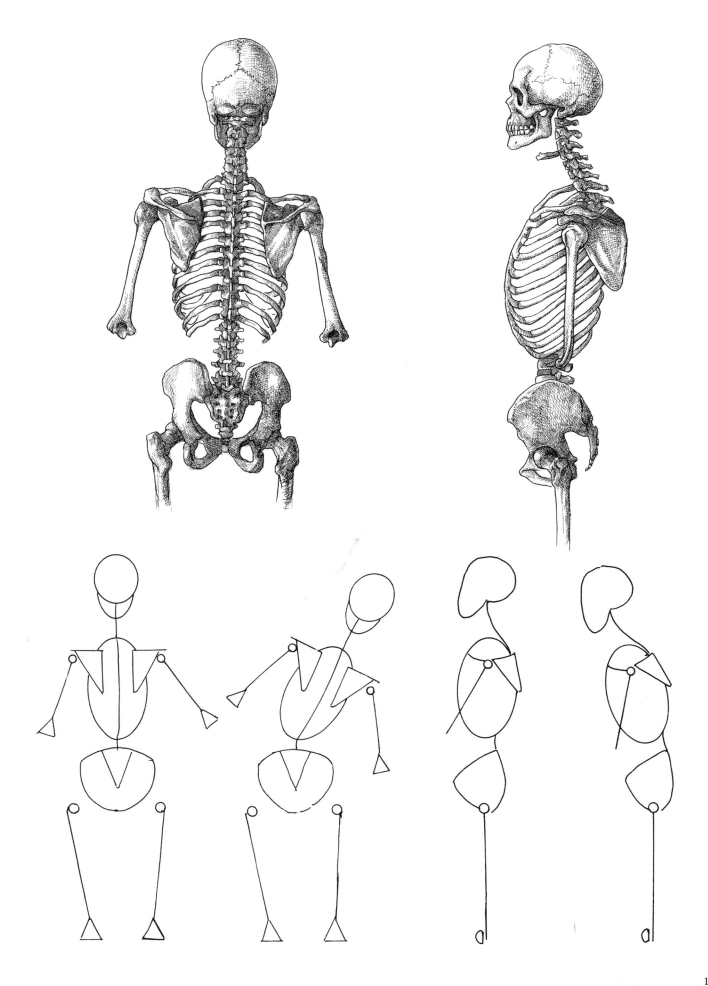

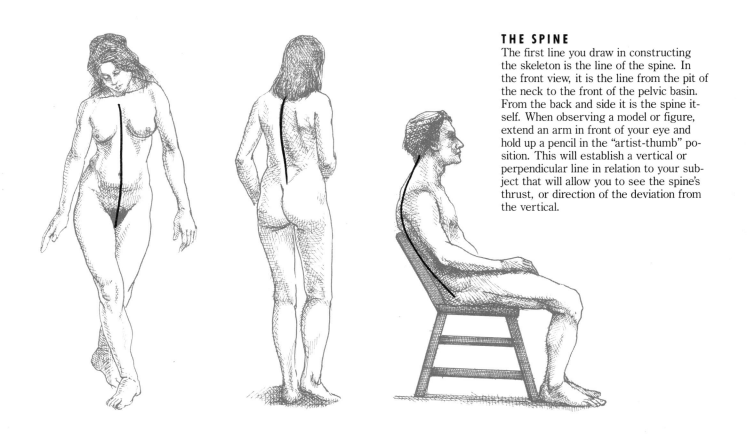

THE SPINE

The first line you draw in constructing the skeleton is the line of the spine. In the front view, it is the line from the pit of the neck to the front of the pelvic basin. From the back and side it is the spine itself. When observing a model or figure, extend an arm in front of your eye and hold up a pencil in the "artist-thumb" position. This will establish a vertical or perpendicular line in relation to your subject that will allow you to see the spine's thrust, or direction of the deviation from the vertical.

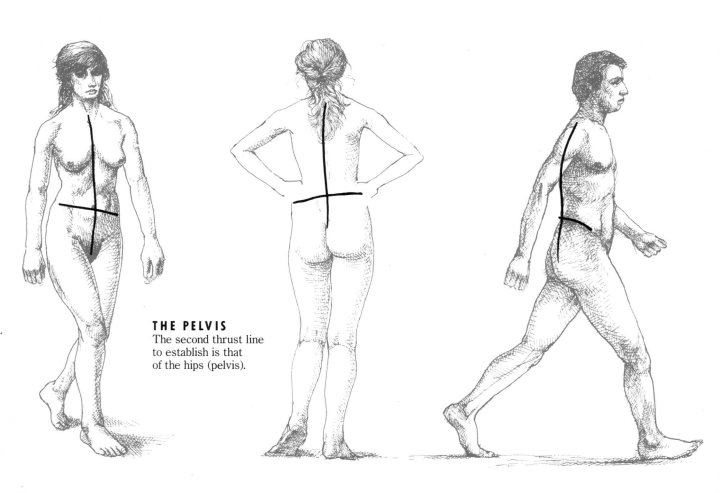

THE PELVIS

The second thrust line to establish is that of the hips (pelvis).

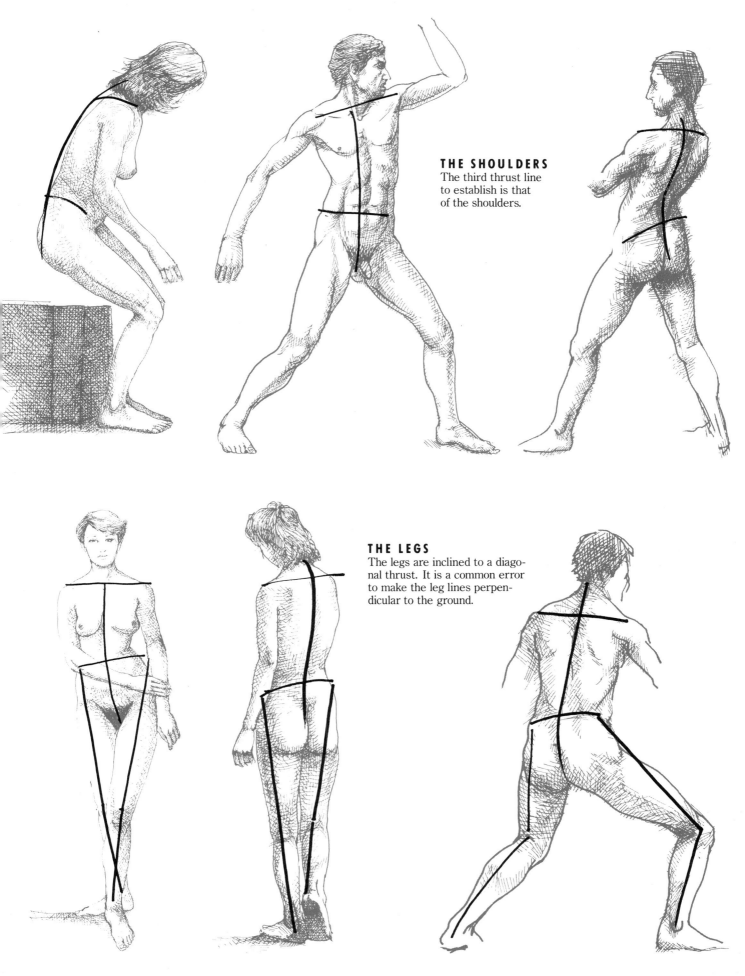

THE SHOULDERS
The third thrust line
to establish is that
of the shoulders.

THE LEGS
The legs are inclined to a diago-
nal thrust. It is a common error
to make the leg lines perpen-
dicular to the ground.

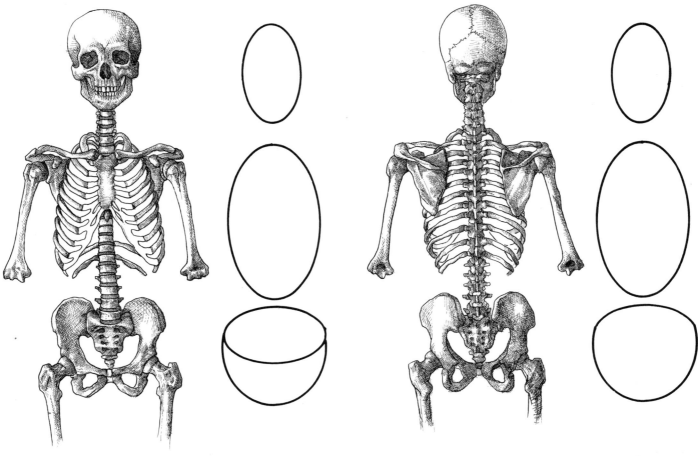

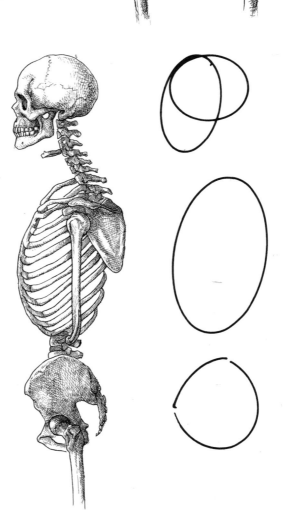

RIB CAGE AND SKULL

The ribs emanate from the spine; the rib cage is not separate from the spine; the relationship of the two is constant. The rib cage and skull are both essentially ovals.

Since we are using the length of the head from top to bottom as the unit of measure, the oval for the rib cage is considered to be half a head larger than the oval for the skull. They are both half as wide as their length.

When you establish the figure using thrust lines, keep in mind the measured relationship between the two ovals.

PELVIC BASIN

The pelvis can be considered as an oval or sphere sliced in half, like a basin. It is a head wide and a head long. The top of the pelvic basin takes the direction of the hip thrust line. The pelvic basin is highest at the back. It descends forward at an angle. The top of the descending basin stops about a third of a head down. Place the pelvic basin on your drawings.

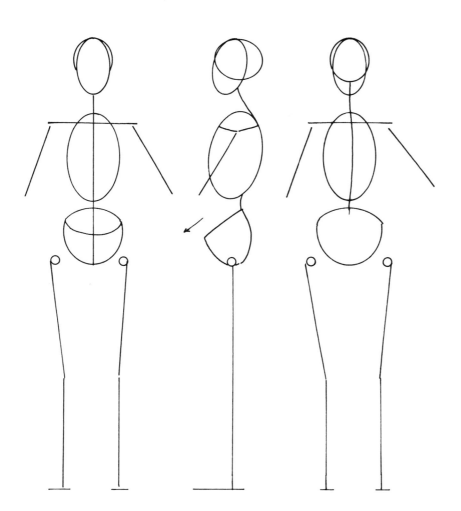

SHOULDER GIRDLE AND UPPER ARM BONE

The line indicating the direction of the shoulders represents the shoulder girdle, which rests atop the rib cage and consists of the collarbone (clavicle) on the front and the scapula on the back. The upper arm bone joins at the shoulder girdle and ends near the bottom of the rib cage oval.

THE LEG

The leg joins to the bottom of the pelvic basin with a ball-and-socket joint. The bottom of the pelvis has the socket and the top of the leg has the ball. Include the ball at the top of the leg line in your drawings.

From the top of the head to the bottom of the pelvic basin is one-half of the length of the skeleton. The bottom of the pelvic basin to the bottom of the foot is the other half of the skeleton. Add the leg lines to your drawings with this in mind.

POINT OF GRAVITY

The last important line marks the point of balance—the plumb or gravity line. If you drop a plumb line from the erect figure's chin, it falls directly in the middle of the feet. As the weight shifts to the side, the plumb line drops closer to the foot that takes the weight. The hip on the side that takes the weight will tilt up, and the shoulders will tilt in opposition to the hip.

Practice drawing the figure without fleshing it out or worrying about the head and arms. Simply think in terms of thrusts: the line of the spine; the direction of the hips and shoulders; and the plumb line.

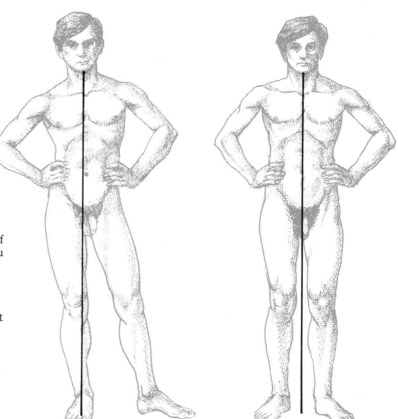

Just as for every action there is an opposing action, for every thrust there is an opposing thrust. The interplay of opposing actions maintains the balance. For example, in walking, the forward leg is opposed by the arm on the same side going back; the pelvis is brought forward by the leg and the torso is brought back by the arm. Look for the opposing thrusts in people at rest and in motion, and analyze the relationship between the parts.

Looking at the figure from the side you see a series of opposing angles that provide balance. The two ovals of the head join the neck at about half the width of the two ovals together.

The head naturally angles forward slightly, opposed by the neck. The neck, in turn, is opposed by the rib cage, which itself is opposed by the pelvic basin. The top of the pelvic basin is angled forward. The pelvic basin joins the upper leg bone from the center of the bottom of the pelvic basin. Think of the leg as bone, and the bone as a straight line.

Draw the simplified skeleton from the side. Include the head, rib cage, shoulder girdle, upper arms, pelvic basin, and legs.

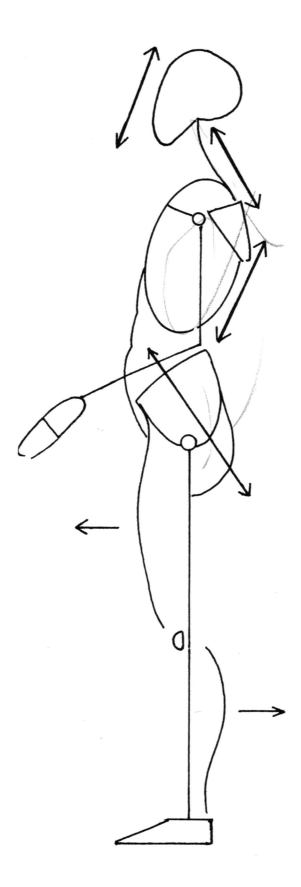

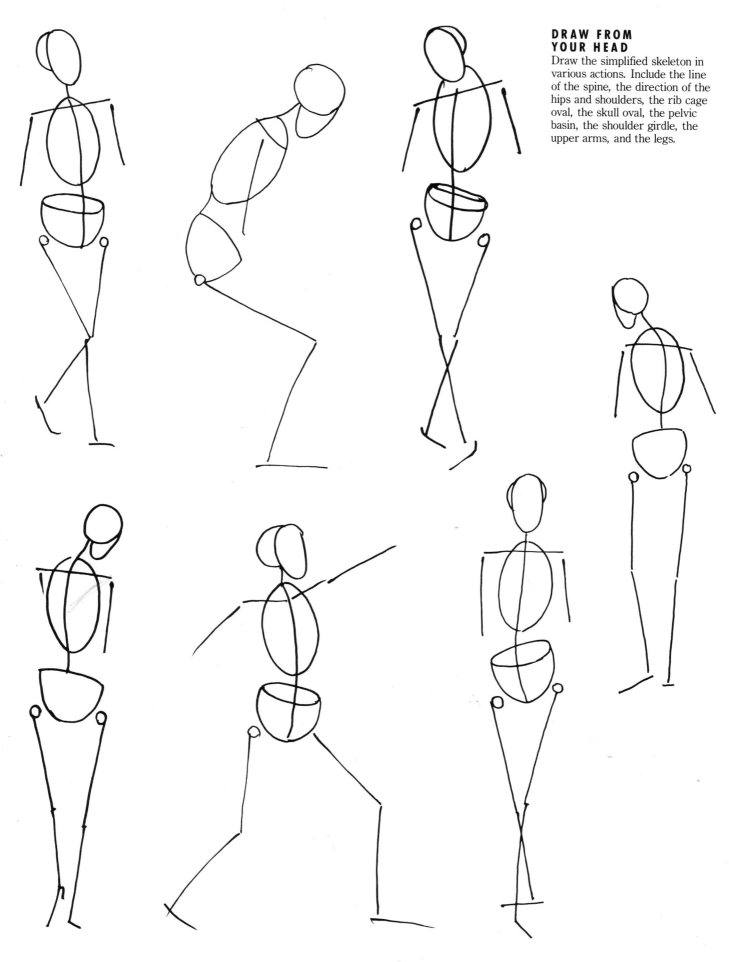

Draw the simplified skeleton in various actions. Include the line of the spine, the direction of the hips and shoulders, the rib cage oval, the skull oval, the pelvic basin, the shoulder girdle, the upper arms, and the legs.

2 MEASUREMENT AND PROPORTION

Esthetics are personal and largely come from within. Everyone is unique and has a unique sensibility. Measurement and proportion is not an attempt to rob you of it. Measurements are a standard against which you can judge your particular esthetic sensibility. The point of learning measurement and proportion is to put you in control of your drawing rather than to let you be controlled by it.

There have been many theories of measurement and proportion throughout history. Every culture had its own standard. The Byzantines, Egyptians, and the Greeks had standards of measurement that they held to rather strictly.

El Greco's oversized figures were based on a Byzantine canon. The Greeks believed in the divinity of numbers. They had different proportions for each deity; for example, Hermes and Heracles had numerical differences that expressed their divine differences. Most of us no longer serve a divine canon or live in a society bound by rigidly codified rules.

The measurements used in this system are general. The body does not actually fall so neatly into such perfectly rounded divisions, and there is, of course, constant variation from individual to individual. The system itself differs from

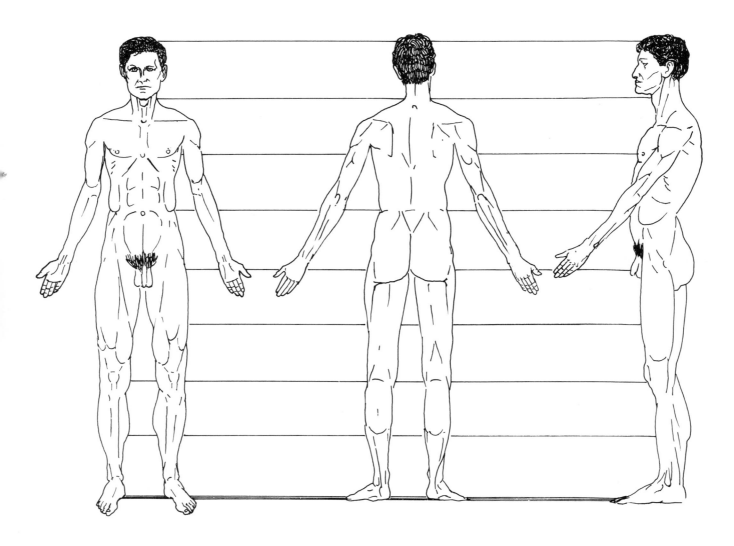

reality—for example, the rib cage divides a little lower than suggested here—but it doesn't really matter. You can't really see the difference, and it is unrealistic to break things down into tiny fractions.

My experience as a teacher has shown me that people who draw figures with long legs or short legs or big heads or little heads, and so forth, do it by habit, not by intention. These habits often go undetected, hence uncorrected. A constant measure enables you to identify undetected, habitual errors in drawing. Once you are in control, you will be in a position to impose your personal esthetics. You can draw a figure as tall as an El Greco or as short as the Egyptian divine dwarf Bes.

This book uses the head as the unit of measure. The average body measure is 7½ heads tall. Short people are about 7 heads tall. Tall people are about 8 heads tall. The standard we will be using is an 8-head measure. It is tall, elegant, and expedient. This measure will be marked-off on a grid. Most people have shorter upper legs than this 8-head model. When you draw the average 7½-head figure, however, the legs appear a bit stubby. We seem to be conditioned to think of legs as longer than they actually are.

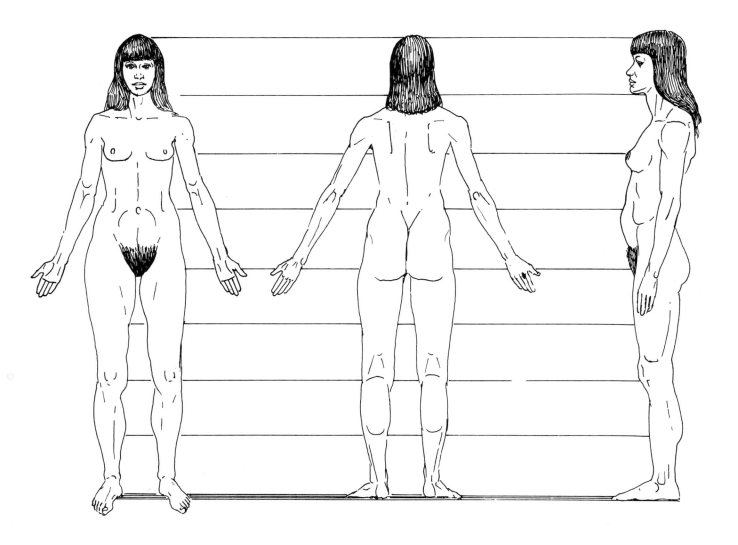

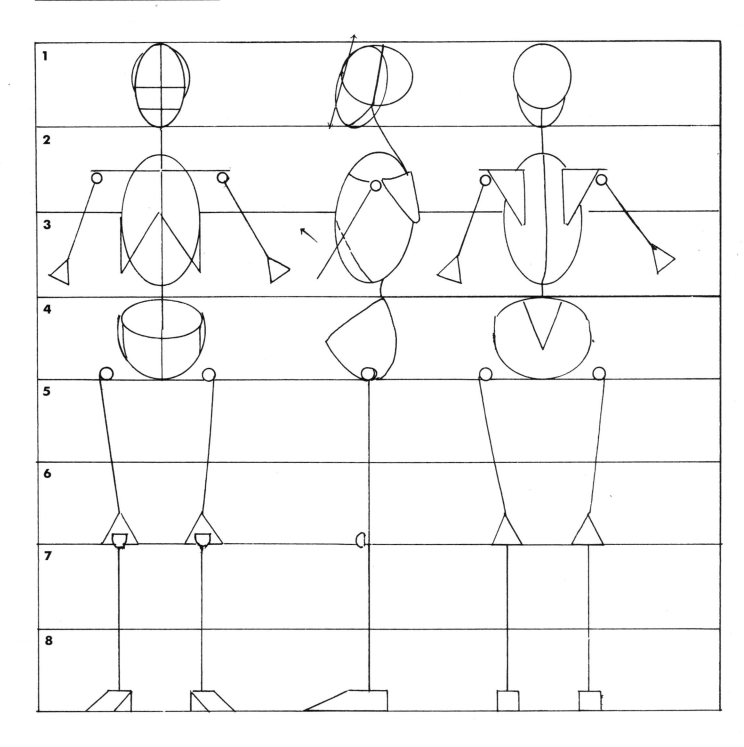

1 **2** **3**

Throughout this book you will be given directions for drawing the various parts of the body. These parts are to be added in order to a skeletal schematic constructed on an 8-head measure grid. This chapter is about proportional relationships among the various parts of the body in the 8-head skeletal schematic as seen from different views. As we proceed, you will add the following body parts to the grid in order.

1. Head
2. Division of Rib Cage/Bottom of Scapula
3. Top of Pelvic Basin
4. Bottom of Pelvic Basin/Great Trochanter
5. Mid Thigh/Lower Arm and Hand (not included at this time)
6. Kneecap/Top of Lower Leg/Bottom of Upper Leg
7. Mid Lower Leg/Calf
8. Bottom of Foot

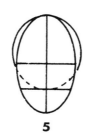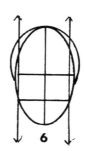

4

5 **6**

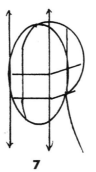

7

THE HEAD

The first unit of our 8-head measure is the head itself, an oval whose width is half its length.

1. Draw the oval for the head in the first head measure of your grid. Establish the vertical median line.
2. Divide the head at half its length with a line to represent the level of the upper eyelid. This also indicates the top of the nose.
3. Draw a line between the eye line and the bottom of the head oval (chin) to indicate the bottom of the nose. This also establishes placement of the ears.
4. Eyelid and nose lines move with the directions of the head.
5. Draw a ball to represent the base of the skull. It should touch the bottom of the nose.
6. The outside lines of the original oval represent the front plane of the head.
7. When the median line moves from front to side the plane change is established at the outside line of the original oval.

RIB CAGE, SHOULDER GIRDLE, AND UPPER ARM

1. The rib cage is 1½ heads long. Its width is 1 head across. Until you are comfortable with the proportional relationships between the parts, you should use your fingers as a ruler.

2. Draw the rib cage beginning with an oval, then divide it. Do not draw a rib cage already divided, which can lead to distorted, misshapen torsos. The rib cage floats evenly in the second and third head measure, leaving a quarter of a head above for the neck. Leave a quarter of a head between the bottom of the rib cage and the top of the pelvis.

The shoulder girdle sits about a sixth of the way down from the top of the rib cage oval. It consists of the clavicle in front and the scapula in back. Each shoulder girdle moves independently of the other and is capable of moving up, down, forward, and backward.

The median line of the rib cage is the sternum, which runs down the front of the rib cage. It is a flat bone in the shape of a *u* between the clavicles. The sternum is the point of constancy for the clavicle. Draw the clavicle and the sternum as straight lines on your grid.

The upper arm bone (humerus) articulates with the scapula. It has a ball-and-socket joint. The top of the upper arm bone is drawn as a circle. The bone itself is approximately 1½ heads long and ends in a triangle with the apex up. At its base, the triangle measures a quarter of a head. This triangle determines the plane direction of the arm. For now, place the upper arm as a line on your drawing in the second and third head measure ending near the bottom of the rib cage oval.

It is very important to establish the median line in the head and the rib cage and to determine the direction of the planes of limbs. The head and the rib cage can twist in opposing directions.

3. Place a triangle apex up at the bottom of the upper arm bone. When the upper arm bone rotates, the triangle move accordingly.

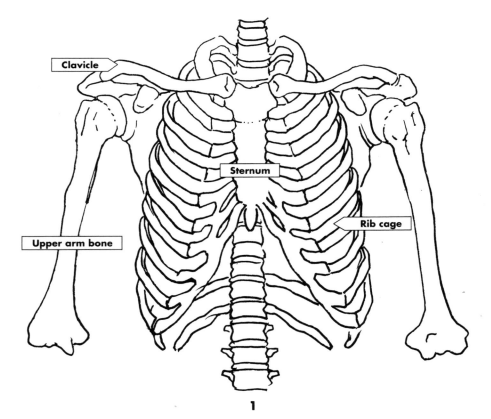

1

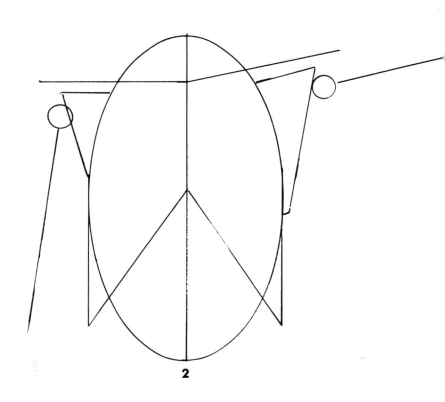

2

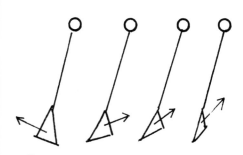

3

PELVIC BASIN

1. The top of the pelvic basin (ilium) begins at the third head measure. The average pelvic basin is 1 head long and 1 head wide. The fourth head measure is the bottom of the pelvic basin, which is the halfway point of the figure from top to bottom. The pelvic basin is highest at the back and descends at an angle. The top of the descending basin (iliac crest) stops about a third of a head down.

2. Draw the pelvic basin in the fourth head measure on your grid. The great trochanter is represented by a ball at the point of articulation.

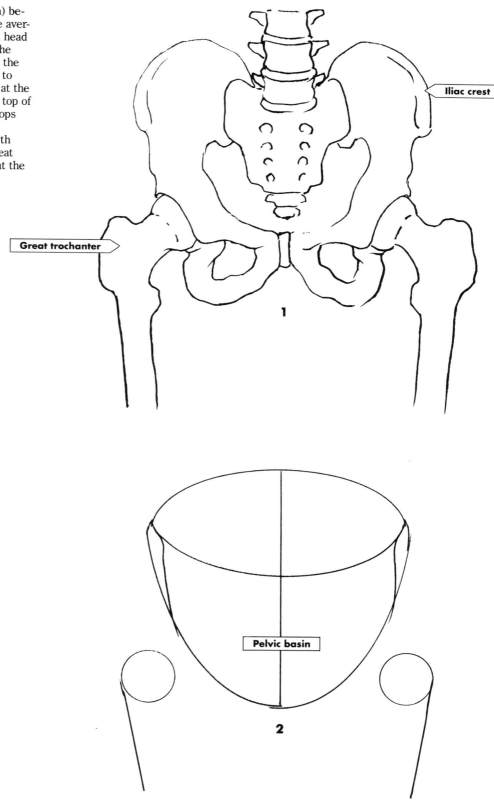

Iliac crest

Great trochanter

1

Pelvic basin

2

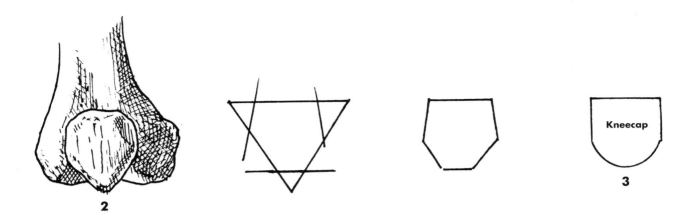

UPPER LEG BONE

1. The upper leg bone (femur) is 2 heads long. Its base is represented by a triangle, which measures almost half of a head across. This triangle moves with the rotation of the upper leg bone. For the ball of the upper leg bone, draw a circle that takes the leg out from the pelvic basin. (Actually, the upper leg bone's head leads to its neck and ends in the great trochanter, which is always visible in the fleshed-out leg as a protrusion or an indentation.)

2. The kneecap (patella) is a base-up triangular bone.

3. The two points of the base are simplified to a shield shape. The kneecap sits in the middle of the bottom of the triangle at the base of the upper leg bone. Add the upper leg bone and kneecap in the fifth and sixth head measure on your grid.

LOWER LEG AND FOOT

4. The lower leg to the bottom of the foot measures 2 heads. The foot schematic measures a quarter of a head wide and deep. Think of the foot as a box with the front cut at an angle. For now, think of the lower leg as a line. Draw the lower leg and foot in the seventh and eighth head measure on your grid.

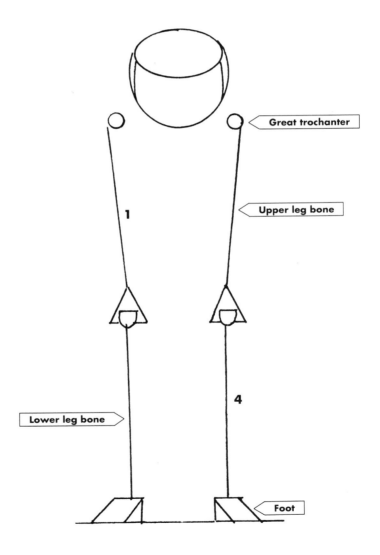

THE HEAD

1. Draw a circle for the back of the skull three-quarters of the length of the head oval. Balance it on the vertebrae of the neck.

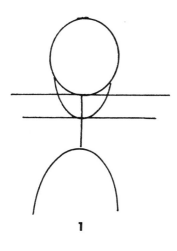

1

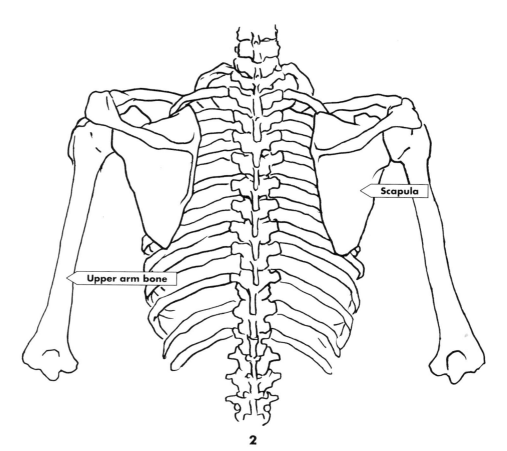

Upper arm bone

Scapula

2

RIB CAGE, SHOULDER GIRDLE, AND UPPER ARM

2. The scapula, part of the shoulder girdle, is a triangular bone with the apex facing down.

3. Draw the scapula three-quarters of a head long and sitting about one-sixth of the way down from the top of the rib cage oval, ending just below the second head measure.

Add the upper arm as a simple line on your grid ending in a base-down triangle.

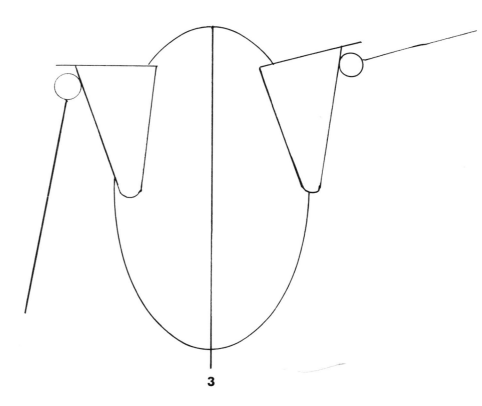

3

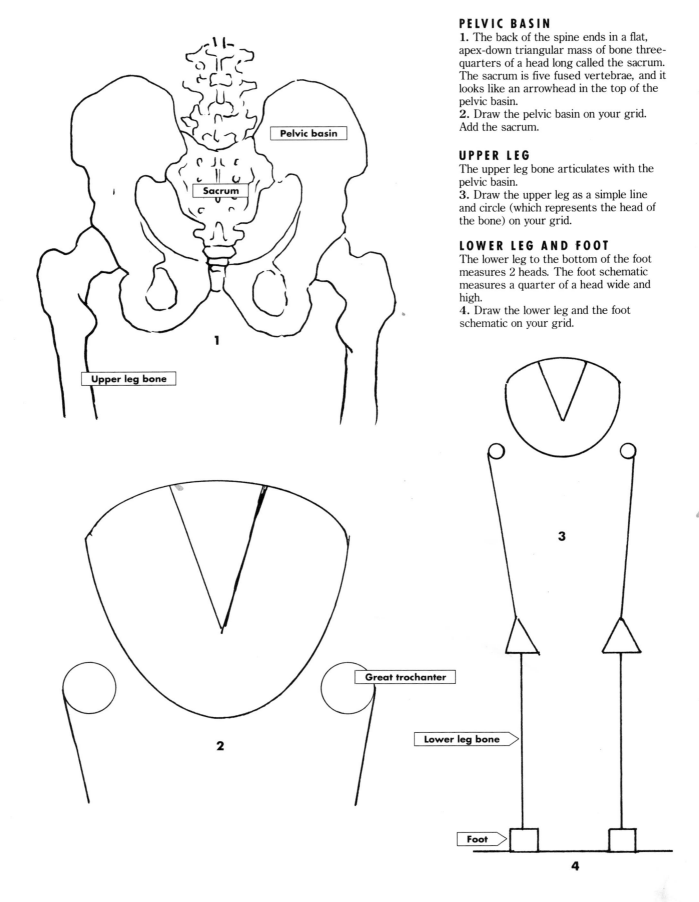

PELVIC BASIN

1. The back of the spine ends in a flat, apex-down triangular mass of bone three-quarters of a head long called the sacrum. The sacrum is five fused vertebrae, and it looks like an arrowhead in the top of the pelvic basin.

2. Draw the pelvic basin on your grid. Add the sacrum.

UPPER LEG

The upper leg bone articulates with the pelvic basin.

3. Draw the upper leg as a simple line and circle (which represents the head of the bone) on your grid.

LOWER LEG AND FOOT

The lower leg to the bottom of the foot measures 2 heads. The foot schematic measures a quarter of a head wide and high.

4. Draw the lower leg and the foot schematic on your grid.

Pelvic basin

Sacrum

Upper leg bone

Great trochanter

Lower leg bone

Foot

1

THE HEAD

1. Two ovals join to form the head in the side view. The oval for the base of the skull touches the three-quarters line. The oval for the face is about half the width of the oval of the base of the skull.
2. The angle of the face is rarely vertical at rest.
3. There is great flexibility in the head's movement. Draw the head on your grid.

2

3

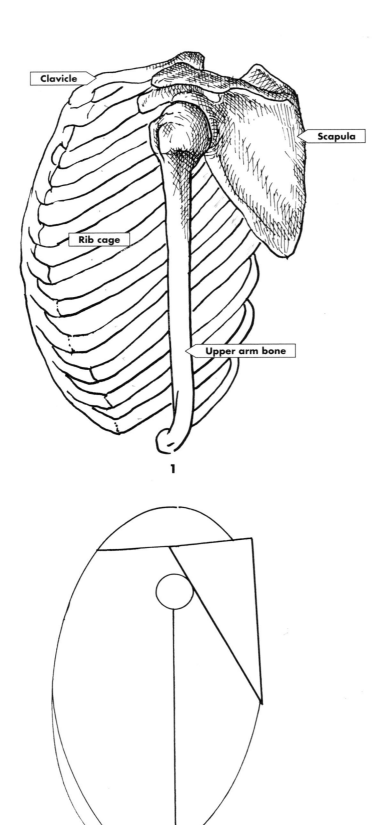

Clavicle

Scapula

Rib cage

Upper arm bone

1

RIB CAGE, SHOULDER GIRDLE, AND UPPER ARM

1. The rib cage, 1½ heads deep and 1 head wide, divides in front at the second head measure.

2. Draw the rib cage on your grid. Draw the line for the front of the shoulder girdle, the clavicle, one-sixth of the way down from the top of the rib cage. The clavicle joins the triangle of the scapula at about half of the width of the rib cage at that point.

3. The upper arm moves to the horizontal with the top of the scapula without significantly affecting the scapula's position.

4. Above that point, the upper arm bone takes the top of the scapula triangle with it. From the side, you see the narrow side of the triangle at the bottom of the upper arm bone, which indicates the direction of the plane with an arrow pointing forward. Draw the ball of the humerus near the top of the inside border of the scapula triangle.

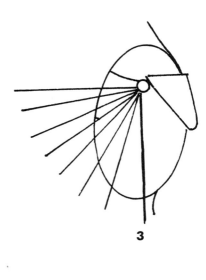

3

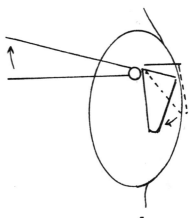

4

2

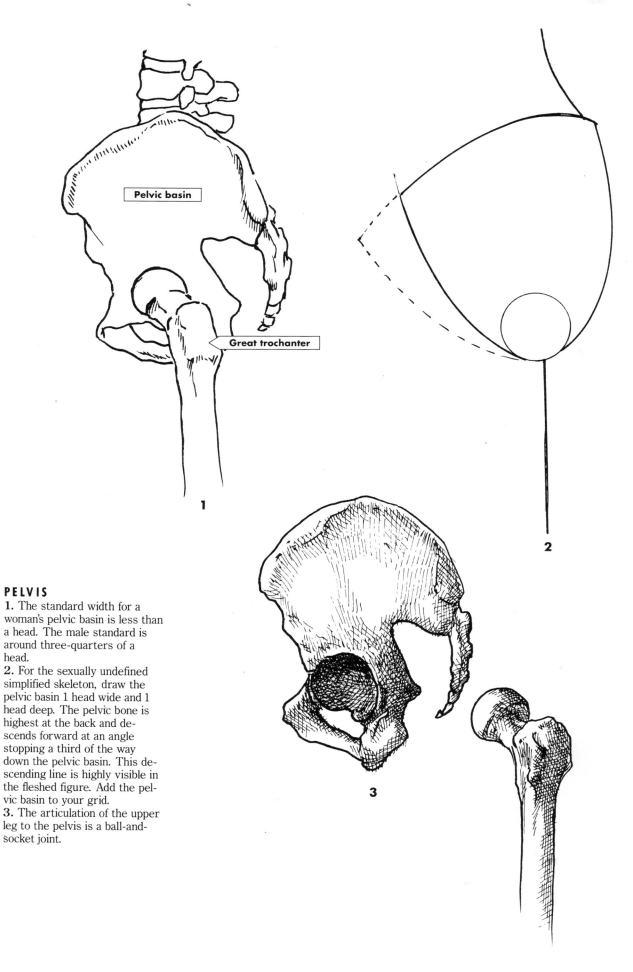

Pelvic basin

Great trochanter

1

2

3

PELVIS

1. The standard width for a woman's pelvic basin is less than a head. The male standard is around three-quarters of a head.

2. For the sexually undefined simplified skeleton, draw the pelvic basin 1 head wide and 1 head deep. The pelvic bone is highest at the back and descends forward at an angle stopping a third of the way down the pelvic basin. This descending line is highly visible in the fleshed figure. Add the pelvic basin to your grid.

3. The articulation of the upper leg to the pelvis is a ball-and-socket joint.

SPINE

Except on extremely thin people, the vertebrae do not show. Normally, only the seventh neck vertebra sticks out. To understand how the body balances by opposition, however, you must know that the spine consists of four parts: the neck, the rib cage, the lower back, and the pelvic parts.

1. Draw these interlocking, opposing arches.

UPPER LEG

The head of the upper leg bone joins the socket joint of the pelvic bone with the great trochanter, a visible landmark. The 2-heads-long upper leg bone connects to the pelvis directly at its bottom and squarely in its middle. The kneecap below is a shallow pan.

2. For now, draw the upper leg as a ball and straight line and add the kneecap on your grid.

LOWER LEG AND FOOT

The lower leg to the bottom of the foot schematic measures 2 heads.

3. The foot is a quarter of a head high and wide. As a rule, the foot from toe to heel is about 1 head long. Consider the foot as a planed object.

4. Divide a rectangular box in half.

5. At the halfway point, angle a line down. Divide the back half of the box again.

6. The rear quarter of the box is the point where the foot joins to the lower leg. Draw the lower leg as a simple line on your grid and include the foot schematic.

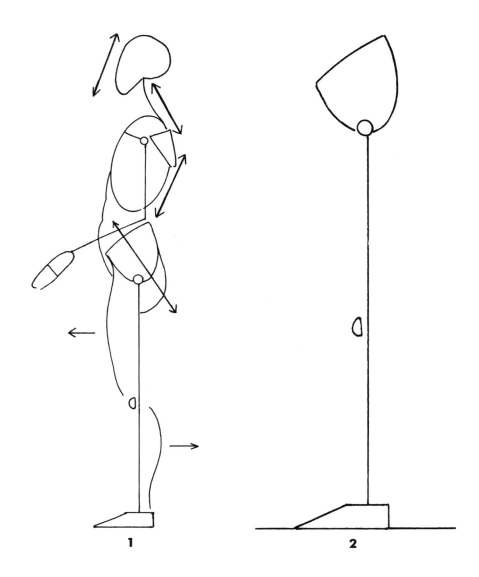

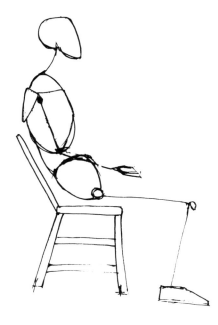

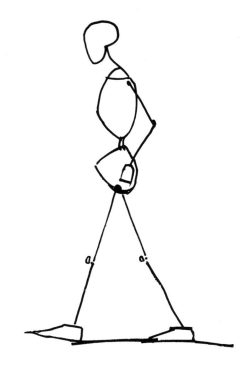

Exercise 1. Use yourself as a model. Don't use a mirror. Sit down in a hard chair. Sit stiffly like a soldier. Be aware of yourself sitting. Hold the position. Feel it—now relax; sit as you ordinarily would. Do this over and over: stiffen and relax. Sense your spine; feel your neck. Be aware of the change in thrust and direction from every view as you move. Get a sense of the direction of your face. Put your hand on your face. Determine its direction. Put your hand on your chest. See what happens to your rib cage when you relax after sitting stiffly. Sit stiffly with your hands on your hips. Relax. What did your pelvic basin do? Sense the changes from every view. Remember, you are sensing yourself, not looking at yourself.

Exercise 2. Draw the simplified skeleton from the side in a stiff position. Now draw it in a relaxed position.

Exercise 3. Get up. Stand naturally. Sit, then stand again. Move quickly and naturally. Don't freeze yourself in motion. Go through the entire motion. Do it again and again. As you go through the motion, concentrate on a part: neck, spine, pelvis, leg positions, and so forth. Become completely aware of what your body is doing. Draw the simplified skeleton getting up.

Exercise 4. Sense and feel the basic thrusts of the position you are in as you read this book. Close your eyes and concentrate on what your body is doing. Draw your simplified skeleton. Brake from the pose and draw it from memory. Return to the pose and concentrate on it.

Exercise 5. Observe people moving, walking, sitting, and so forth. Analyze the basic thrusts. Consider the skeleton. Draw the simplified skeleton in action. Draw it walking. Remember opposition. When the figure walks, the forward leg is opposed by the arm on the same side.

One of the things that distinguishes humans from other animals is bipedal (two-legged) walking. One of the features of bipedal walking is called *striding*, which is characterized by striking the heel, rolling over to the ball of the foot, and pushing off with the big toe. Without taking the stride into account, your figure will look as if it is tiptoeing, sneaking, or handicapped. Go through the walking motion yourself. Get a friend or a model to go through the motion. Now draw the simplified skeleton walking in different attitudes; for example: quickly, casually, and so forth.

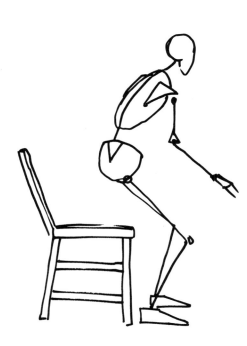

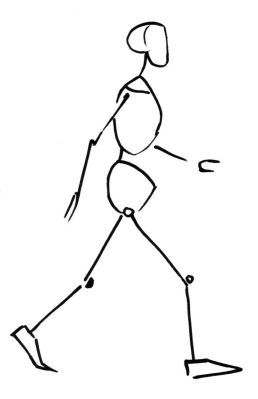

Exercise 6. Watch people at the park, beach, subway, and so forth, and observe and simply analyze motion. Draw the simplified skeleton in every imaginable posture, attitude, and motion. Take a constant measurement check. Draw in pen to prevent fussing, erasing, and procrastination. It will also help you overcome any timidity in drawing.

3 THE DELTOID

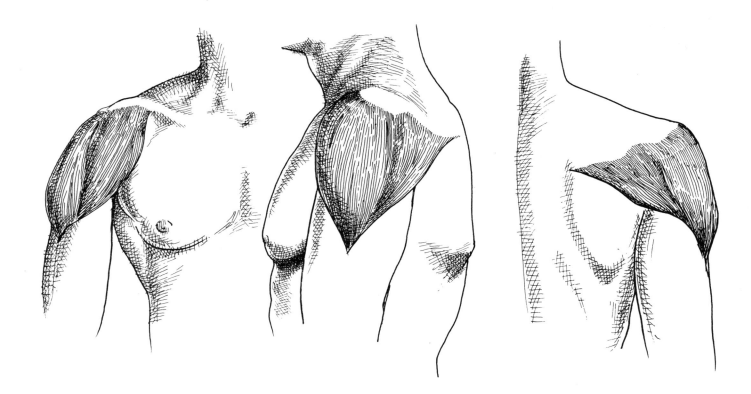

The first muscle to apply to the simplified skeleton is the deltoid. The deltoid is named after the triangular Greek letter, delta, and is shaped like an inverted triangle.

The deltoid has three aspects: front, side, and back (see figure above). It originates along the clavicle in the front and along the spine of the scapula in the back, and it inserts at the second head measure on the upper arm bone. When the deltoid contracts, it elevates or abducts (moves from the median) the arm.

When the front, side, or back aspects of the deltoid contract independently, the arm lifts to the front, side, or back. When they contract cooperatively, the arm lifts laterally. The deltoid lifts the arm only as far as the horizontal, as a muscle cannot lift beyond its point of origin.

The 8-head measure grid (opposite, top right) shows the three aspects of the deltoid as positioned on the simplified skeleton.

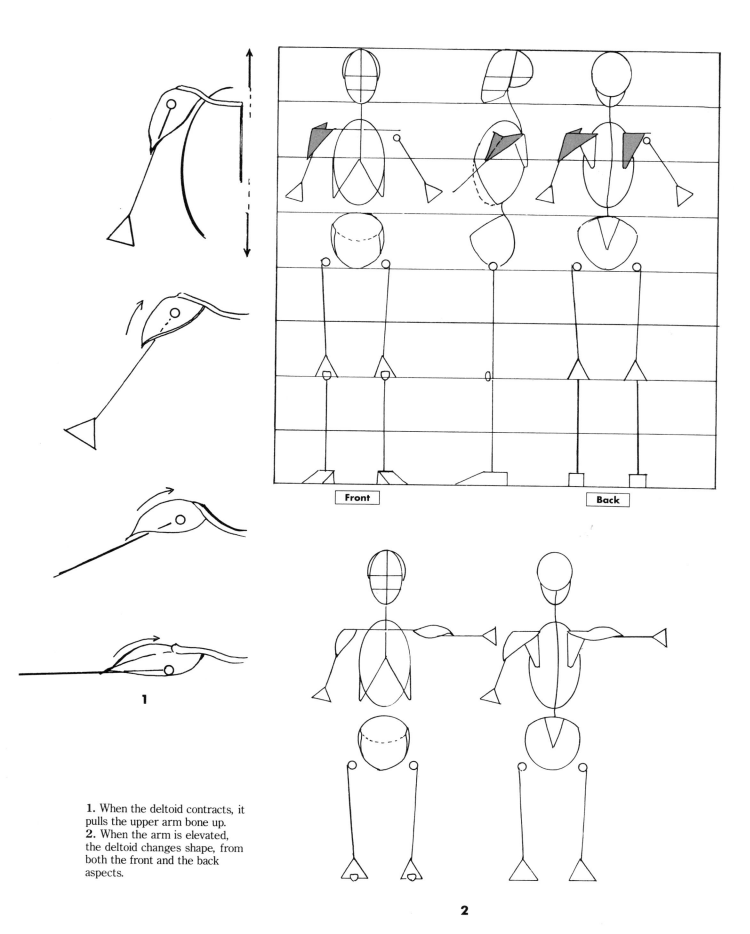

Front

Back

1

1. When the deltoid contracts, it pulls the upper arm bone up.
2. When the arm is elevated, the deltoid changes shape, from both the front and the back aspects.

2

35

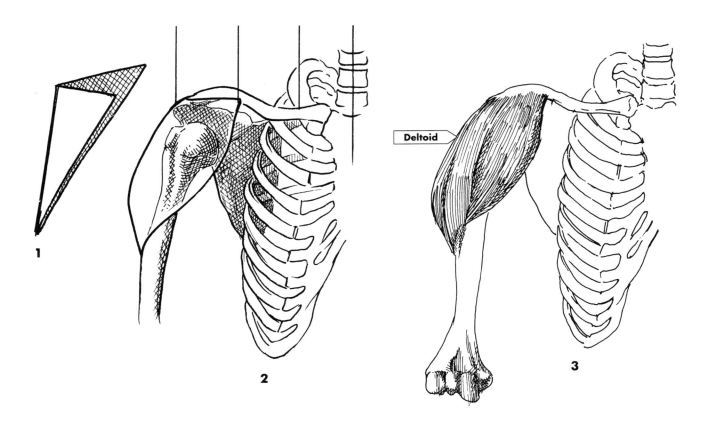

1

2

3

Deltoid

In the simple construction of the figure you can reduce the three aspects of the deltoid to a single form: a creased triangle. The deltoid originates on the outside third of the clavicle and inserts at the second head measure.

1. Draw a creased triangle to represent the deltoid.

2. Place the triangle on the outside third of the clavicle.

3. Round off the creased triangle to represent the finished deltoid.

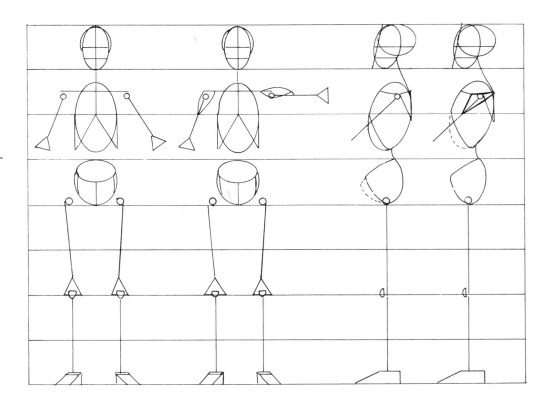

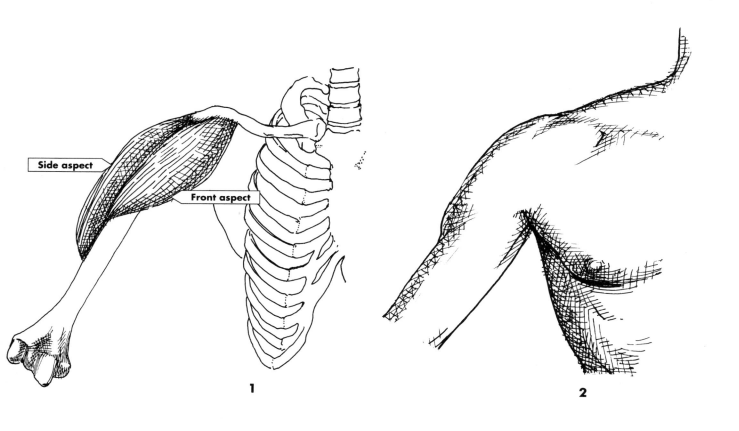

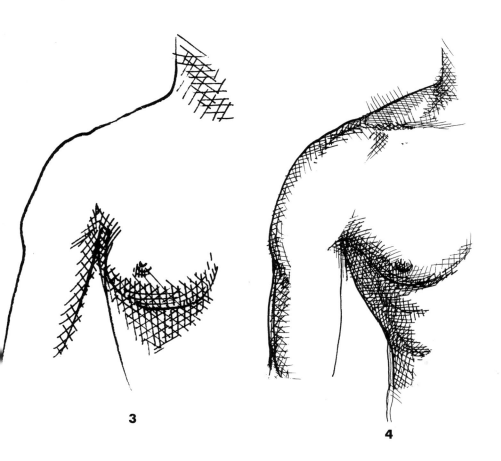

1

2

3

4

REFINEMENTS
1. When the arm is lifted out, the side aspect of the deltoid is pronounced, and there is a delineation between the front and side aspects.
2. Although it is essentially triangular, the deltoid on the figure becomes rounded.
3. Fat tends to accumulate about two-thirds of the way down the deltoid, altering its original shape.
4. The deltoid is prominent in the fleshed-out figure.

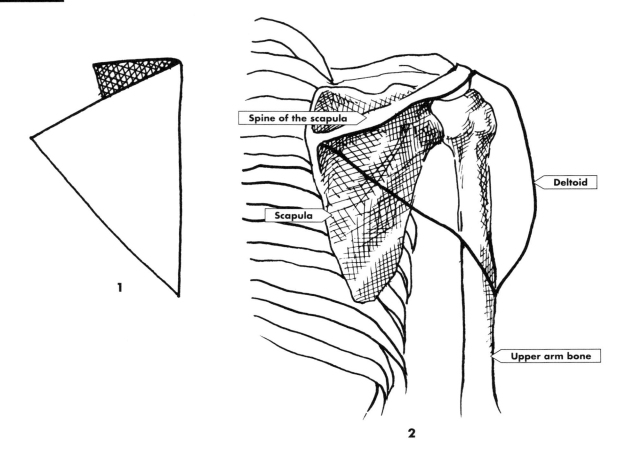

Spine of the scapula

Deltoid

Scapula

Upper arm bone

1

2

1. Draw a creased triangle to represent the deltoid muscle.
2. Place the deltoid triangle on the top border of the scapula. This border is defined by the spine of the scapula, a diagonal ridge of bone along the upper back of the scapula. Insert the deltoid triangle at the second head measure and round off the form.

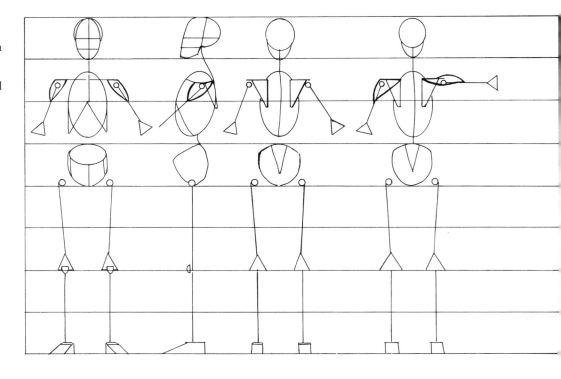

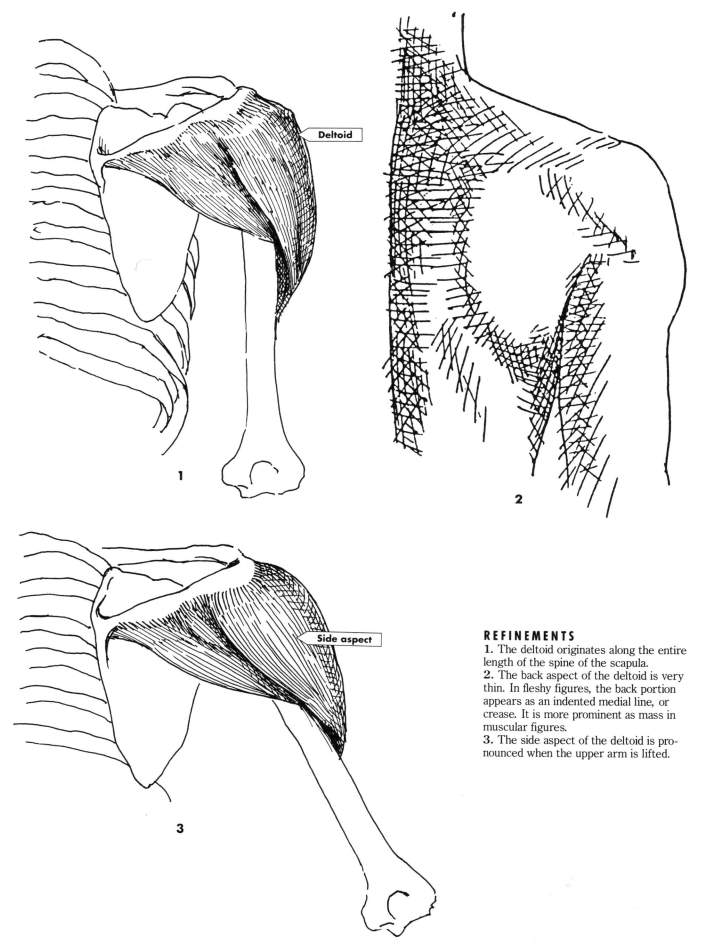

Deltoid

1

2

Side aspect

3

REFINEMENTS

1. The deltoid originates along the entire length of the spine of the scapula.

2. The back aspect of the deltoid is very thin. In fleshy figures, the back portion appears as an indented medial line, or crease. It is more prominent as mass in muscular figures.

3. The side aspect of the deltoid is pronounced when the upper arm is lifted.

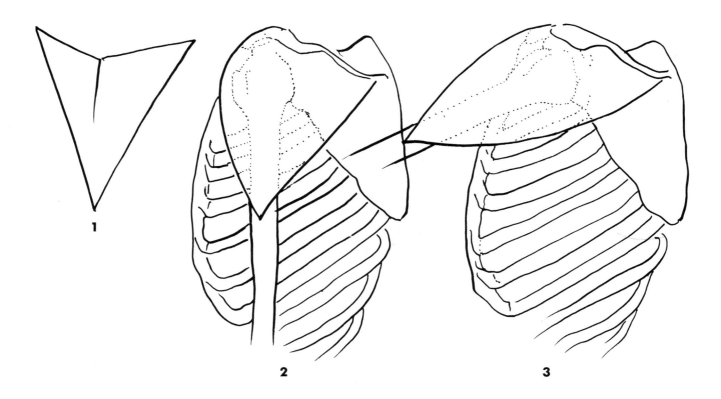

1

2

3

1. Draw a creased triangle to represent the deltoid.
2. Place the deltoid triangle originating on the clavicle on the outside third and originating in the back at the top of the scapula triangle (spine of the scapula). Insert the deltoid triangle at the second head measure.
3. Round the triangular form to represent the finished muscle.

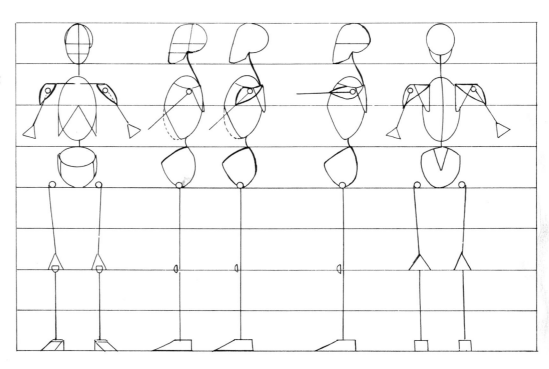

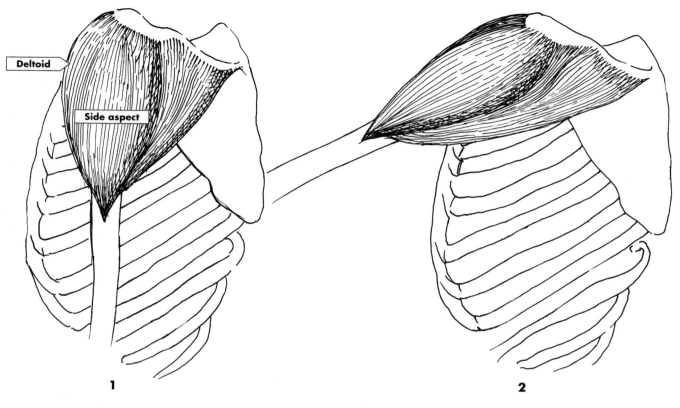

Deltoid

Side aspect

1

2

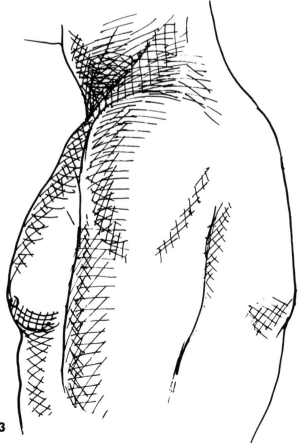

3

REFINEMENTS

1. The side aspect of the deltoid is very prominent.

2. As the side aspect contracts, the shape of the entire deltoid broadens in the direction of the contraction. It often looks like a single form.

3. In muscular people, the delineation between the front and the side aspects are defined.

4 THE BUTTOCKS

When combined the muscles called the gluteus medius and gluteus maximus form the buttocks.

Where you have a similar function, you have a similar form. The gluteus medius is another triangular muscle like the deltoid. Its principle function is to abduct (take from the median line) the upper leg. Consider it as a triangle on the simplified skeleton.

The gluteus maximus is an extensor (straightener). It is attached to the back of the upper leg and inserts a third of a head measure below the bottom of the pelvic basin. Remember that the origins and insertions are constant. The gluteus maximus always follows the bone. When it contracts, it brings the bone back. It keeps the pelvic basin erect. It is almost always fatty, except in extremely athletic bodies.

By learning to draw the simplified forms of the buttocks, you will be able to draw from your head the type of figures represented in action on the opposite page. The figures opposite, right, and below, right, represent the relationship of the buttocks, to the fleshed-out figure. The ones opposite, left, and below, left, show the buttocks on the simplified skeleton.

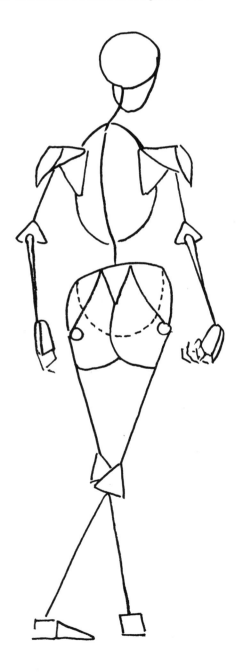
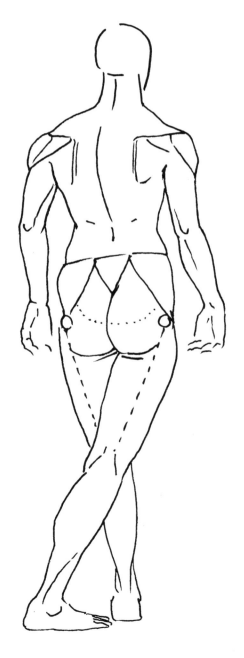

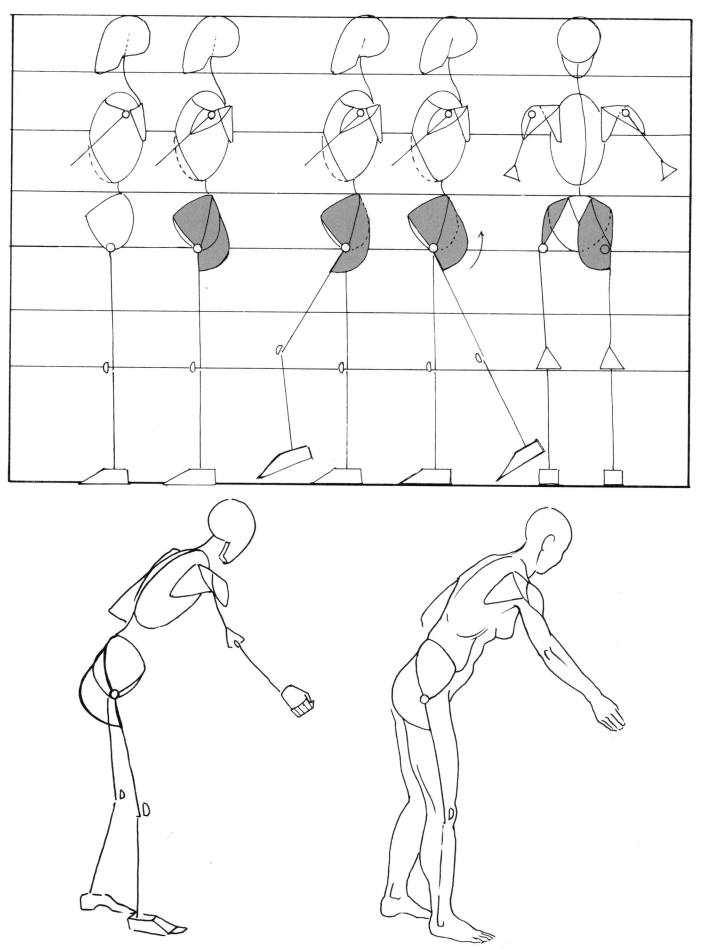

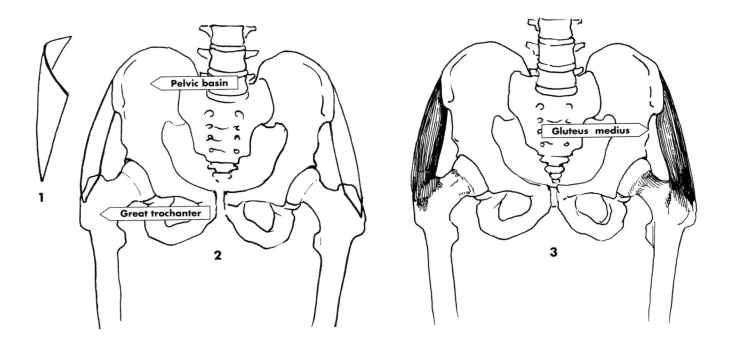

1

Pelvic basin

Great trochanter

2

Gluteus medius

3

1. Draw a triangle to represent the gluteus medius.
2. Place the gluteus medius triangle on the side of the pelvic basin. Insert the apex at the great trochanter.
3. Round out the triangles on both sides of the pelvic basin.

REFINEMENTS
The anatomical references from the front are the same as those from the back (see opposite page).

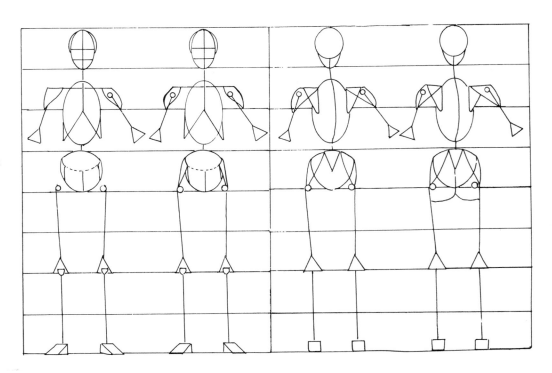

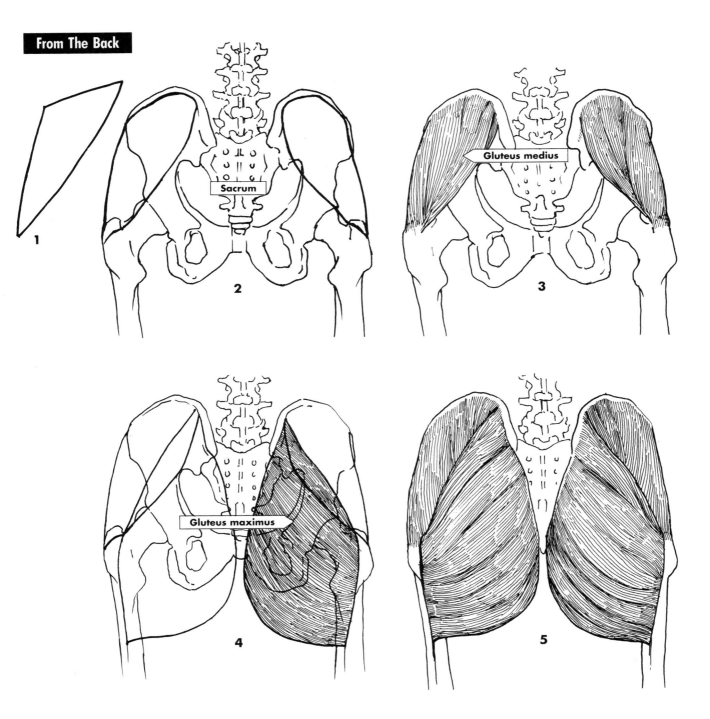

Sacrum

Gluteus medius

Gluteus maximus

1. Draw a triangle to represent the gluteus medius.

2. Place the base of the gluteus medius triangle at the pelvic crest. Insert at the great trochanter.

3. Flesh out the gluteus medius.

4. The gluteus maximus is teardrop-shaped. Place it at the very back of the pelvic basin. It runs down along the outside border of the sacrum and inserts at the bone a third of a head measure below the pelvic basin.

5. Flesh out the gluteus maximus.

REFINEMENTS

The pelvic region is relatively larger in females. As a rule, women have larger buttocks, abdomens, and upper thighs. The significant difference between the male and female pelvic bone is the size relative to the rib cage and to the rest of the body.

The gluteus medius is particularly evident in females. It is fattier and relatively larger.

The line separating the gluteus medius from the gluteus maximus is never visible in the fleshed figure. The sacrum is very important to the form in the area of the buttocks; it creates a flat plane.

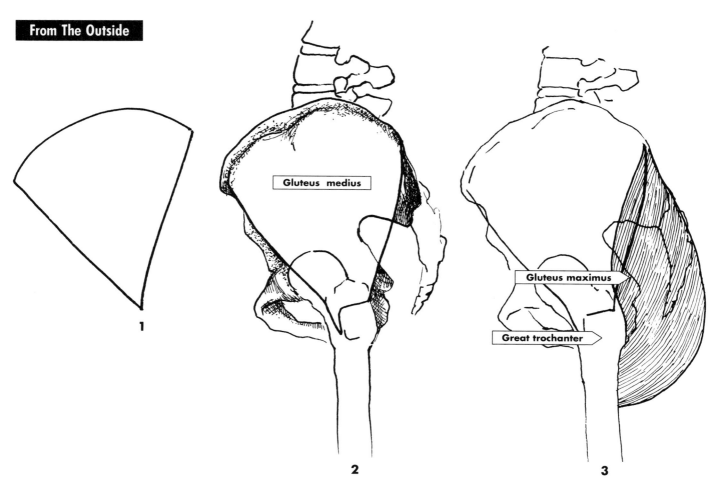

Gluteus medius

Gluteus maximus

Great trochanter

1

2

3

1. Draw a triangle to represent the gluteus medius.

2. Draw the gluteus medius triangle emerging from the pelvic crest. Insert the apex at the great trochanter. Round the form of the triangle.

3. The gluteus maximus here looks like a teardrop shape sliced in half. The shape is obviously narrow at the top and fuller at the bottom. Place the shape on the back of the pelvic basin. The insertion is on the back of the upper leg bone. The measure is a third of a head measure below the pelvic basin.

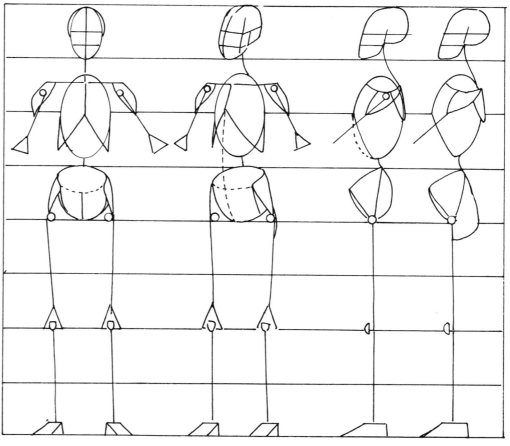

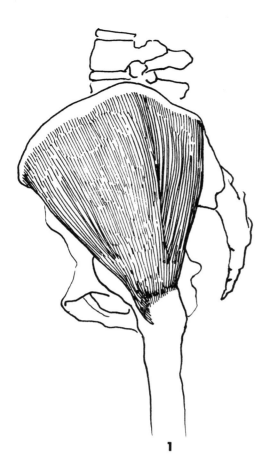

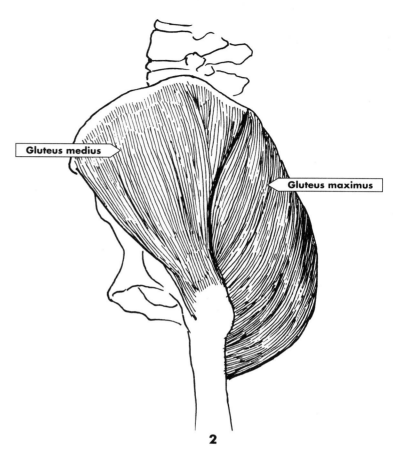

1

2

REFINEMENTS

1. The gluteus medius is visible in contraction at times without elevating the leg; for example, it is visible in a standing posture when the pelvis is held to the leg and the weight is on that leg. It is also visible in walking when the weight shifts to the side.

2. The gluteus maximus, always fatty, is an extensor of the upper leg. It serves an evolutionary purpose as it keeps the pelvis erect. This makes the gluteus maximus a particularly human muscle.

5 EXTERNAL OBLIQUE AND RECTUS ABDOMINIS

The external oblique is the muscle that connects the rib cage to the pelvic basin. It flanks the abdominal cavity and gives the appearance of hanging from the bottom of the rib cage. The external oblique sits on the pelvic crest. When one side contracts, it brings the rib cage to the pelvic crest on the side of the contraction. When the two sides contract cooperatively it flexes (or bends) the trunk. When the trunk is fixed, it elevates the pelvis.

The rectus abdominis is another ovoid. It is placed in the hollow that is left after the external oblique is added. The rectus abdominis is a flexor of the trunk.

The figures opposite, bottom, show the relationship of the external oblique and rectus abdominis to the fleshed-out figure. The figures below show the external oblique and rectus abdominis in their relationship to the simplified skeleton.

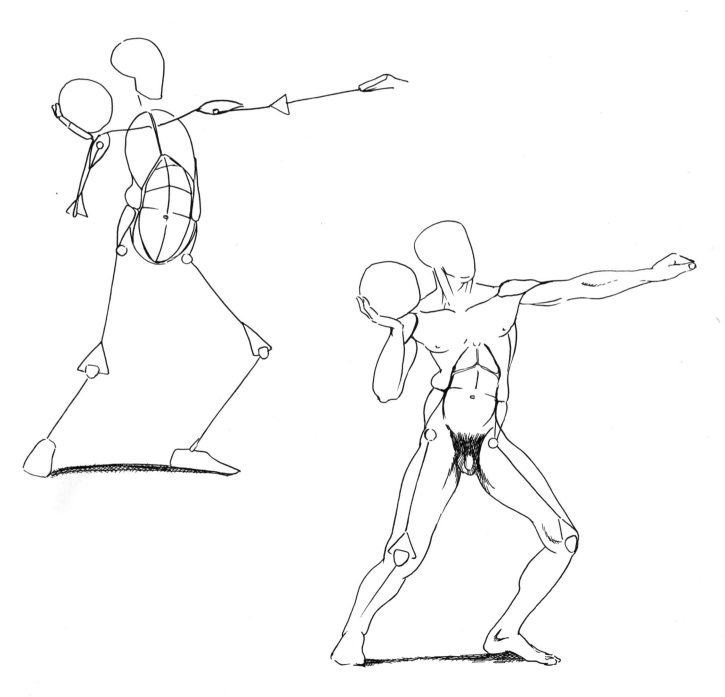

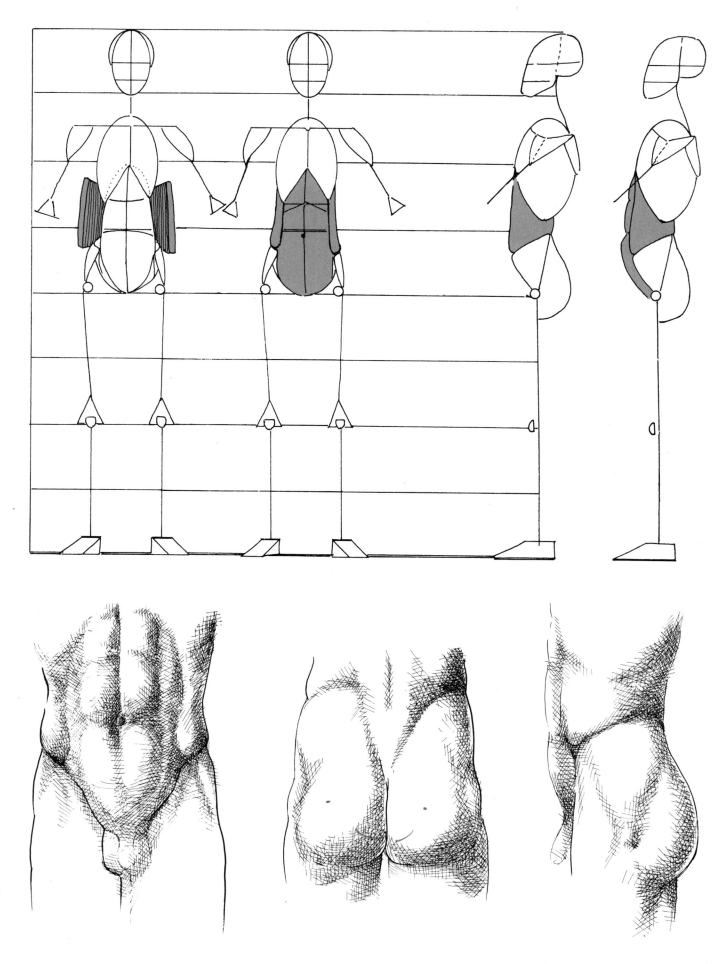

49

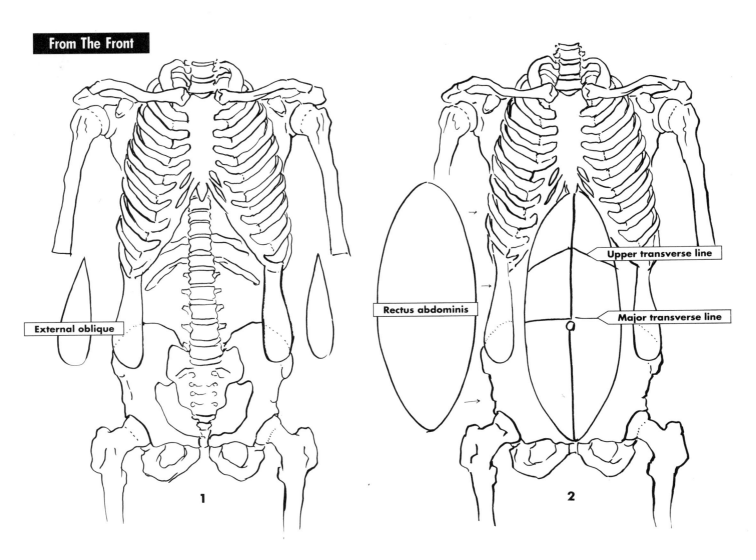

External oblique

Rectus abdominis

Upper transverse line

Major transverse line

1

2

The external oblique has the appearance of a teardrop that hangs from the bottom of the rib cage and sits on the pelvic crest.

1. Add the external oblique to your drawing. Place the rectus abdominis oval in the hollow left after the external oblique has been added.

2. Include the median line. Divide across at the third head measure to determine the transverse line. The upper transverse lines have an oblique turn.

There is great variation in the placement of the navel. As a rule, however, place it at the third head measure, right below the major transverse line.

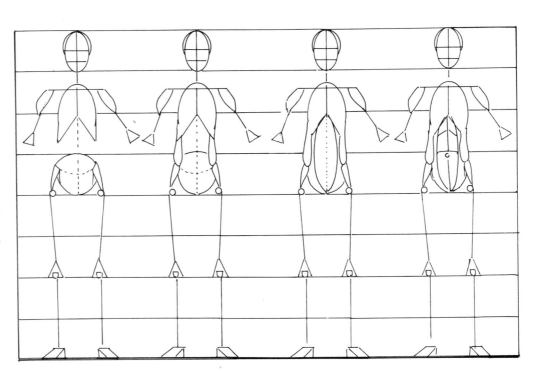

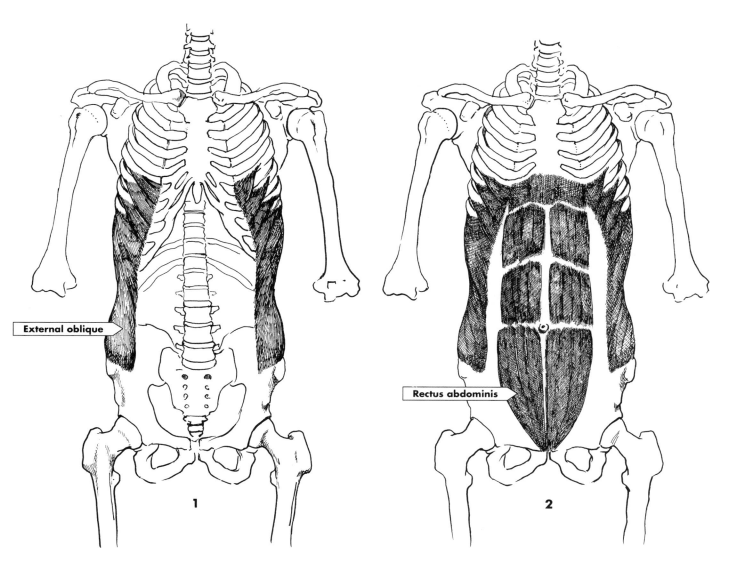

External oblique

1

Rectus abdominis

2

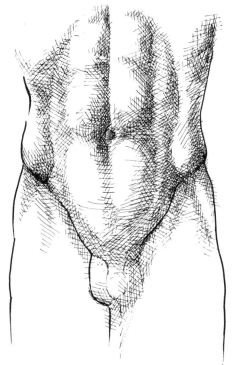

3

REFINEMENTS

1. The external oblique originates at the lower ribs. When it loses tone in men, it is called the "spare tire." Because of the approximate similarity of width of the rib cage to the pelvic crest, it tends to hang over the side of the hips. In women the pelvic crest is wider and accommodates the excess.

2. The rectus abdominis is not actually an ovoid, although it appears as such in drawings. It is a long, flat muscle sheathing the abdominal area.

3. Both men and women have a layer of fat beneath the surface of the skin, but women have slightly more fat, which gives them a softer, less defined abdominal region.

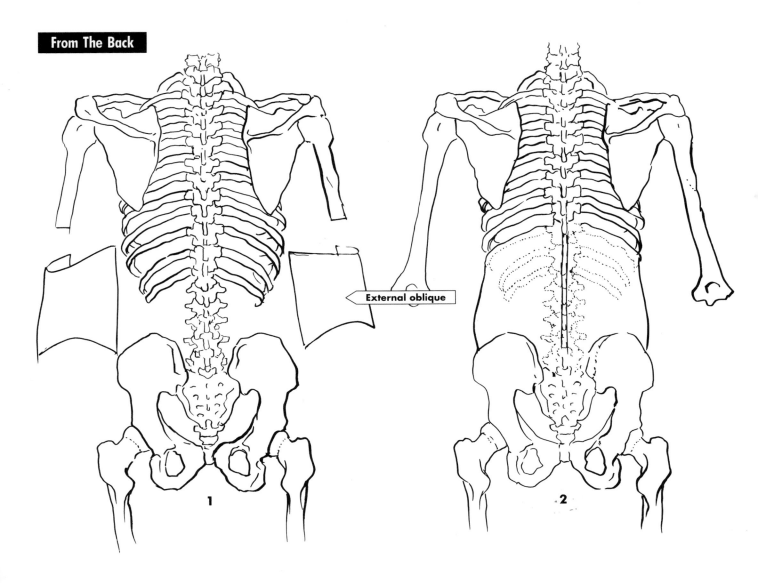

External oblique

1. Begin with the external oblique as connecting tissue.

2. For the sake of construction, draw the external oblique hanging down from the rib cage, going around to the spine, and sitting on the top of the pelvic basin. The rectus abdominis, however, is never part of the back.

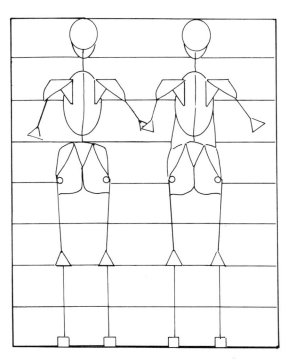

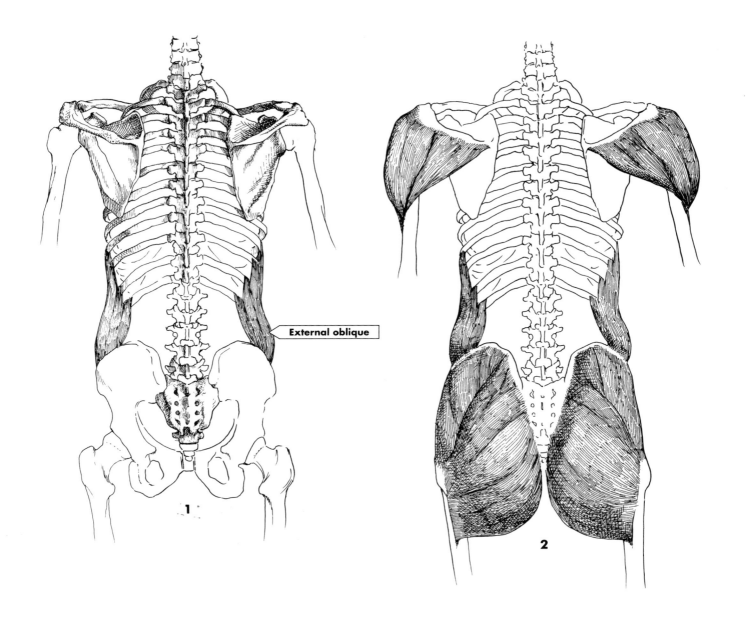

External oblique

1

2

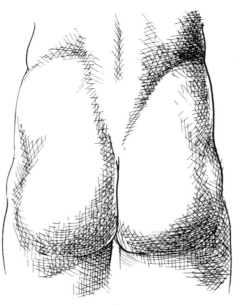

3

REFINEMENTS

1. The external oblique does not actually go all the way around to the back but occupies the front three-quarters of the pelvic crest. The remainder of the pelvic crest is taken by the latissimus dorsi (see chap. 14). The separation between the latissimus dorsi and the external oblique here is rarely visible.

2. The external oblique sits on the crest of the pelvic basin, and the gluteus medius hangs down from it.

3. The external oblique forms a prominent part of the lower back in the fleshed-out figure.

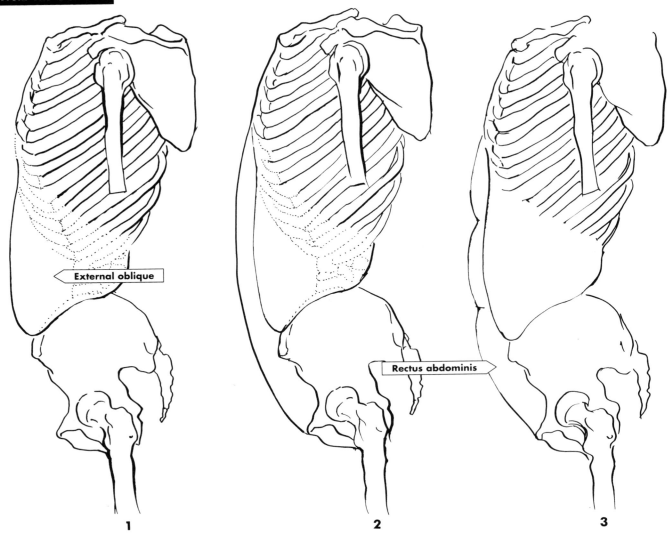

External oblique

Rectus abdominis

1

2

3

1. Consider the external oblique as hanging from the bottom of the rib cage and coming to rest on the pelvic crest.
2. Place the ovoid for the rectus abdominis in the hollow originating at the rib cage division and inserting at the pelvis. The external oblique flanks the rectus abdominis ovoid. The separation is highly visible even in very thin and very fat figures.
3. The major transverse line occurs at the third head measure. Divide the area within the third head measure in half for the next division.

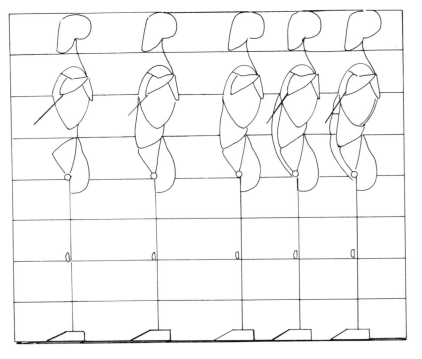

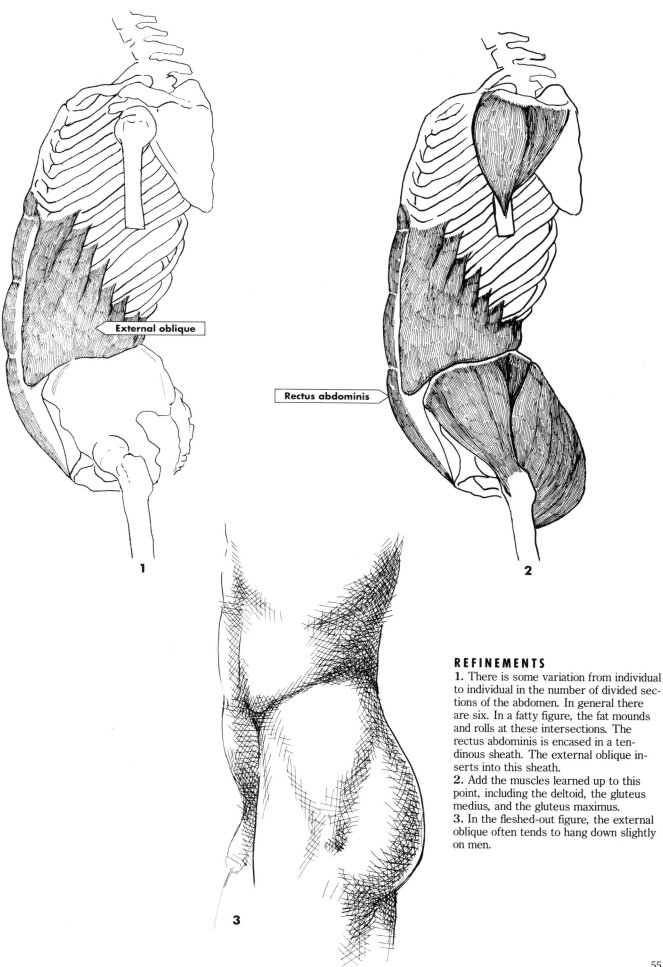

External oblique

Rectus abdominis

1

2

3

REFINEMENTS

1. There is some variation from individual to individual in the number of divided sections of the abdomen. In general there are six. In a fatty figure, the fat mounds and rolls at these intersections. The rectus abdominis is encased in a tendinous sheath. The external oblique inserts into this sheath.

2. Add the muscles learned up to this point, including the deltoid, the gluteus medius, and the gluteus maximus.

3. In the fleshed-out figure, the external oblique often tends to hang down slightly on men.

6 THE UPPER ARM Biceps and Triceps

The two important upper arm muscles are the biceps, a flexor, and the triceps, an extensor. The biceps sits directly on the front plane of the upper arm bone, and the triceps sits directly on the back.

In the simple construction of the figure, think of the two muscles as ovoids of equal size on a rotating upper arm bone.

The figures below, right, and opposite, right, show the relationship of the biceps and triceps to the fleshed-out figure. The figures below, left, and opposite, left show the relationship of the biceps and triceps to the simplified skeleton.

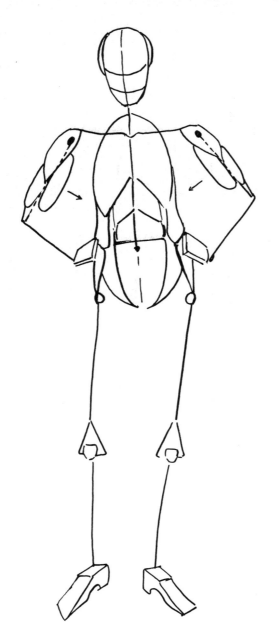

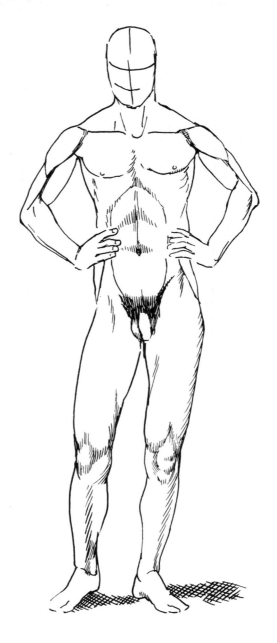

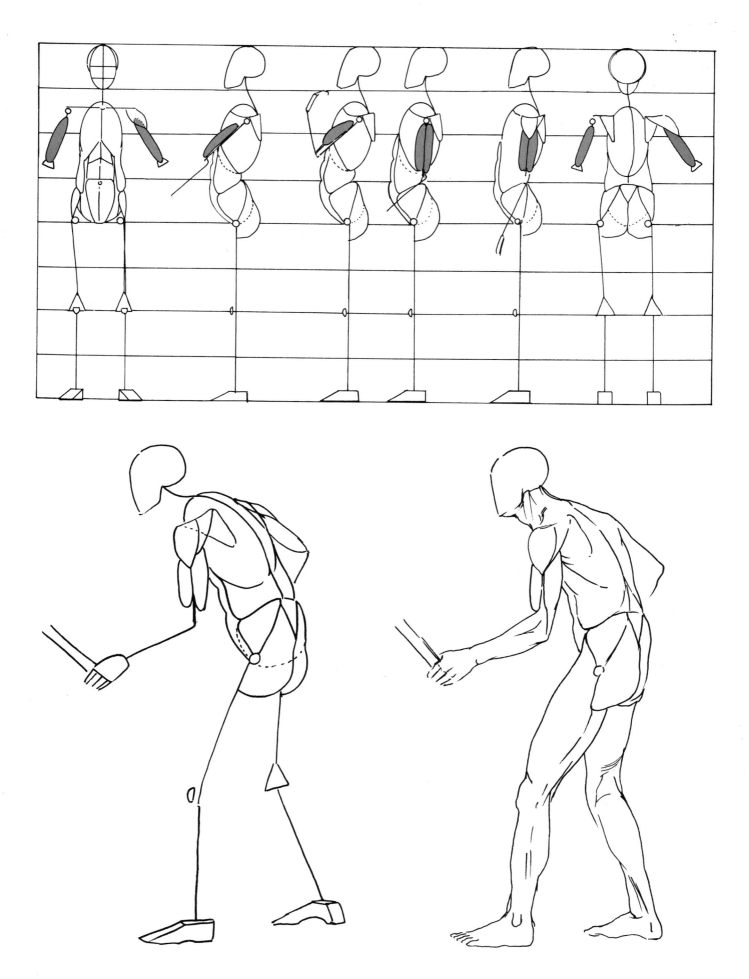

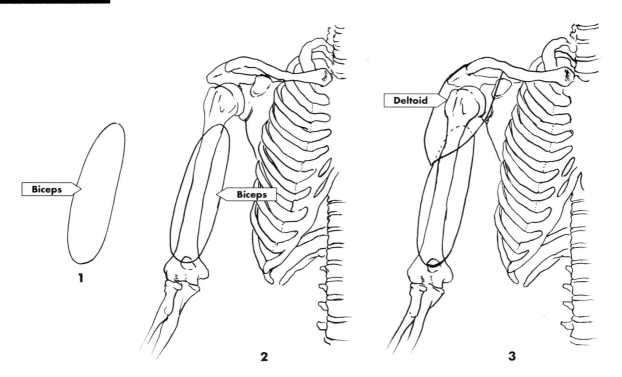

Biceps

Biceps

1

Deltoid

2

3

1. Begin with the biceps ovoid.
2. Place it directly on the front plane of the upper arm bone.
3. The deltoid lays on the top of the biceps and tucks into the upper arm bone behind it. Add the deltoid.

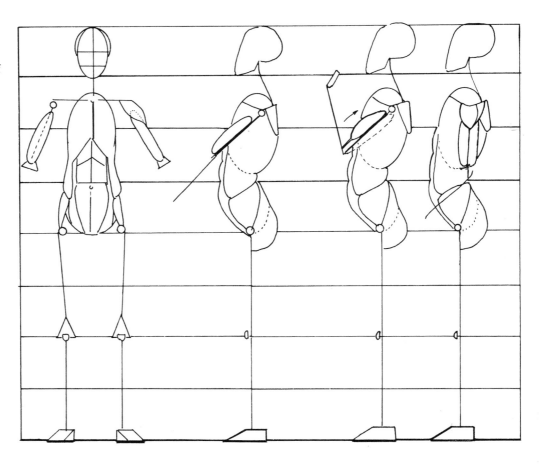

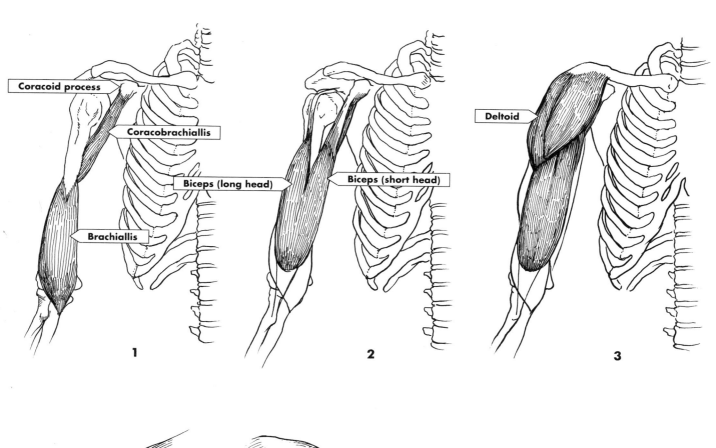

Coracoid process

Coracobrachiallis

Brachiallis

Biceps (long head)

Biceps (short head)

Deltoid

1

2

3

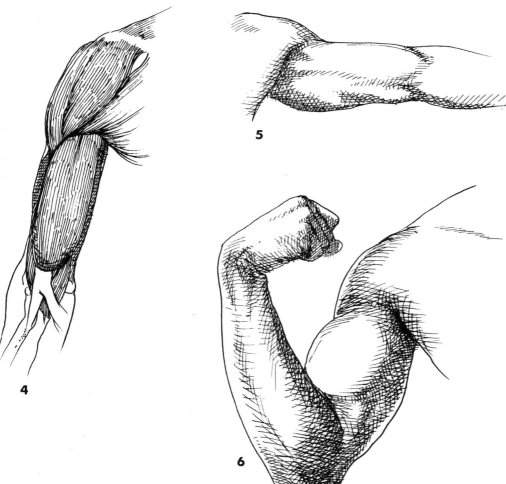

4

5

6

REFINEMENTS

1. The biceps sits on a deep layer of muscle consisting of the coracobrachiallis and the brachiallis. The brachiallis, a forearm flexor, covers the lower half of the upper arm bone and inserts at the lower arm bone. It sits underneath the lower half of the biceps. The coracobrachiallis, an upper arm flexor and adductor, originates at the coracoid process of the scapula. It runs medially and inserts on the medial surface opposite the deltoid insertion.

2. The biceps originates at the scapula. The short, medial head originates at the coracoid process.

3. The deltoid covers the upper portion of the biceps and triceps.

4. The biceps inserts by a tendon at the tuberosity of the radius.

5. The coracobrachiallis is only visible when the arm is lifted.

6. When the biceps contracts, it shortens and becomes ball-like.

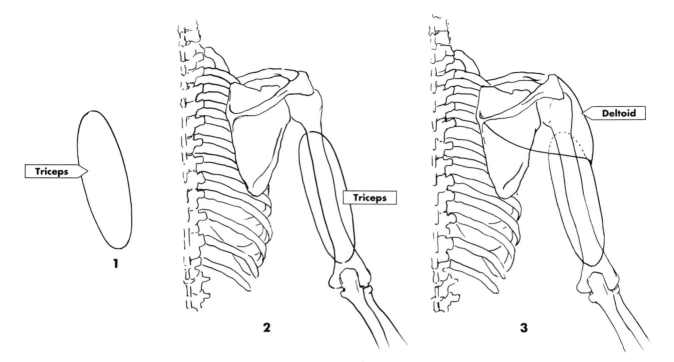

1. Draw an ovoid to represent the triceps.
2. Place the triceps ovoid directly on the back plane of the upper arm bone.
3. The deltoid inserts laterally, draping the upper part of the triceps. It tucks between the biceps and the triceps. Add the deltoid. When the triceps contracts, the lower arm straightens.

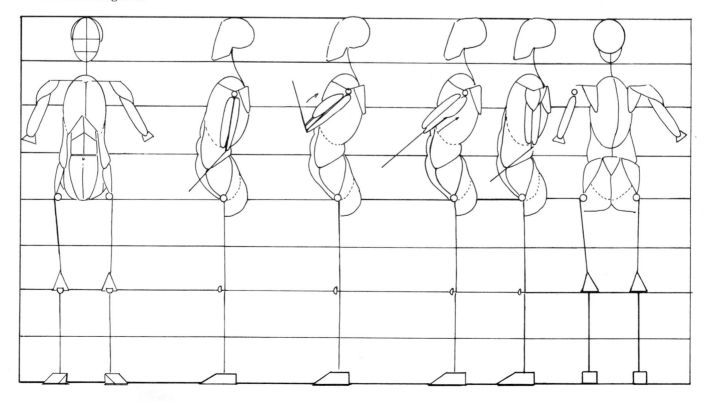

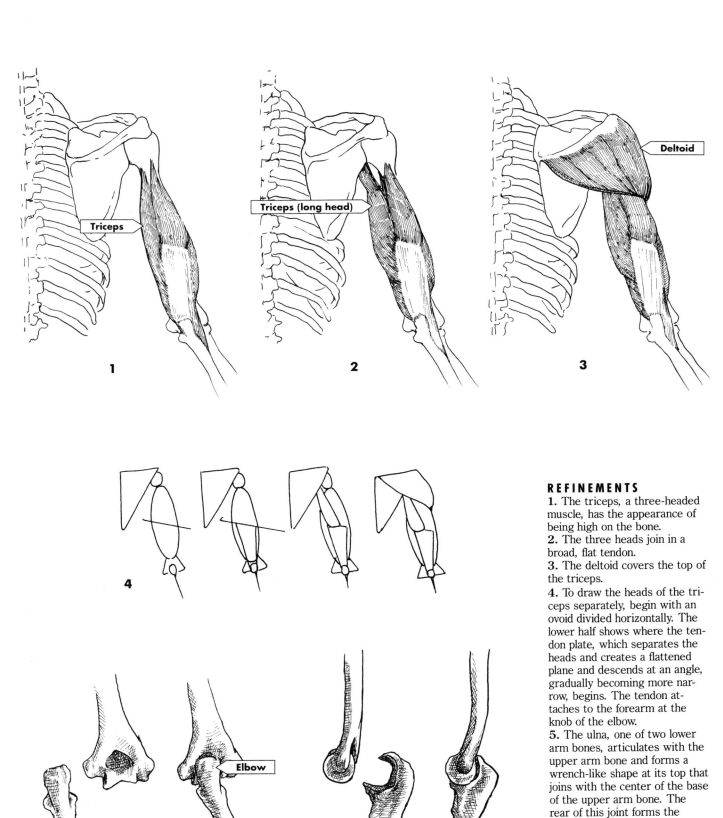

1

Triceps

2

Triceps (long head)

3

Deltoid

4

5

Elbow

Ulna

Ulna

REFINEMENTS

1. The triceps, a three-headed muscle, has the appearance of being high on the bone.

2. The three heads join in a broad, flat tendon.

3. The deltoid covers the top of the triceps.

4. To draw the heads of the triceps separately, begin with an ovoid divided horizontally. The lower half shows where the tendon plate, which separates the heads and creates a flattened plane and descends at an angle, gradually becoming more narrow, begins. The tendon attaches to the forearm at the knob of the elbow.

5. The ulna, one of two lower arm bones, articulates with the upper arm bone and forms a wrench-like shape at its top that joins with the center of the base of the upper arm bone. The rear of this joint forms the elbow.

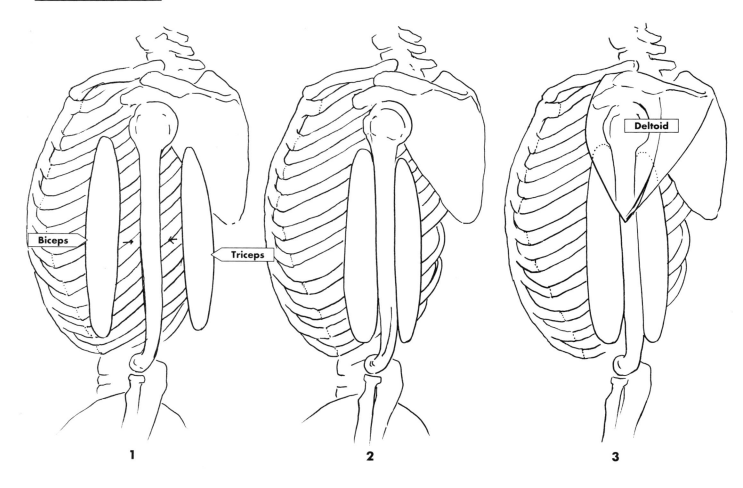

1 **2** **3**

1. Draw an ovoid to represent the biceps and triceps.
2. Place an ovoid of equal size on each side of the upper arm bone to represent the biceps (front) and the triceps (back).
3. Add the deltoid, which inserts between the biceps and the triceps.

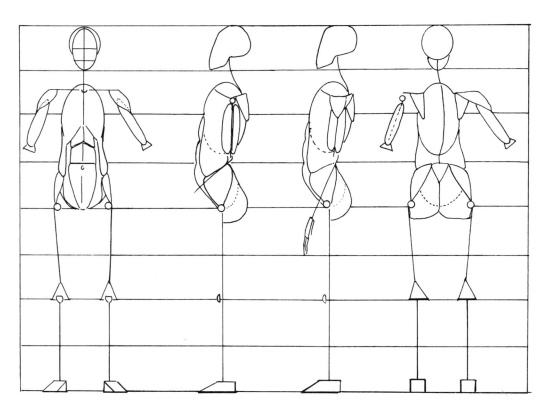

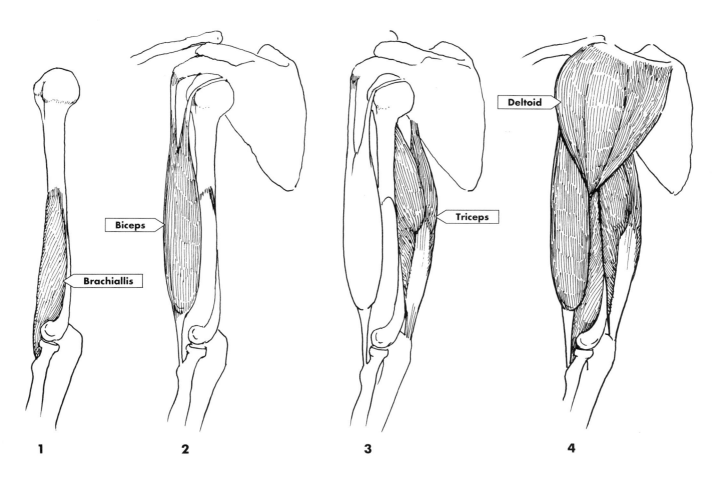

Biceps

Brachiallis

Triceps

Deltoid

1 2 3 4

5

6

REFINEMENTS

1. The biceps sits on the brachialis, which is a deep muscle.
2. The long head of the biceps originates at the glenoid cavity. The tendon of the long head runs over the head of the upper arm bone. The two heads of the biceps are not usually seen as distinctly divided.
3. The body of the biceps is lower than the major portion of the body of the triceps. The flat tendon plate creates a flattened plane that emphasizes the highlying triceps. It is important to give width to the knob of the elbow.
4. The upper portion of the muscle is covered by the deltoid.
5. When the biceps contracts, it becomes ball-like.
6. When the triceps contracts, its mass rides up the upper arm and the biceps stretch.

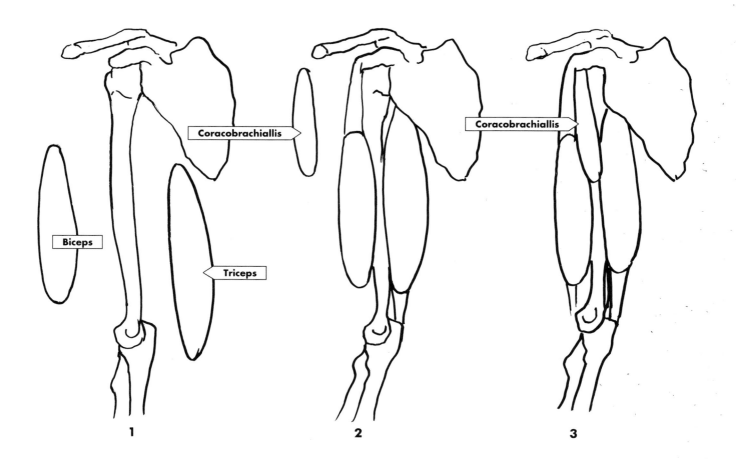

Coracobrachiallis

Biceps

Triceps

Coracobrachiallis

1 **2** **3**

1. Draw two ovoids of equal
size to represent the biceps and
the triceps.
2. Place an ovoid on each side
of the upper arm bone. Draw
the coracobrachiallis as a long,
thin ovoid.
3. Add the coracobrachiallis
ovoid between the biceps and
triceps.

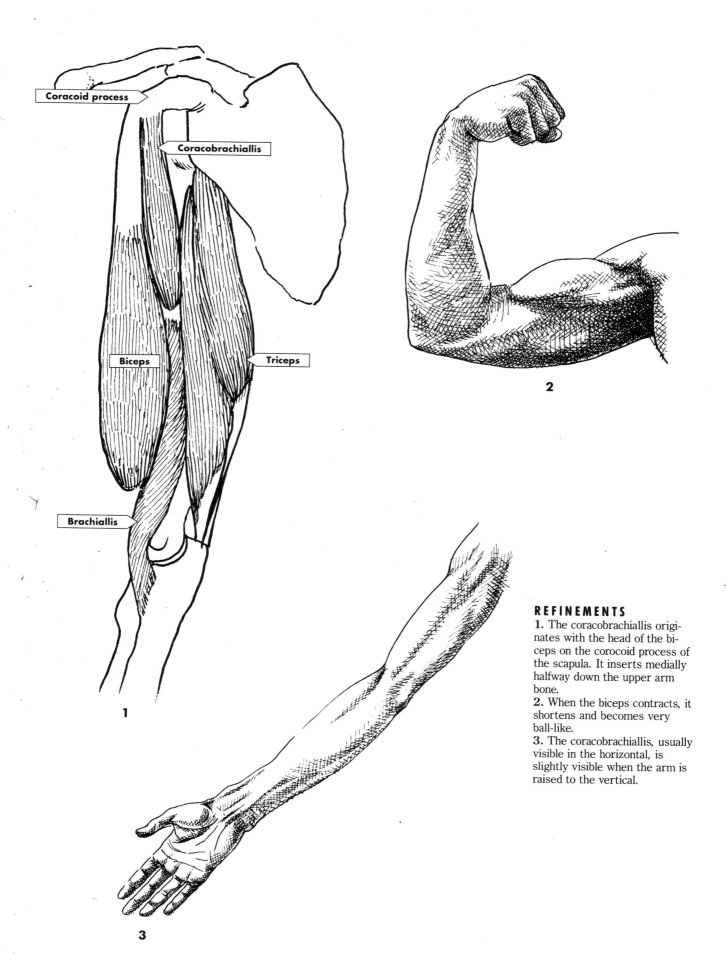

Coracoid process

Coracobrachiallis

Biceps

Triceps

Brachiallis

1

2

3

REFINEMENTS
1. The coracobrachiallis originates with the head of the biceps on the corocoid process of the scapula. It inserts medially halfway down the upper arm bone.
2. When the biceps contracts, it shortens and becomes very ball-like.
3. The coracobrachiallis, usually visible in the horizontal, is slightly visible when the arm is raised to the vertical.

7 THE UPPER LEG Quadriceps and Hamstring

The quadriceps ("four-headed") muscle sits on the front and outside of the upper leg. The body of one of the four heads is largely covered and looks and works like the triceps.

The hamstring originates on the back plane of the upper leg. It is visible from the back and sides and looks like a biceps. The hamstring ovoid comes down at an angle from the pelvic basin, touching the top third of the triangle at the bottom of the upper leg bone. This angle is significant to the form of the upper leg, giving it a conical look. The hamstring

ovoid divides toward its bottom and draws to either side of the lower leg. When it contracts, it pulls the lower leg up. Between it and the quadriceps, a third of a head down from the great trochanter, is the insertion point of the gluteus maximus.

The figures below, right, and opposite, right, show the quadriceps and hamstring in their relationship to the fleshed-out figure. The figures below, left, and opposite, left, show the quadriceps and hamstring on the simplified skeleton.

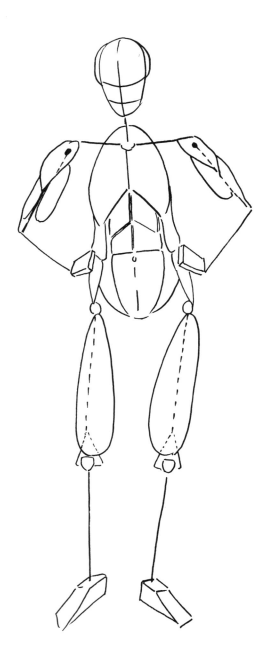

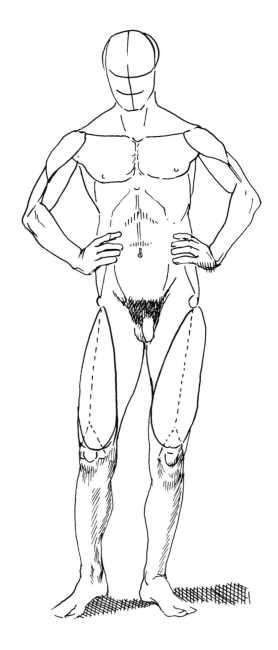

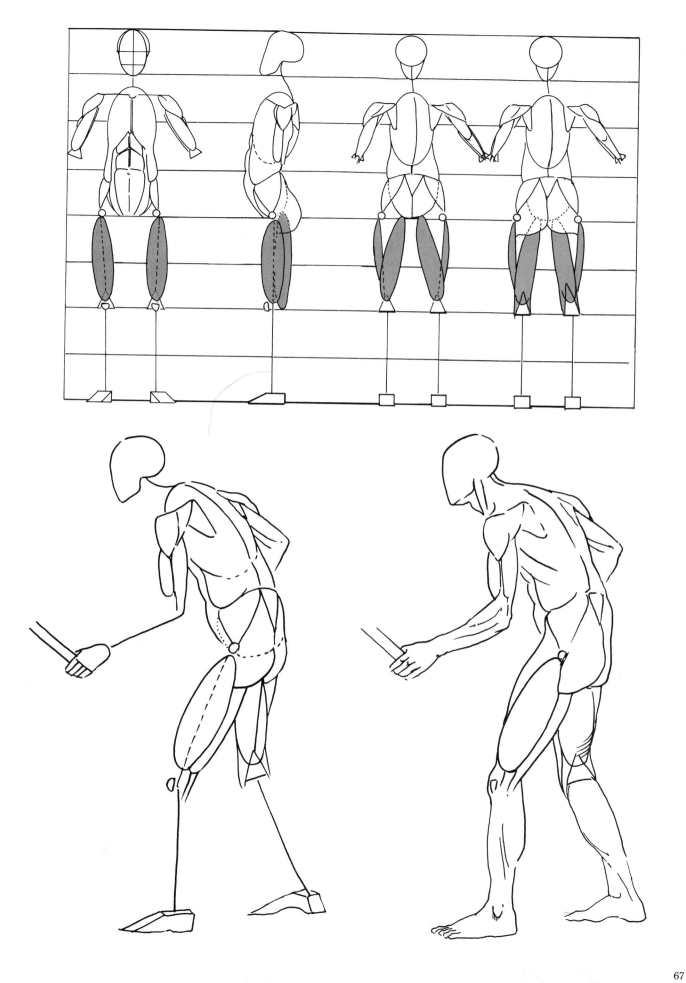

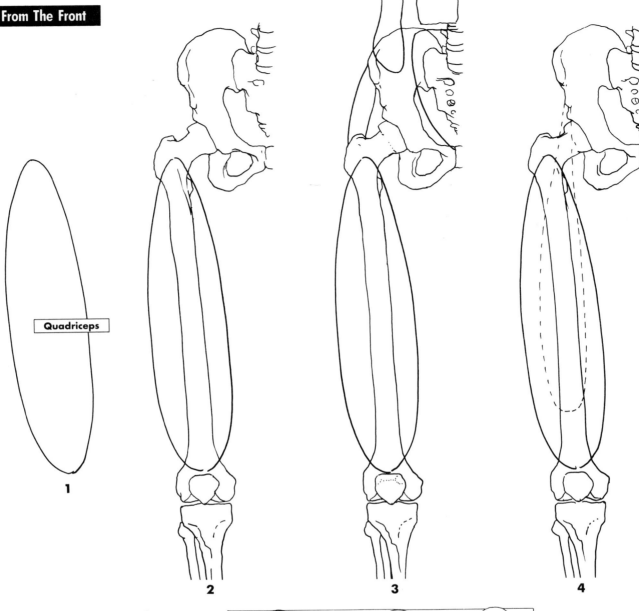

Quadriceps

1

2

3

4

1. Draw an ovoid to represent the quadriceps.

2. Draw the quadriceps as a simple ovoid sitting directly on and taking the direction of the upper leg bone, from the great trochanter at the top to just above the kneecap. Draw the width equal on each side of the bone. The hamstring does not show from this view.

3. Add the gluteus medius and the external oblique.

4. The rectus femoris is represented here by a dotted line (see Chap. 9).

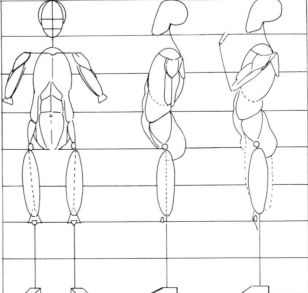

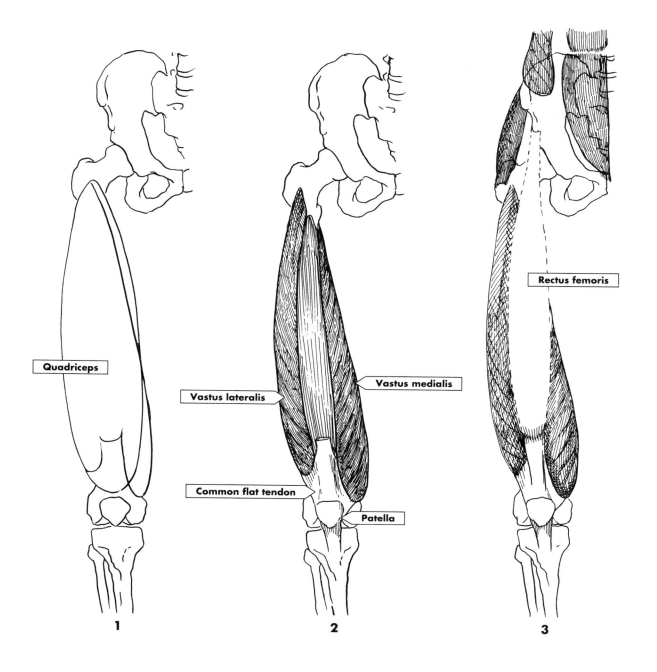

Quadriceps

Vastus lateralis

Vastus medialis

Common flat tendon

Patella

Rectus femoris

1

2

3

REFINEMENTS
1. The quadriceps has a teardrop shape.
2. The heads of the quadriceps are joined by a common flat tendon that inserts at the kneecap and lower leg bone. During contraction, the muscles harden and ride up the leg, slightly raising and defining the form at the bottom of quadriceps. The defining line is often diffused by fat. There is also another layer of fat lying just below the muscle line. As a result, the lower quadriceps can appear to be sitting on and hugging the kneecap.
3. The bottom defining line of the quadriceps is clearly visible in walking when the leg is extended. In the drawing, the rectus femoris (see Chap. 9) is represented by dotted lines.

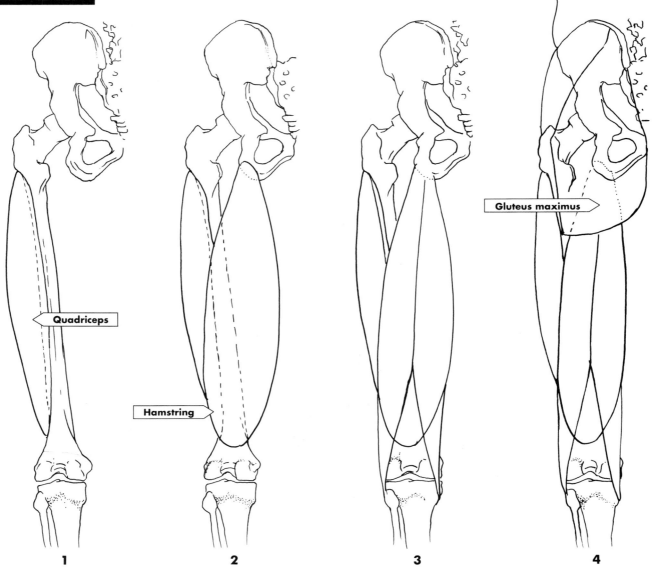

Quadriceps

Hamstring

Gluteus maximus

1 **2** **3** **4**

1. The quadriceps is visible from the back. Draw it as a semi-ovoid sitting on the outside of the bone.

2. The hamstring ovoid originates at the pelvic basin and then angles out slightly from the median line, reaching down to the top third of the triangle at the bottom of the upper leg bone. This angle gives the upper leg a clear conical look.

3. Divide the hamstring ovoid toward its bottom and draw it on either side of the lower leg.

4. Add the gluteus maximus inserting at the back of the upper leg bone a third of a head down from the great trochanter between the quadriceps and the hamstring.

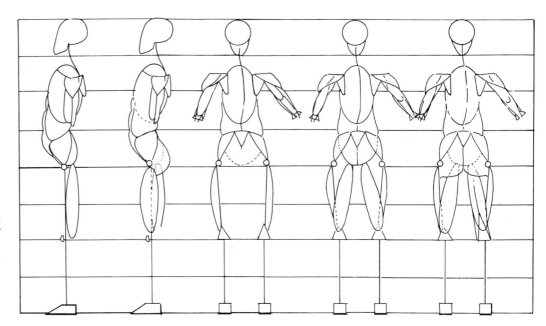

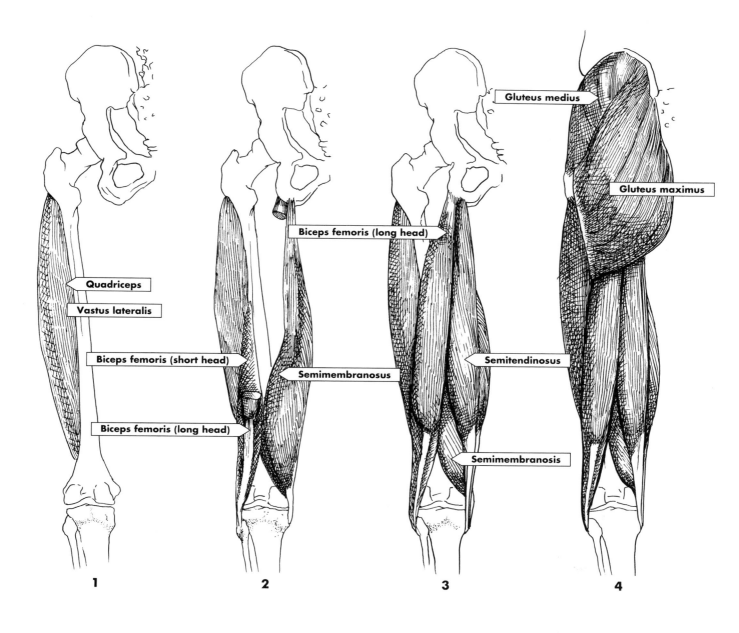

Quadriceps

Vastus lateralis

Biceps femoris (short head)

Biceps femoris (long head)

Biceps femoris (long head)

Semimembranosus

Gluteus medius

Gluteus maximus

Semitendinosus

Semimembranosis

1 2 3 4

REFINEMENTS

1. The outside head of the quadriceps is the most voluminous of the group. It takes the direction of the upper leg bone and is visible in both men and women, although it is more prominent in women, as they are inclined to have fat deposits on it.

2. The hamstring originates at the pelvic basin. The hamstring, a flexor of the lower leg, looks like a two-headed muscle and appears as a single ovoid divided down the center with a tendon pulling to each side like a prong. The original ovoid, though, retains its shape.

3. The hamstring inserts at the uppermost portion of the lower leg.

4. The gluteus maximus inserts at the back of the upper leg bone a third of a head down from the great trochanter between the quadriceps and the hamstring.

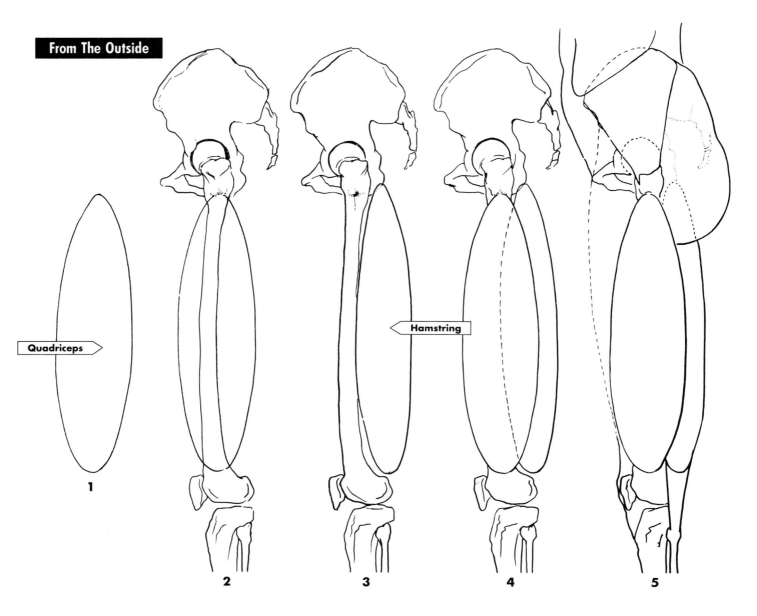

Quadriceps

Hamstring

1 **2** **3** **4** **5**

1. Draw an ovoid to represent the quadriceps.

2. Place the quadriceps ovoid directly on the upper leg bone. It originates at the base of the great trochanter. The common flat tendon attaching to the kneecap and the ligament from the kneecap to the shinbone are clearly visible and form the connecting line on the front of the lower leg. The dotted line on the front of the upper leg in the drawing is the rectus femoris.

3. Place the hamstring ovoid on the back plane of the upper leg.

4. Cover the ovoid partially with the quadriceps.

5. Think of the hamstring ovoid as being joined to the lower leg by a tight tendon. The rule for size is two quadriceps to the one visible portion of the hamstring.

Draw the gluteus maximus, which appears to slip between the quadriceps and the hamstring. There is always a layer of gluteal fat right below the point of insertion of the gluteus maximus.

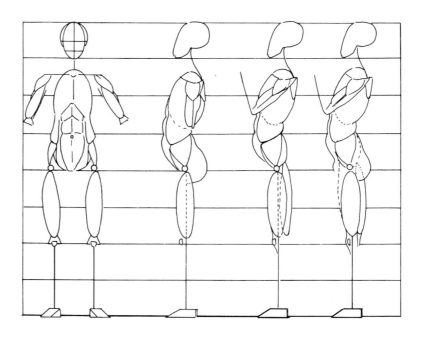

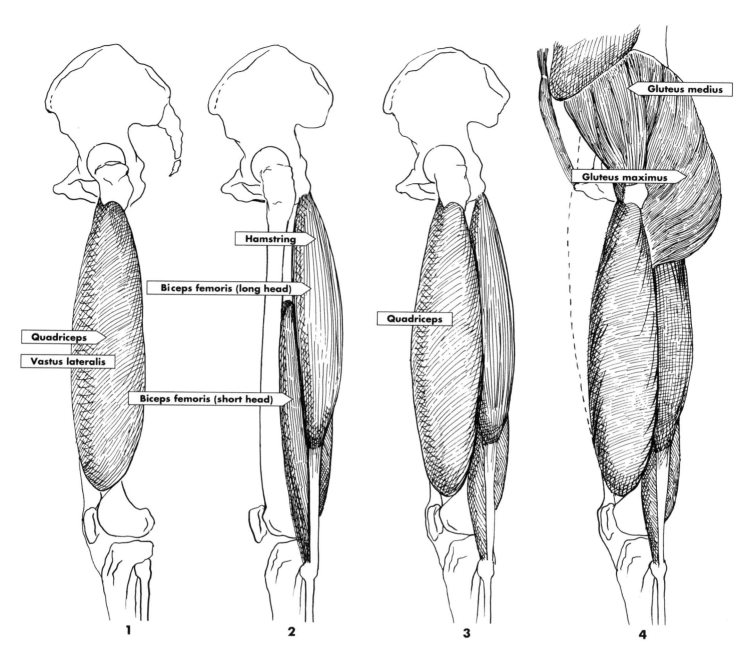

Quadriceps

Vastus lateralis

Hamstring

Biceps femoris (long head)

Biceps femoris (short head)

Quadriceps

Gluteus medius

Gluteus maximus

1 **2** **3** **4**

REFINEMENTS

1. The quadriceps originates at the base of the great trochanter, leaving what looks like a slightly protruding ball on part of the bone. In fleshy bodies this often appears as an indentation. The bottom and back line of the quadriceps is almost always visibly defined. It is always visible in walking figures.

2. The lateral mass of the hamstring inserts at the head of the outer lower leg bone. The hamstring lies high on the leg, and as it descends to its insertion, it narrows.

3. The quadriceps partially covers the hamstring.

4. The gluteus maximus slips between the quadriceps and hamstring. There is always a layer of gluteal fat right below the point of insertion of the gluteus maximus.

Quadriceps

1

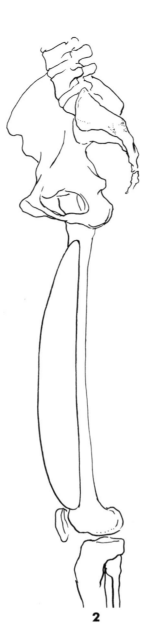

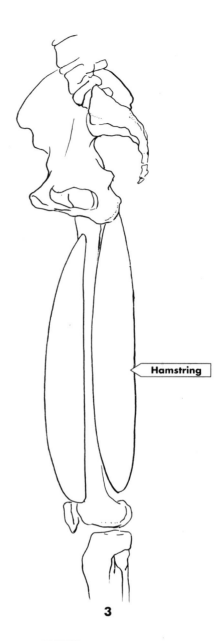

Hamstring

2

3

1. Draw an ovoid to represent the inside quadriceps.

2. The inside head of the quadriceps is much smaller than the outside head. Draw the inside-head ovoid directly on the surface of the upper leg bone.

3. Draw the hamstring ovoid directly on the back. Think of the inside-head ovoid as about equal to the hamstring ovoid. A muscle group, the adductors (see Chap. 8) occupies the space that is left.

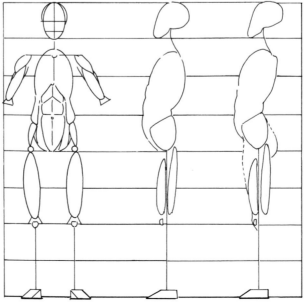

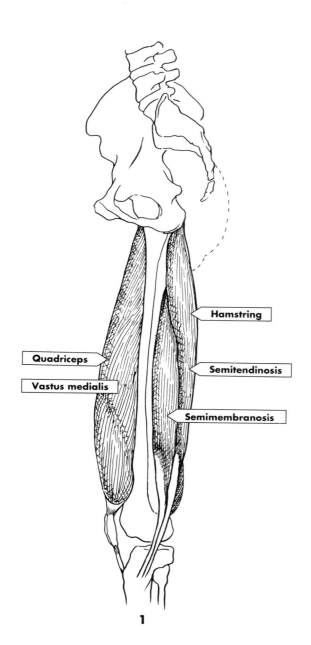

Quadriceps

Vastus medialis

Hamstring

Semitendinosis

Semimembranosis

1

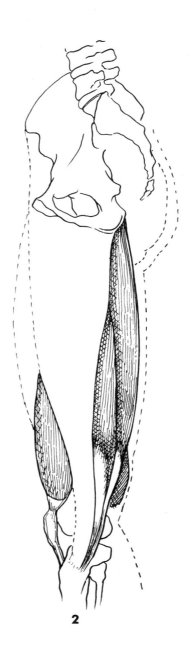

2

REFINEMENTS
1. The inside head of the quadriceps is largely covered, but a small teardrop shape is often distinct, and the bottom defining line is almost always visible. The common flat tendon attaching to the knee-cap and the ligament from the kneecap to the shinbone are clearly visible and form a connecting line. The medial mass of the hamstring forms a thick, long ovoid inserting at the shinbone. The hamstring originates at the pelvis.
2. A muscle group, the adductors, occupies the inside triangular area. The dotted area on the front represents the rectus femoris muscle (see Chap. 9).

8 THE UPPER LEG The Adductors

The adductors as a visible group consist of five muscles (four genuine adductors plus the gracilis). They never divide and are rarely, if ever, visible as separate lines. Think of the adductors as a flexible triangle creased down the middle and originating at the pelvic basin and inserting on the inside of the upper leg bone and shinbone.

For every action there is an opposing action. Therefore, if you have abduction (taking away from the median line), it stands to reason that you have *adduction* (bringing to the median line).

The figures below, right, and opposite, show the adductors in their relationship to the fleshed-out figure. The figure below, left, shows the relationship of the adductors to the simplified skeleton.

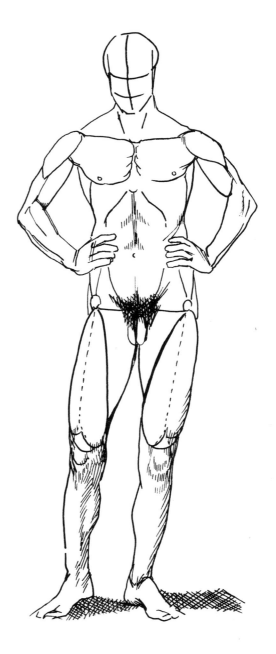

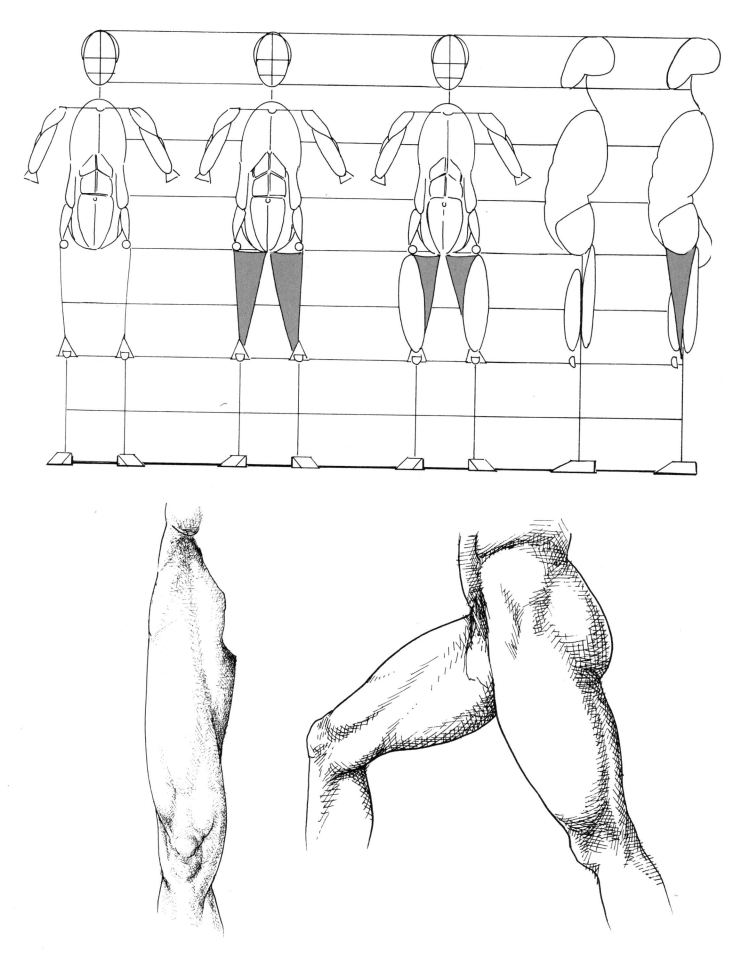

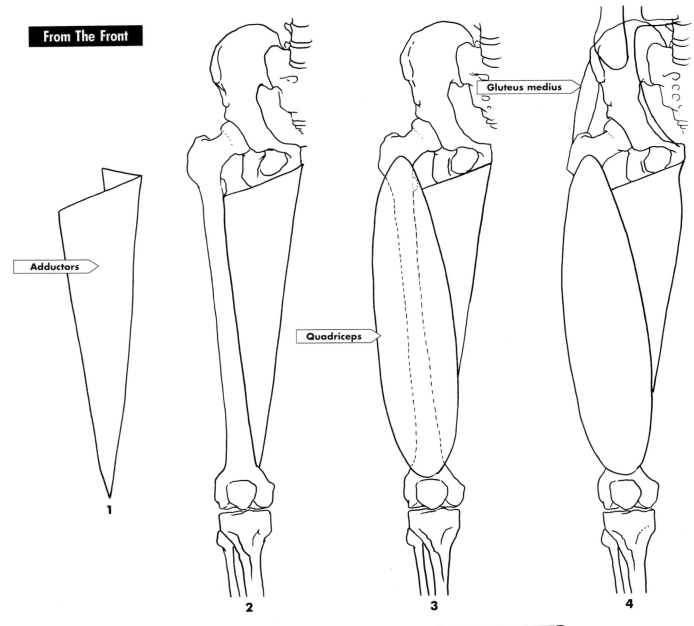

Adductors

Quadriceps

Gluteus medius

1

2

3

4

1. Draw a creased triangle to represent the adductors.
2. Place the top of the adductor triangle at the pelvis, then attach it to the upper leg bone. It inserts medially.
3. Draw the quadriceps ovoid sitting on the front surface of the upper leg bone. This gives a conical quality to the upper leg.
4. Add the gluteus medius.

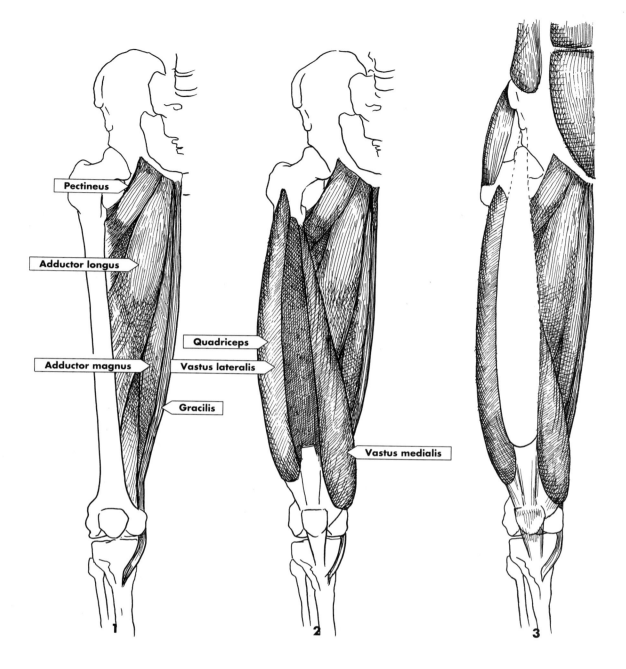

Pectineus

Adductor longus

Adductor magnus

Gracilis

Quadriceps

Vastus lateralis

Vastus medialis

1

2

3

REFINEMENTS

1. The adductor group consists of the pectineus, adductor longus, adductor brevis, and adductor magnus, along with the gracilis, which is a long, thin muscle whose function is adduction, rotation, and flexion of the lower leg. The gracilis melds with the adductor group and inserts at the tibia.

2. The quadriceps originates at the upper leg bone. The quadriceps and the hamstring tend to be harder, more defined, and less fatty than the adductors. The quadriceps and hamstring are brought into use when walking, but the adductors are less used, so they tend to be softer and more rounded. There is a slight spiral shape and a tuck at the top of this group.

3. An additional quadriceps muscle, the rectus femoris, is indicated by dotted lines (see Chap. 9).

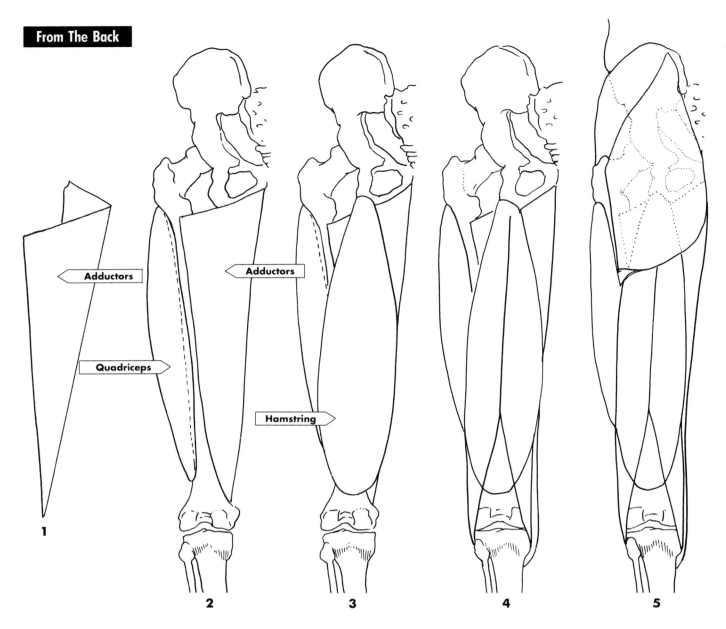

Adductors

Quadriceps

Adductors

Hamstring

1

2

3

4

5

1. Draw a creased triangle to represent the adductors.

2. Add the adductor triangle to the skeleton, originating at the pelvis and inserting at the upper leg bone. Draw the quadriceps ovoid on the outside of the upper leg bone.

3. Add the hamstring. The adductors are almost completely covered from the back by the hamstring.

4. Divide the hamstring ovoid down the middle pulling to the sides.

5. Now you can add the buttocks to your drawing.

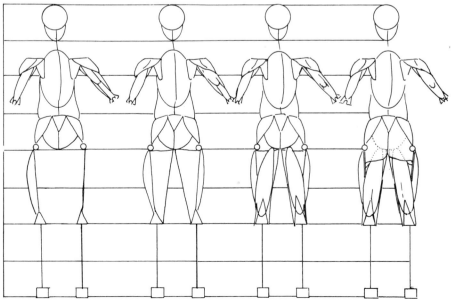

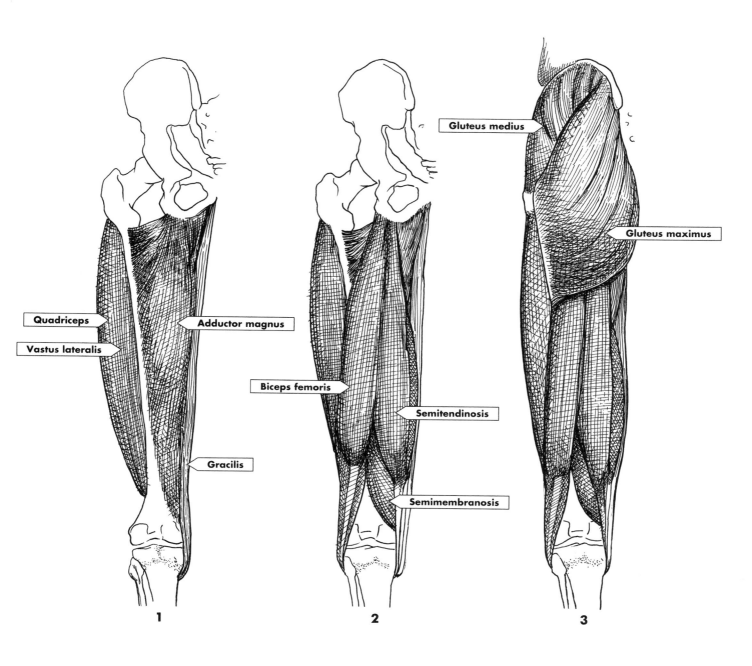

Quadriceps

Vastus lateralis

Adductor magnus

Gracilis

1

Gluteus medius

Biceps femoris

Semitendinosis

Semimembranosis

2

Gluteus maximus

3

REFINEMENTS
Because the adductors as a rule are used less than the quadriceps and hamstring and are inclined to more fat, there is often a fuller, more rounded, fattier quality to the upper inside thigh. This is particularly true in women.
1. The adductors originate at the bottom of the pelvic basin.
2. The hamstring almost completely covers the adductors.
3. The gluteus maximus inserts between the hamstring and the quadriceps.

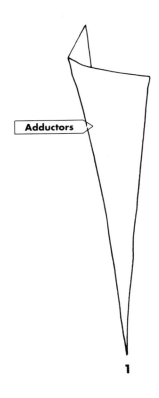

Adductors

1

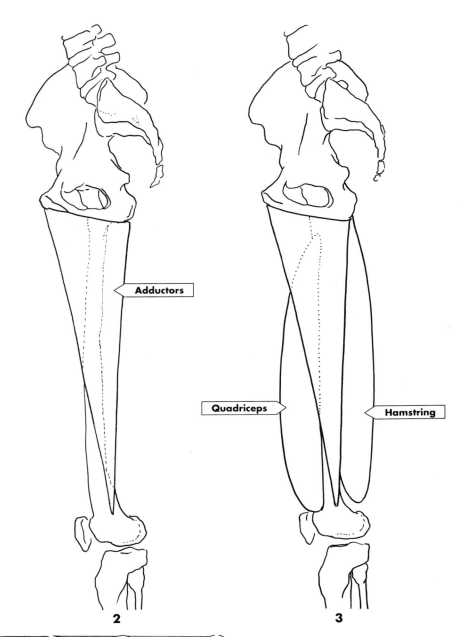

Adductors

Quadriceps

Hamstring

2

3

1. Draw a creased triangle to represent the adductors.
2. Place the adductor triangle down the middle of the leg.
3. Draw the quadriceps and hamstring. The adductors cover the upper portion of the quadriceps.

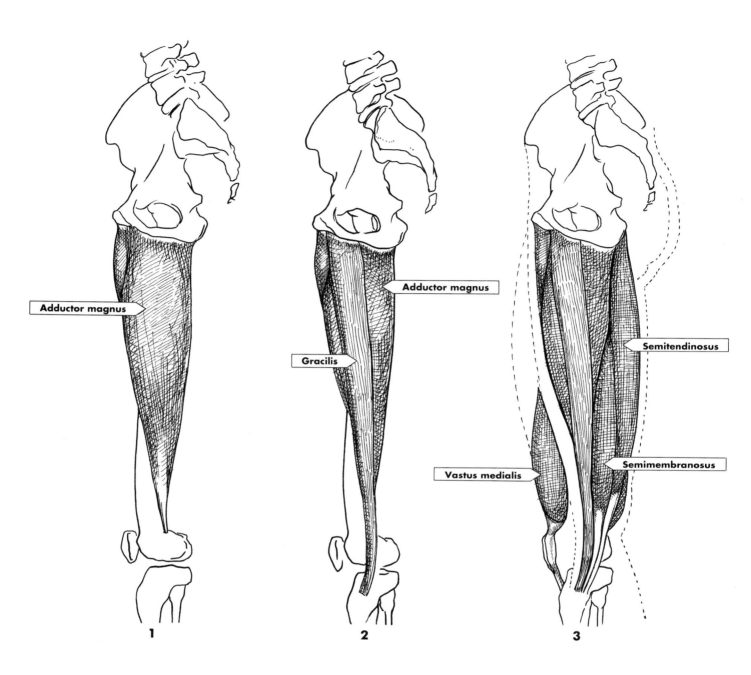

Adductor magnus

Adductor magnus

Gracilis

Semitendinosus

Vastus medialis

Semimembranosus

1

2

3

REFINEMENTS

1. The adductor group consists of the pectineus, adductor longus, adductor brevis, and adductor magnus. They are never seen as distinct, but form a mass along with the gracilis.

2. The gracilis is a long, thin muscle that inserts at the tibia. Its functions are adduction, rotation, and flexing of the lower leg. It is visually part of the adductor group.

3. The quadriceps and hamstring tend to be harder, more defined, and less fatty than the adductors. Unlike the adductors, they are used in walking.

There are three muscles left in the upper leg to consider. The rectus femoris is the final head of the quadriceps. It is another ovoid and sits on the front of the quadriceps ovoid. It gives width and shape to the upper leg from the outside and the inside. From the front, it is less defined as a distinct form except in muscularly developed bodies. The rectus femoris extends the leg and flexes the thigh.

The tensor, a teardrop-shaped muscle, originates at the front tip of the pelvic crest. It descends obliquely to the outside, covering the great trochanter from the front. From the outside, it joins with the gluteus maximus by a band of fibrous tissue that reaches over the gluteus medius. The band inserts at the shinbone. The tensor flexes the thigh and tenses the band of fibrous tissue.

The sartorius It runs in a graceful diagonal from the tip of the pelvic crest to the inside of the lower leg. The sartorius joins with the adductors and one tendon of the hamstring, creating a mound on the inside of the leg across from the kneecap called the goosefoot. This is very important in the construction of the leg. The sartorius itself often reads as an indented line. It emphasizes the division between the quadriceps and the adductors, and it flexes the thigh and rotates the leg.

The figures opposite (front and back views) and below, right, show the muscles of the upper leg in their relationship to the fleshed-out figure. The figure below, left, shows the muscles of the upper leg in their relationship to the simplified skeleton as seen from the front.

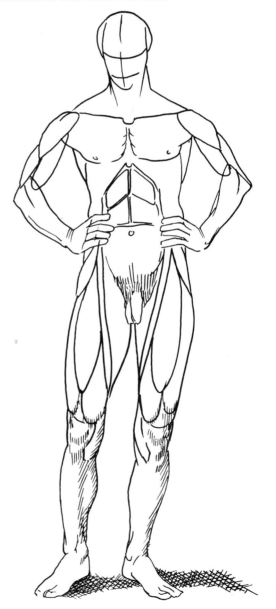

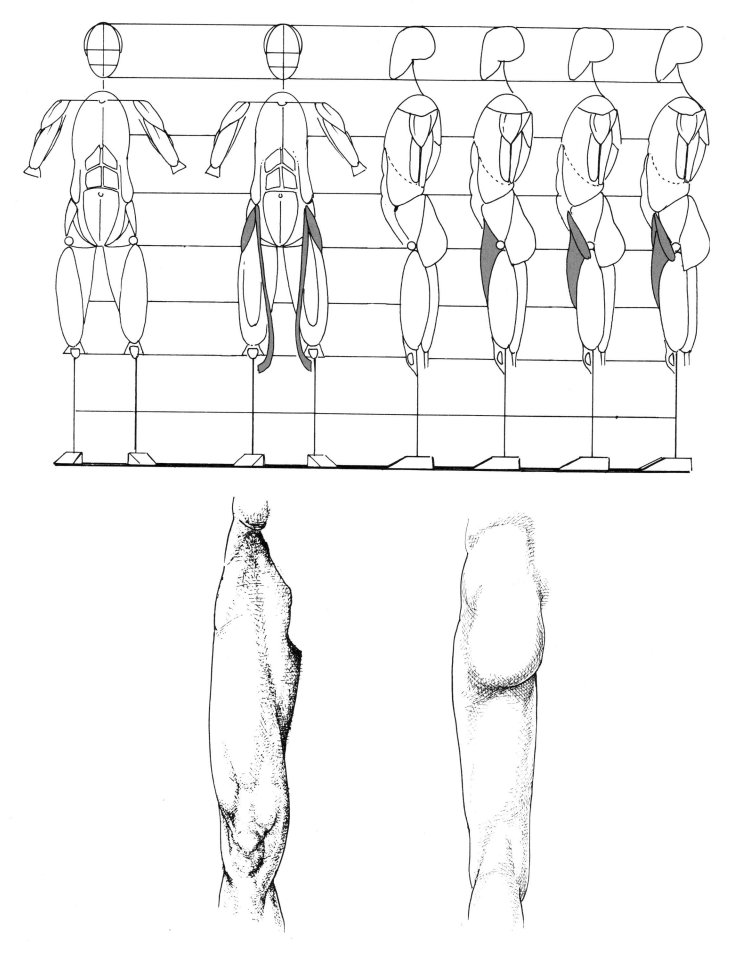

From The Front

Quadriceps

Adductors

Rectus femoris

Tensor

Sartorius

Goosefoot

1 2 3 4

1. Draw the upper leg. Include the quadriceps ovoid and the adductor triangle.

2. Draw the rectus femoris ovoid originating half-way down the pelvic basin. End the rectus femoris ovoid a quarter of a head above the bottom of the upper leg bone.

3. Place the teardrop shape of the tensor at the front tip of the pelvic crest. Draw it running down and outward, covering the great trochanter.

4. Begin the long line of the sartorius at the front tip of the pelvic crest. Draw the sartorius running diagonally along the line dividing the quadriceps and adductors to the inside of the upper portion of the lower leg. The sartorius picks up volume from the adductors, and this combination forms the goosefoot. Insert it at the top of the lower leg to create the goosefoot. Reduce the sartorius to a line and consider the goosefoot as mass.

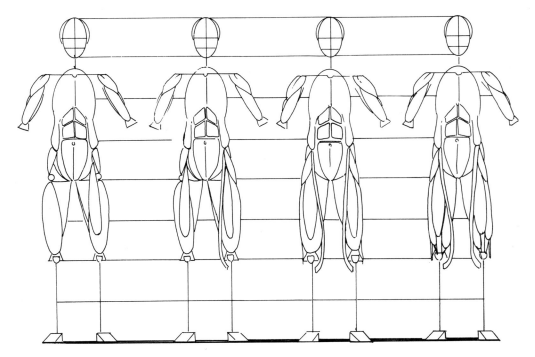

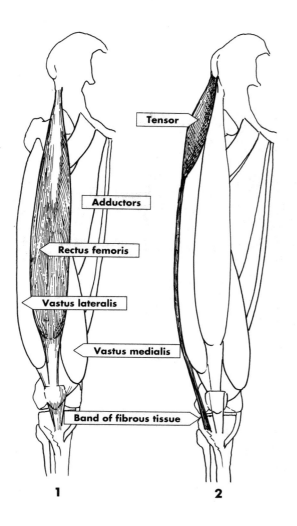

Tensor

Adductors

Rectus femoris

Vastus lateralis

Vastus medialis

Band of fibrous tissue

1

2

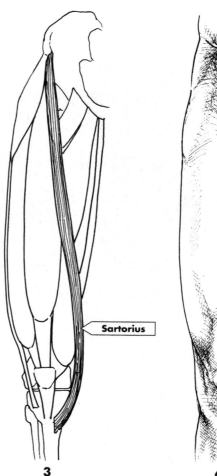

Sartorius

3

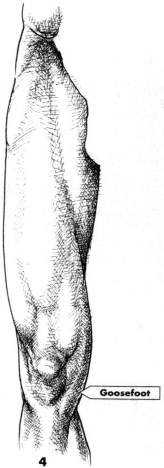

Goosefoot

4

REFINEMENTS

1. The rectus femoris is the only head of the quadriceps that originates at the pelvis. It is visible from the front in muscularly developed bodies, less so in the average person. Along with the rest of the quadriceps, the rectus femoris is an extensor of the upper leg and a flexor of the thigh.

2. The tensor originates at the front tip of the pelvic basin. It angles out and down, covering the great trochanter. The tensor attaches to a band of fibrous tissue and inserts at the shinbone. The line of insertion is sometimes visible.

3. The sartorius originates next to the tensor. It angles down and to the inside at a diagonal. It is the longest muscle in the body. The sartorius has a slightly spiral *S* shape and is approximately two fingers wide.

4. The sartorius is often visible, even in extremely nonmuscular bodies. Sometimes it is seen as an indented line. The sartorius is a flexor and a rotator of the upper leg.

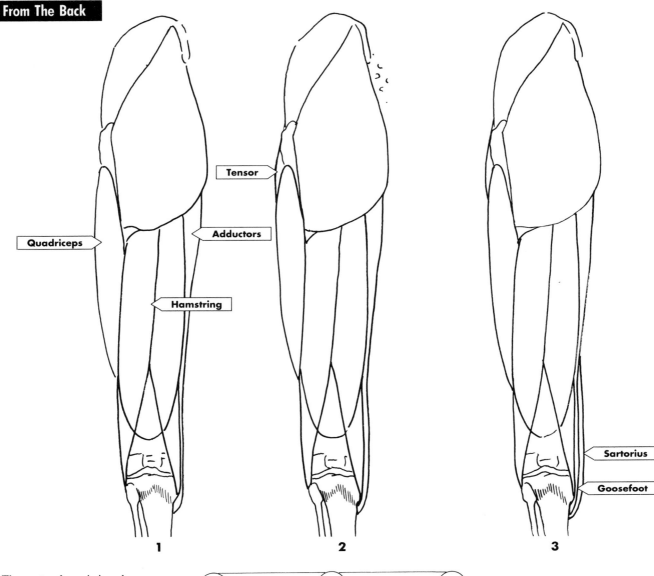

Tensor

Quadriceps

Adductors

Hamstring

Sartorius

Goosefoot

1 **2** **3**

1. The rectus femoris is only on the front of the leg. The teardrop shape of the tensor is largely hidden.

2. Draw the tensor filling out the area around the great trochanter.

3. Draw the sartorius joining with the adductors and inside hamstring to form the goosefoot; it should appear full in contrast to the outside hamstring insertion, which is tight and straight.

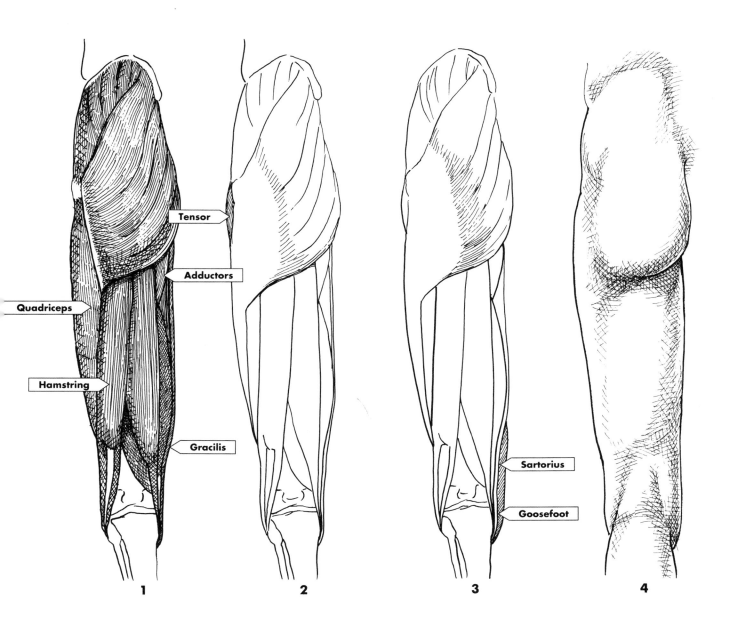

Quadriceps

Hamstring

Tensor

Adductors

Gracilis

Sartorius

Goosefoot

1　　　**2**　　　**3**　　　**4**

REFINEMENTS

1. The rectus femoris does not appear from the back.

2. The tensor fills out around the area of the great trochanter. The tensor attaches to the band of fibrous tissue, which, when visible, creates a crease or indentation on the outside head of the quadriceps (vastus lateralis). If you do include it, avoid confusing the form in that area.

3. The goosefoot consists of the sartorius, gracilis, and inside hamstring. It is more inclined to fat than the outside hamstring and has more mass.

4. The gluteus maximus inserts between the hamstring and the quadriceps and also at the band of fibrous tissue, causing the gluteal fold, but this second insertion is not important.

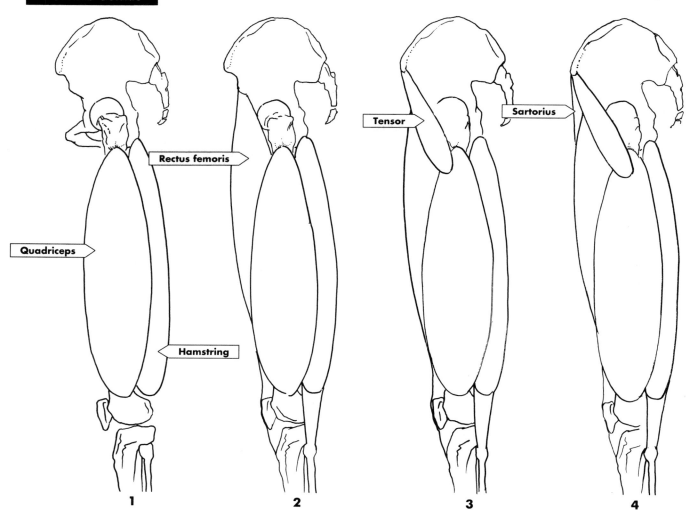

Rectus femoris

Quadriceps

Hamstring

Tensor

Sartorius

1 2 3 4

1. Draw the upper leg. Include the quadriceps and hamstring ovoids.

2. Place the rectus femoris ovoid halfway down the pelvic basin. The volume appears to end half-way down the upper leg.

3. Place the teardrop shape of the tensor at the front tip of the pelvic crest. It continues down to just a little below the great trochanter. Since the pelvic basin is already simplified, the tensor shape is largely accounted for and can be eliminated.

4. Draw the sartorius pulling inward from the front tip of the pelvic crest, squaring off the front part of the upper leg.

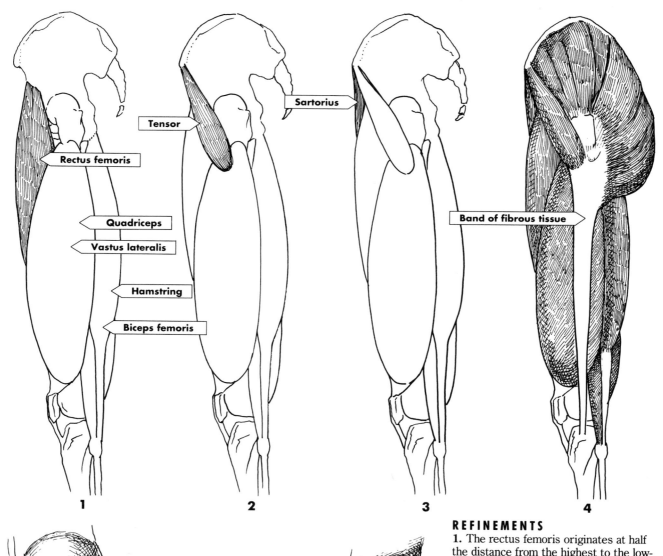

Rectus femoris

Tensor

Sartorius

Quadriceps

Vastus lateralis

Hamstring

Biceps femoris

Band of fibrous tissue

1　　　　　**2**　　　　　**3**　　　　　**4**

5

7

6

REFINEMENTS

1. The rectus femoris originates at half the distance from the highest to the lowest point of the pelvic basin. The rectus femoris, along with the outside and inside heads of the quadriceps, inserts at the kneecap by way of a common tendon. The mass of the rectus femoris is clearly visible. The line separating the outside head of the quadriceps and the rectus femoris is rarely seen.

2. The teardrop-shaped tensor originates at the front tip of the pelvic crest.

3. The sartorius also originates at the front tip of the pelvic crest. It draws to the inside of the leg and is visible only at the very top of the leg. It helps to square off and make a continuous and graceful line to the front of the leg.

4. The band of fibrous tissue divides the leg.

5. When the leg bends, the tensor also bends. In most people the tensor is not visually distinct, but looks like the squared-off front of the pelvic basin.

6. The dividing line between the quadriceps and the hamstring is virtually always visible and is the significant line defining mass.

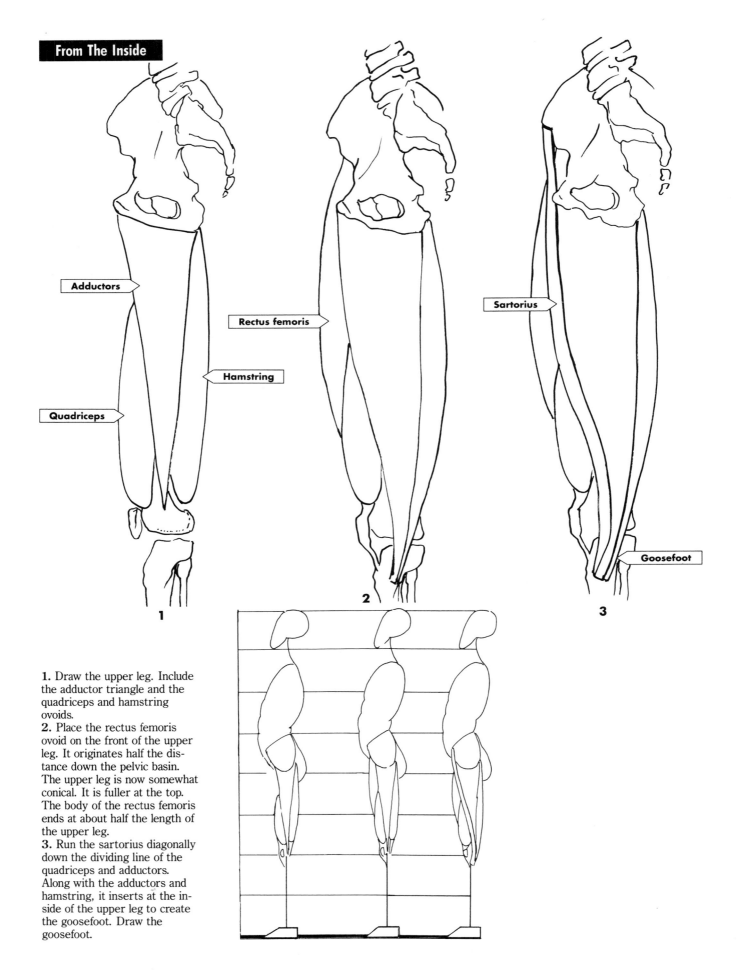

Adductors

Rectus femoris

Sartorius

Hamstring

Quadriceps

Goosefoot

1

2

3

1. Draw the upper leg. Include the adductor triangle and the quadriceps and hamstring ovoids.

2. Place the rectus femoris ovoid on the front of the upper leg. It originates half the distance down the pelvic basin. The upper leg is now somewhat conical. It is fuller at the top. The body of the rectus femoris ends at about half the length of the upper leg.

3. Run the sartorius diagonally down the dividing line of the quadriceps and adductors. Along with the adductors and hamstring, it inserts at the inside of the upper leg to create the goosefoot. Draw the goosefoot.

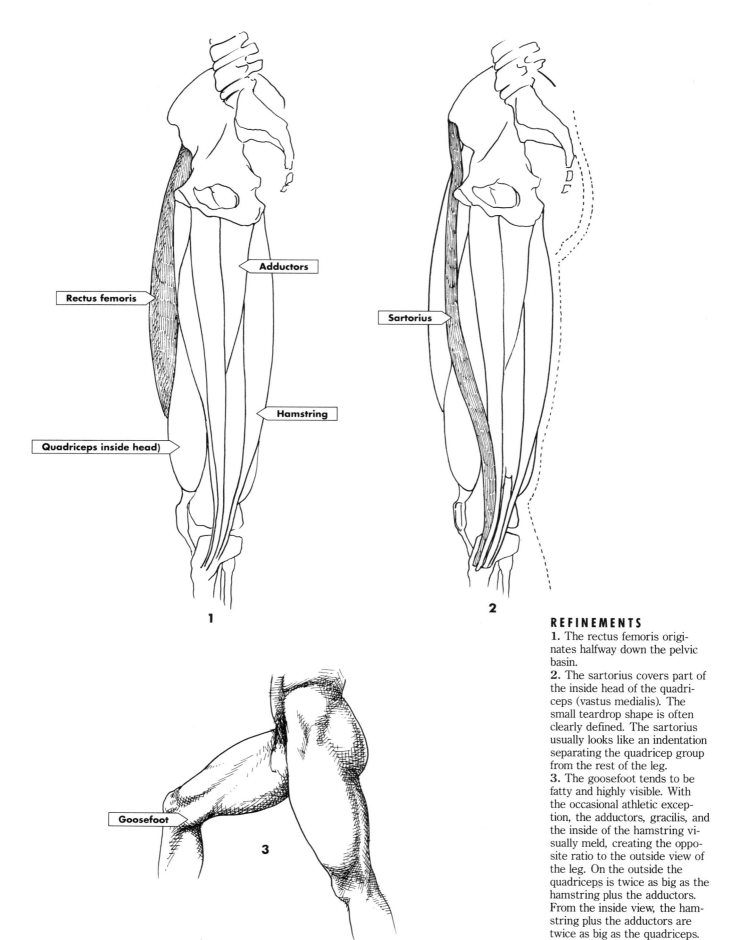

Rectus femoris

Adductors

Quadriceps inside head)

Hamstring

1

Sartorius

2

Goosefoot

3

REFINEMENTS

1. The rectus femoris originates halfway down the pelvic basin.

2. The sartorius covers part of the inside head of the quadriceps (vastus medialis). The small teardrop shape is often clearly defined. The sartorius usually looks like an indentation separating the quadricep group from the rest of the leg.

3. The goosefoot tends to be fatty and highly visible. With the occasional athletic exception, the adductors, gracilis, and the inside of the hamstring visually meld, creating the opposite ratio to the outside view of the leg. On the outside the quadriceps is twice as big as the hamstring plus the adductors. From the inside view, the hamstring plus the adductors are twice as big as the quadriceps.

10 THE BONES OF THE LOWER LEG AND FOOT

In this chapter, we start with the lower leg and proceed to the foot. Most of the bones in the body are understructure and can be reduced to a line or simplified form. The lower leg bones, the tibia and the fibula, like the clavicle and the skull, are exceptions in that the character and form are apparent in the fleshed-out figure. The tibia is represented by a rectangle topped off by an apex-down triangle. The top of the tibia is broad—it is important to give width to the tibia. The tibia is wedge-shaped or prismoid in form.

The long, thin fibula, the smaller of the two bones, is located on the outside of the lower leg. Its lower extremity is the outside anklebone. Draw the fibula as a line topped by a ball (head) and ending in a teardrop (anklebone). The teardrop descends lower than the bottom of the tibia. The fibula is not visible on the finished figure except at the anklebone,

as it is mostly covered by muscle. The outside portion of the hamstring inserts at the head of the fibula.

The foot has three bone segments: the tarsus, the metatarsus, and the phalanges. The tarsus consists of seven separate bones: the talus, calcaneus, navicular, first cuneiform, second cuneiform, third cuneiform, and cuboid. The metatarsus is composed of the bones connected to the phalanges, which make up the toes. There is a progressive diminishing in size from the metatarsus to the tip of the toe. The big toe has two phalanges. The other four toes have three phalanges.

The figures opposite and below, right, show the lower leg and the foot bones in their relationship to the fleshed-out figure. The figure below, left, shows the lower leg and foot bones on the simplified skeleton.

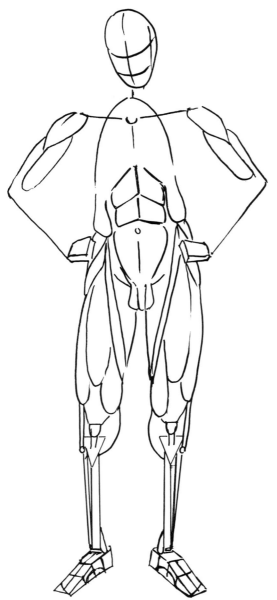
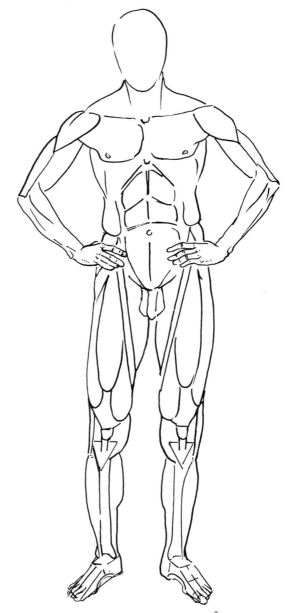

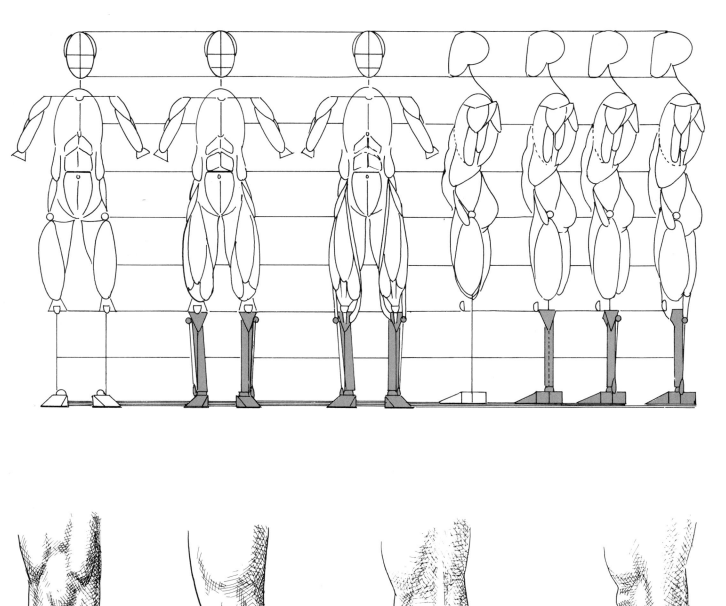

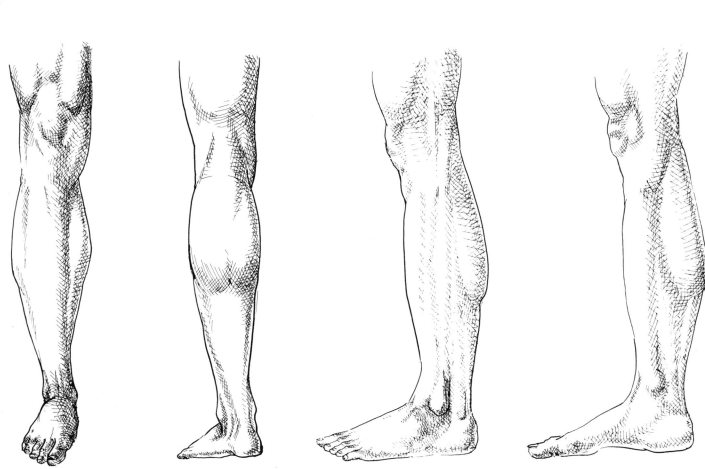

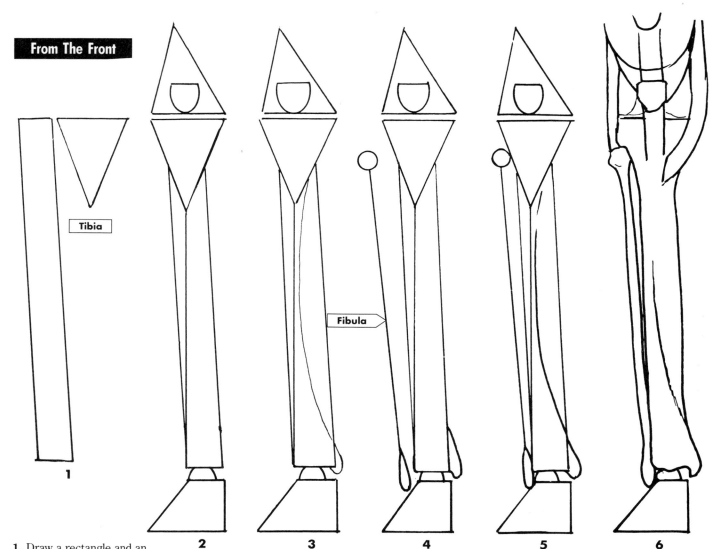

Tibia

1

Fibula

2 **3** **4** **5** **6**

1. Draw a rectangle and an apex-down triangle to represent the tibia.

2. Draw the tibia rectangle at a slight inward angle to match that of the lower leg. Place an apex-down triangle at the top of the tibia rectangle. Include the round articulation surface (talus) of the foot, which measures about a quarter to half the height of the quarter-head-high foot schematic.

3. At the bottom of the tibia rectangle include a teardrop to represent the inside anklebone.

4. Draw the fibula as a line topped by a circle or ball (head) and ending up in a teardrop.

5. The fibula ends lower than the tibia. The angle of the tibia to the fibula is very important to the ankle.

6. Draw the goosefoot attaching at the inside middle of the tibia triangle. Draw the hamstring attaching to the head of the fibula. Connect the quadriceps to the middle of the tibia triangle by way of the kneecap ligament.

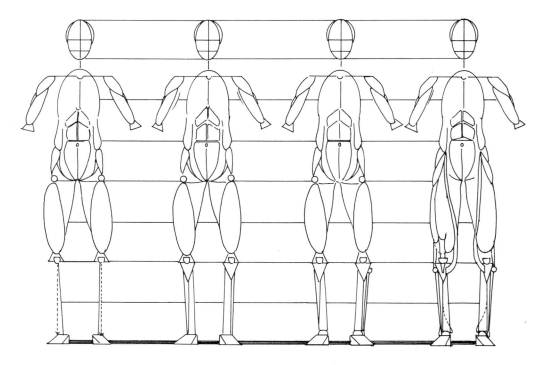

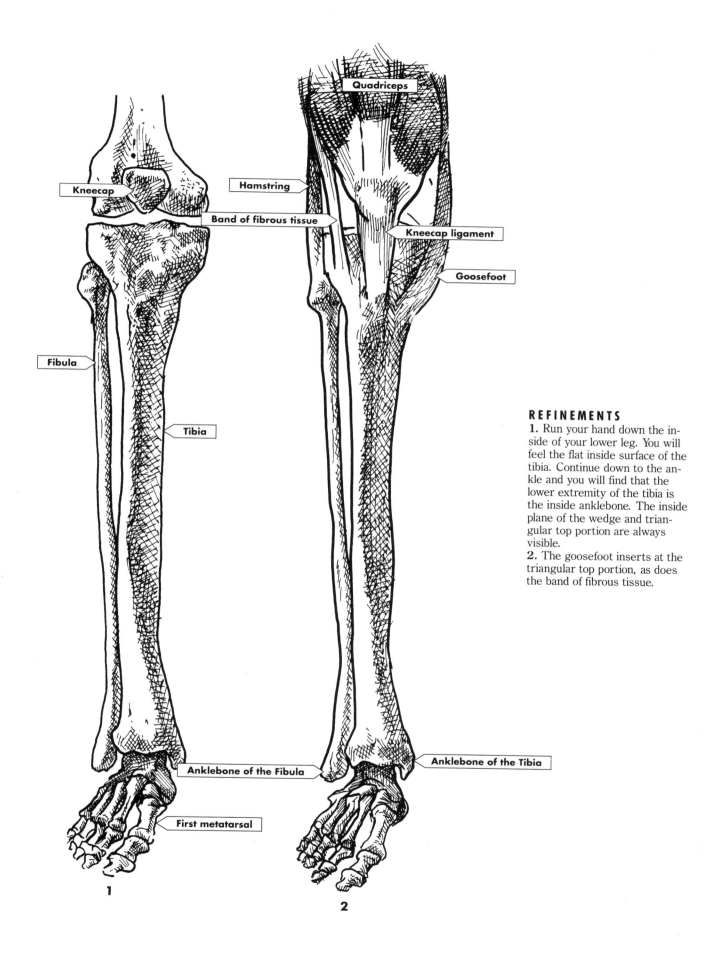

Kneecap

Quadriceps

Hamstring

Band of fibrous tissue

Kneecap ligament

Goosefoot

Fibula

Tibia

REFINEMENTS

1. Run your hand down the inside of your lower leg. You will feel the flat inside surface of the tibia. Continue down to the ankle and you will find that the lower extremity of the tibia is the inside anklebone. The inside plane of the wedge and triangular top portion are always visible.

2. The goosefoot inserts at the triangular top portion, as does the band of fibrous tissue.

Anklebone of the Fibula

Anklebone of the Tibia

First metatarsal

1

2

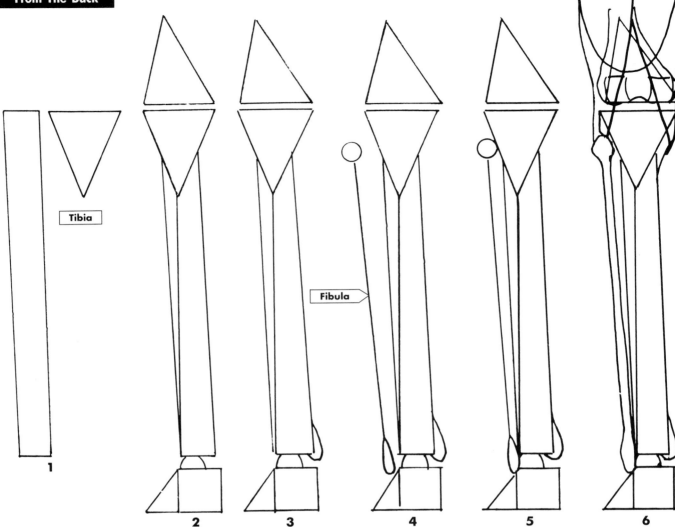

Tibia

Fibula

1 2 3 4 5 6

1. Draw a rectangle and an apex-down triangle to represent the tibia.

2. Add the tibia rectangle and the apex-down triangle to the lower leg. Include the round articulation surface of the foot, which measures about a quarter to half the height of the quarter-head-high foot schematic.

3. At the bottom of the tibia rectangle include a teardrop shape to represent the inside anklebone.

4. The fibula is a line between the head and a teardrop.

5. The fibula ends lower than the tibia. Check the angle of the tibia to the fibula at the ankle.

6. Draw the goosefoot inserting at the inside middle tibia triangle. Draw the hamstring inserting at the head of the fibula.

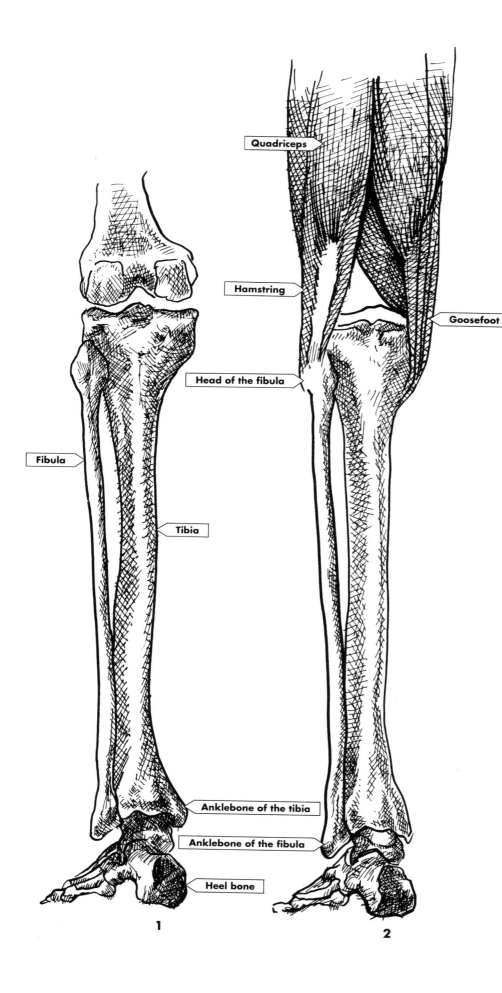

Quadriceps

Hamstring

Goosefoot

Head of the fibula

Fibula

Tibia

Anklebone of the tibia

Anklebone of the fibula

Heel bone

1

2

REFINEMENTS

1. The head of the fibula is often visible as a bump. The bottom of the fibula forms the outside of the anklebone. The inside bottom of the tibia is the inside anklebone. Note the angle created by the bottom of the tibia and fibula.

2. The tendon of the outside aspect of the hamstring inserts at the head of the fibula. The goosefoot inserts at the upper inside and front portions of the tibia.

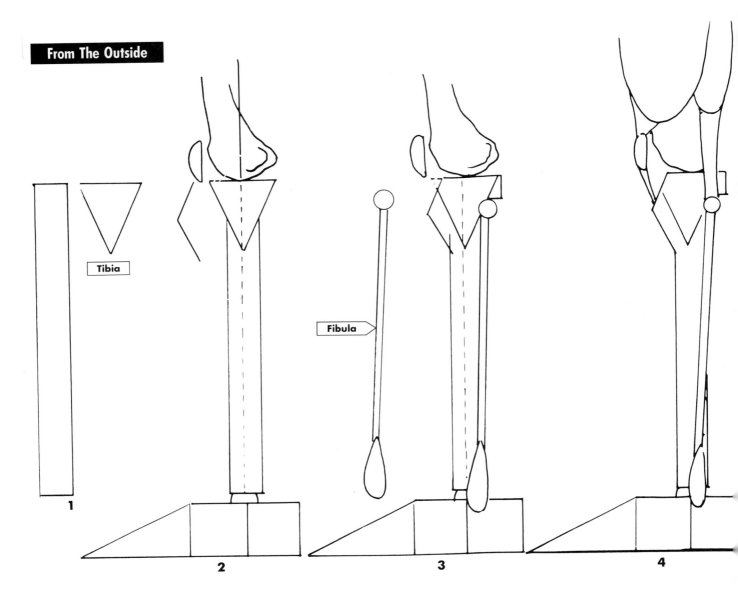

Tibia

Fibula

1

2

3

4

1. Draw a rectangle and an apex-down triangle to represent the tibia.

2. Place the tibia rectangle, topped by the apex-down triangle, squarely on the vertical line of the lower leg. Draw the round articulation surface of the foot about a quarter to half the height of the quarter-head-high foot schematic. There is an additional V-shape to the tibia at the top.

3. Add the V-shape, which comes down from the triangle, to extend the triangle forward to join the kneecap ligament. The fibula is a line between the head and the teardrop, and it ends lower than the tibia. Place the head of the fibula high on the back of the tibia triangle.

4. Draw the hamstring inserting at the head of the fibula. Connect the front line of the quadriceps to the kneecap and from there to the tibia.

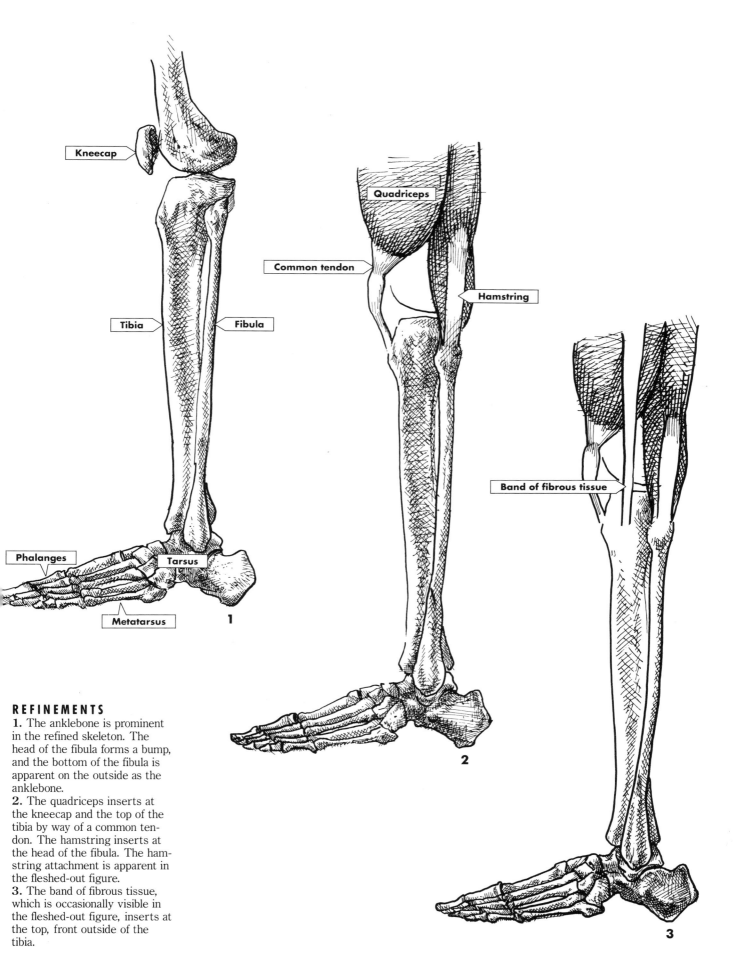

Kneecap

Quadriceps

Common tendon

Hamstring

Tibia **Fibula**

Band of fibrous tissue

Phalanges **Tarsus**

Metatarsus

1

2

3

REFINEMENTS

1. The anklebone is prominent in the refined skeleton. The head of the fibula forms a bump, and the bottom of the fibula is apparent on the outside as the anklebone.

2. The quadriceps inserts at the kneecap and the top of the tibia by way of a common tendon. The hamstring inserts at the head of the fibula. The hamstring attachment is apparent in the fleshed-out figure.

3. The band of fibrous tissue, which is occasionally visible in the fleshed-out figure, inserts at the top, front outside of the tibia.

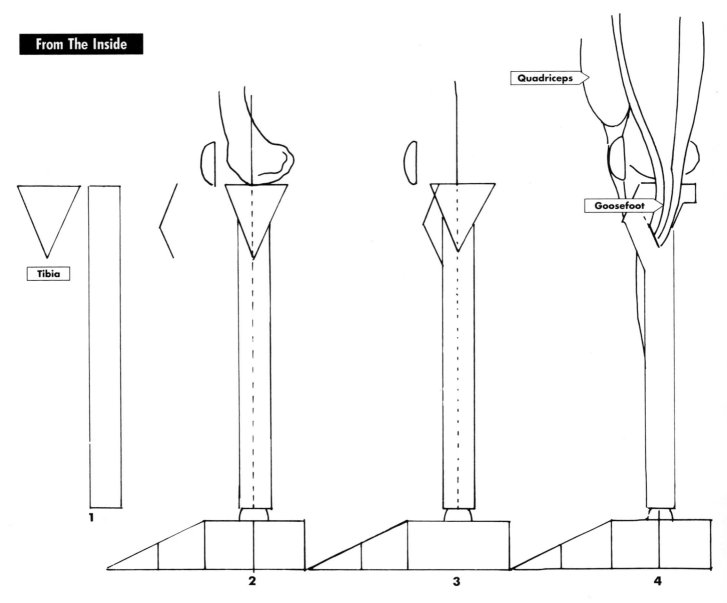

Tibia

Quadriceps

Goosefoot

1. Draw a rectangle and an apex-down triangle to represent the tibia.

2. Place the tibia rectangle squarely on the vertical line of the lower leg. Draw the round articulation surface of the foot about a quarter to half the height of the quarter-head-high foot schematic. Draw a V-shape coming out and down from the apex-down triangle.

3. Attach the V-shape to the triangle.

4. Draw the goosefoot inserting at the tibia triangle. Draw the quadriceps connecting to the tibia and then the kneecap.

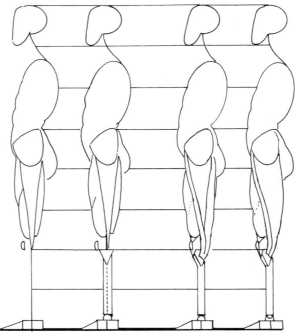

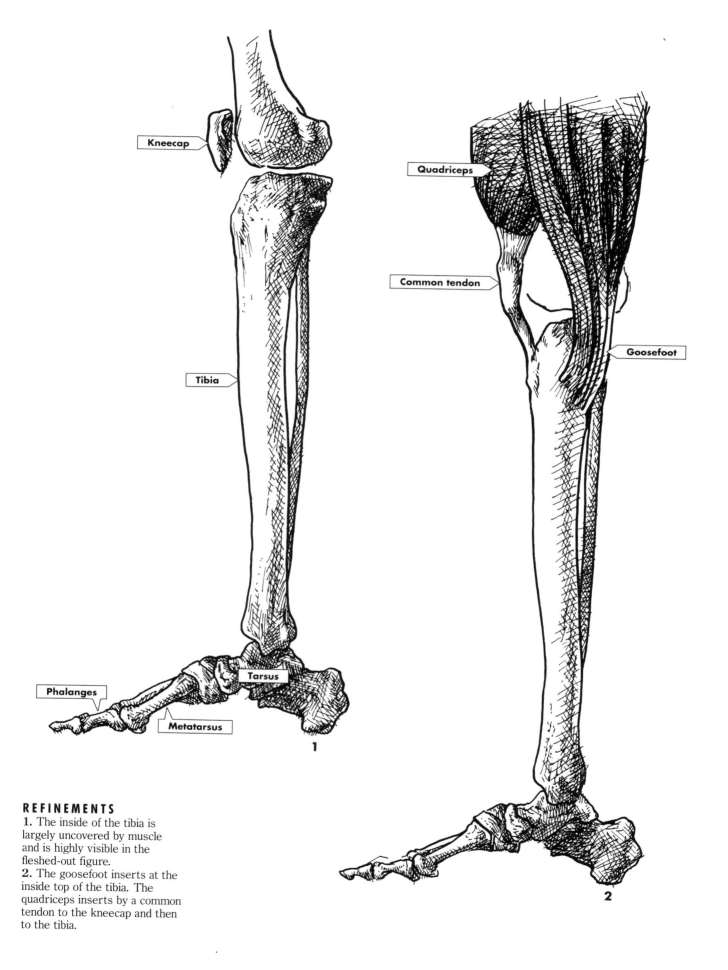

Kneecap

Quadriceps

Common tendon

Tibia

Goosefoot

Tarsus

Phalanges

Metatarsus

1

2

REFINEMENTS

1. The inside of the tibia is largely uncovered by muscle and is highly visible in the fleshed-out figure.

2. The goosefoot inserts at the inside top of the tibia. The quadriceps inserts by a common tendon to the kneecap and then to the tibia.

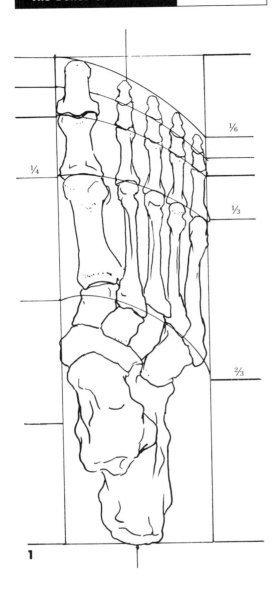

1/6

1/4

1/3

2/3

1

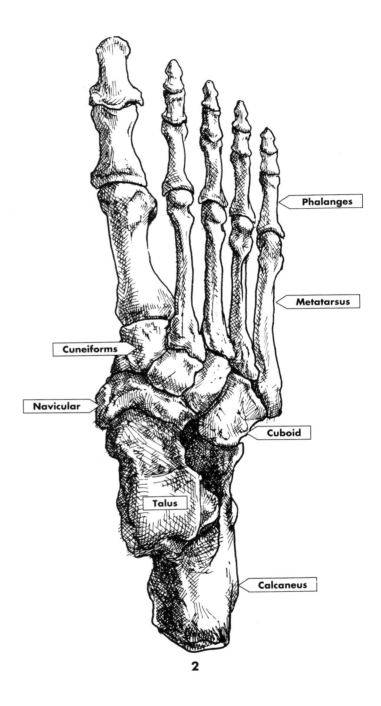

Phalanges

Metatarsus

Cuneiforms

Navicular

Cuboid

Talus

Calcaneus

2

1. If you look down at your feet, you can see that each foot is asymmetrical. The foot schematic is most easily visualized as a box. On the inside of the foot (the side with the big toe), the measurements are in divisions based on quarters, and on the outside, the measurements begin in thirds. There is an angling backward on the outside running toward the heel bone.
2. The foot has three bone segments: the tarsus, the metatarsus, and the phalanges. The tarsus consists of seven separate bones: the talus, calcaneus, navicular, first cuneiform, second cuneiform, third cuneiform, and cuboid. The metatarsus is composed of the bones connected to the phalanges, which make up the toes. There is a progressive diminishing in size from the metatarsus to the tip of the toe. The big toe has two phalanges. The other four toes have three phalanges.

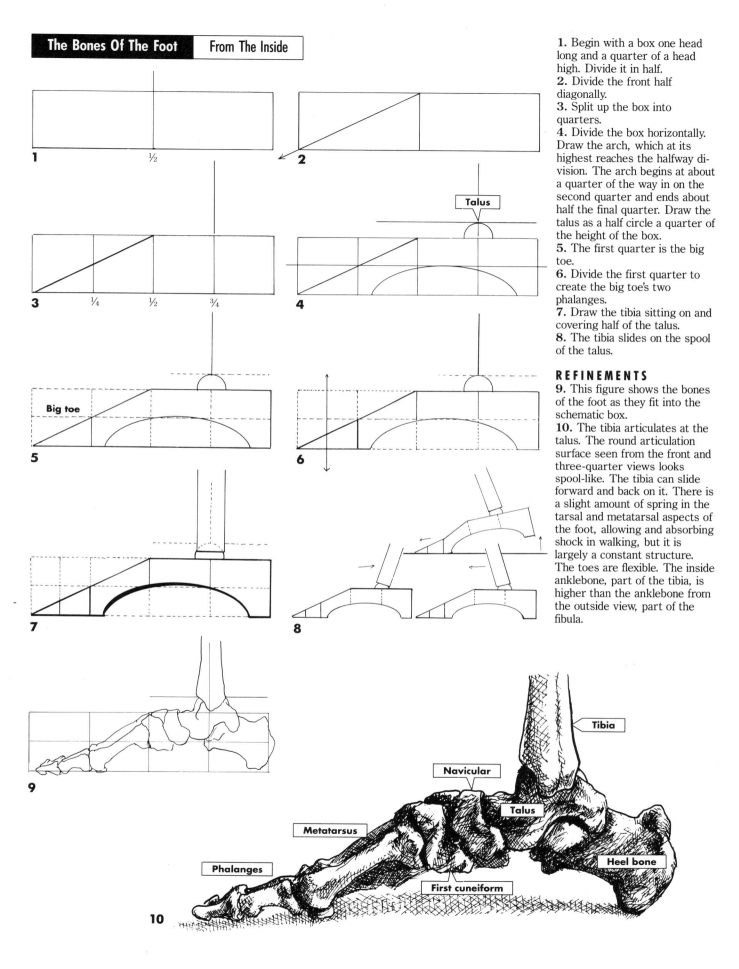

1. Begin with a box one head long and a quarter of a head high. Divide it in half.
2. Divide the front half diagonally.
3. Split up the box into quarters.
4. Divide the box horizontally. Draw the arch, which at its highest reaches the halfway division. The arch begins at about a quarter of the way in on the second quarter and ends about half the final quarter. Draw the talus as a half circle a quarter of the height of the box.
5. The first quarter is the big toe.
6. Divide the first quarter to create the big toe's two phalanges.
7. Draw the tibia sitting on and covering half of the talus.
8. The tibia slides on the spool of the talus.

REFINEMENTS
9. This figure shows the bones of the foot as they fit into the schematic box.
10. The tibia articulates at the talus. The round articulation surface seen from the front and three-quarter views looks spool-like. The tibia can slide forward and back on it. There is a slight amount of spring in the tarsal and metatarsal aspects of the foot, allowing and absorbing shock in walking, but it is largely a constant structure. The toes are flexible. The inside anklebone, part of the tibia, is higher than the anklebone from the outside view, part of the fibula.

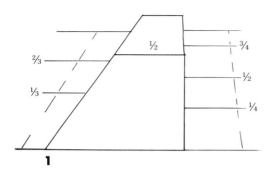

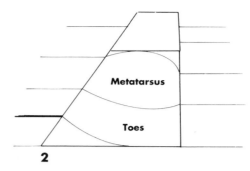

1. Begin with the box schematic and allow for compression toward the back from this view. The foot measures from this view a little more than a quarter of a head high. Divide the outside into thirds. Divide the inside into quarters.

2. Divide the first third on the outside in half and draw a curved line connecting this point to the front line of the schematic on the inside. Connect the one-third point on the outside with a curved line to the one-quarter point on the inside to represent the toe area. Draw a curved line from the two-thirds point on the outside to the halfway division on the inside.

3. Divide the area of the toes in half. Draw a curved line from side to side.

4. Divide the first division of the toes in half. Draw a curved line from side to side. The toe area now has three divisions.

5. Divide the back half of the schematic into quarters. Because of foreshortening, the back half will appear much smaller than the front half.

6. Draw the spool of the talus at the three-quarters point and on the outside half.

7. Draw the tibia on the talus.

8. Draw the fibula. Draw the curve at the bottom of the tibia.

9. Flesh out the toes.

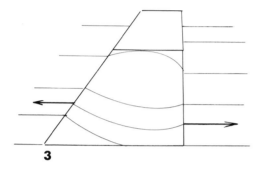

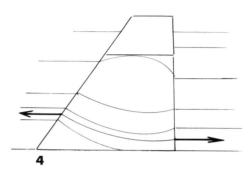

Metatarsus

Toes

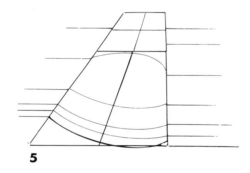

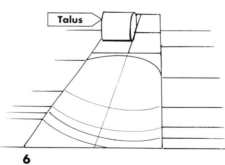

3

4

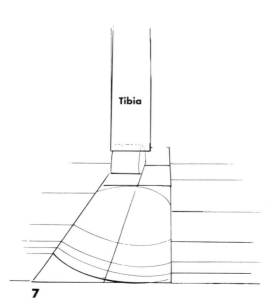

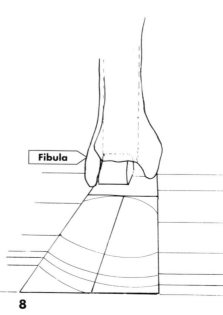

Talus

5

6

Tibia

Fibula

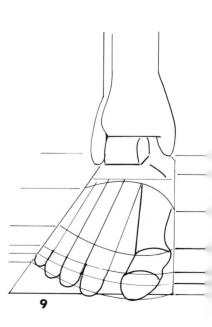

7

8

9

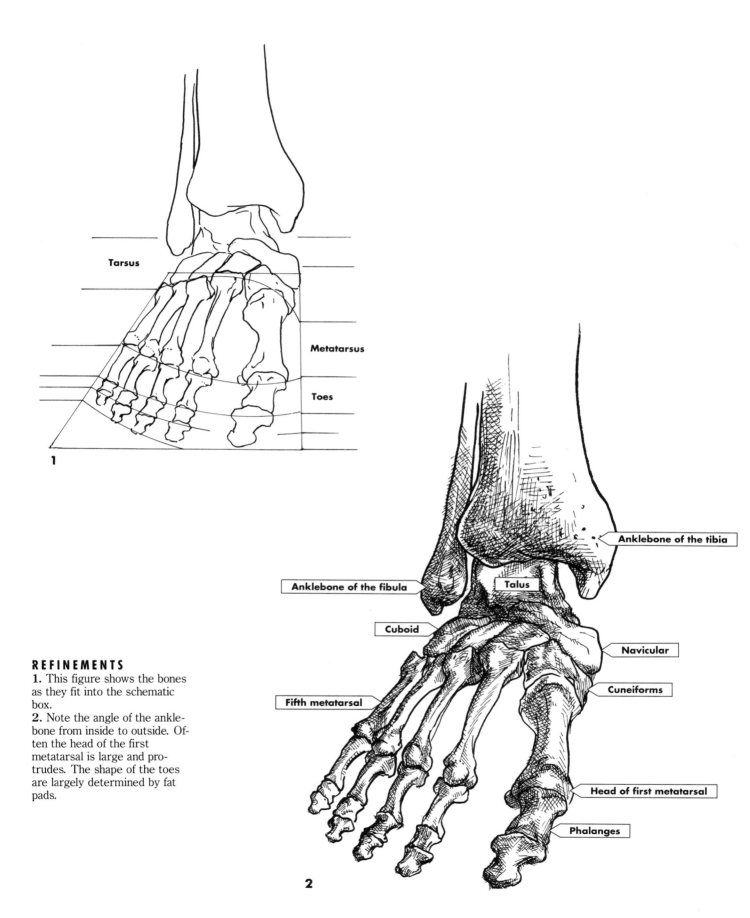

Tarsus

Metatarsus

Toes

1

Anklebone of the tibia

Anklebone of the fibula

Talus

Cuboid

Navicular

Cuneiforms

Fifth metatarsal

Head of first metatarsal

Phalanges

2

REFINEMENTS
1. This figure shows the bones as they fit into the schematic box.
2. Note the angle of the anklebone from inside to outside. Often the head of the first metatarsal is large and protrudes. The shape of the toes are largely determined by fat pads.

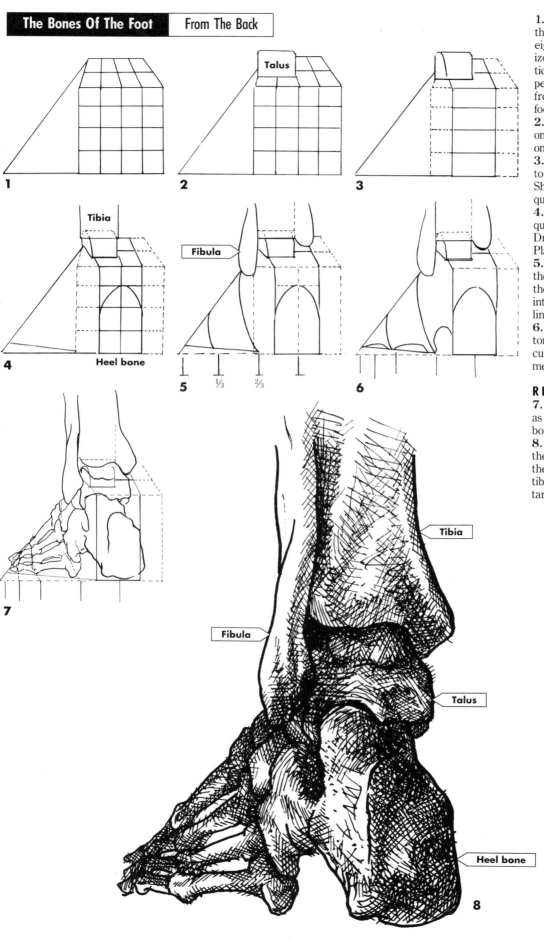

Talus

Tibia

Fibula

Heel bone

1
2
3
4
5 1/3 2/3 6
7
8

Tibia

Fibula

Talus

Heel bone

1. Begin with a cube. Divide the height into quarters, then eighths. Divide the top face horizontally in half. Extend the vertical lines back, allowing for perspective. Include part of the front of the outside angle of the foot as a triangular shape.

2. Place the spool of the talus on the top three-quarters line on the little toe side.

3. Reduce the width of the heel to the internal two quarters. Shave off the first and fourth quarter on the top surface.

4. The heel bone is three-quarters the height of the box. Draw it as an oblong semi-oval. Place the tibia on the talus.

5. Draw the teardrop shape of the fibula. Draw the curve of the tibia. Mark off the outside into thirds. Draw the curved lines.

6. Include the curve at the bottom of the heel bone and the curve at the bottom of the fifth metatarsus.

REFINEMENTS

7. This figure shows the bones as they fit into the schematic box.

8. Highlights of the bones of the foot from the back include the anklebone portion of the tibia and fibula, the fifth metatarsal, and the heel bone.

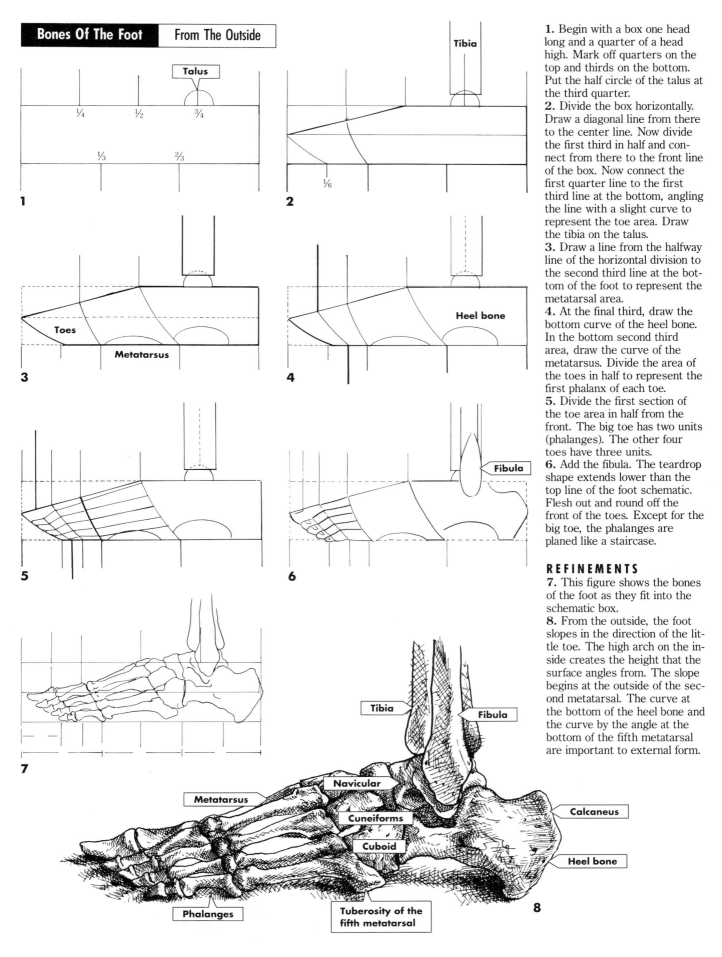

1. Begin with a box one head long and a quarter of a head high. Mark off quarters on the top and thirds on the bottom. Put the half circle of the talus at the third quarter.

2. Divide the box horizontally. Draw a diagonal line from there to the center line. Now divide the first third in half and connect from there to the front line of the box. Now connect the first quarter line to the first third line at the bottom, angling the line with a slight curve to represent the toe area. Draw the tibia on the talus.

3. Draw a line from the halfway line of the horizontal division to the second third line at the bottom of the foot to represent the metatarsal area.

4. At the final third, draw the bottom curve of the heel bone. In the bottom second third area, draw the curve of the metatarsus. Divide the area of the toes in half to represent the first phalanx of each toe.

5. Divide the first section of the toe area in half from the front. The big toe has two units (phalanges). The other four toes have three units.

6. Add the fibula. The teardrop shape extends lower than the top line of the foot schematic. Flesh out and round off the front of the toes. Except for the big toe, the phalanges are planed like a staircase.

REFINEMENTS

7. This figure shows the bones of the foot as they fit into the schematic box.

8. From the outside, the foot slopes in the direction of the little toe. The high arch on the inside creates the height that the surface angles from. The slope begins at the outside of the second metatarsal. The curve at the bottom of the heel bone and the curve by the angle at the bottom of the fifth metatarsal are important to external form.

109

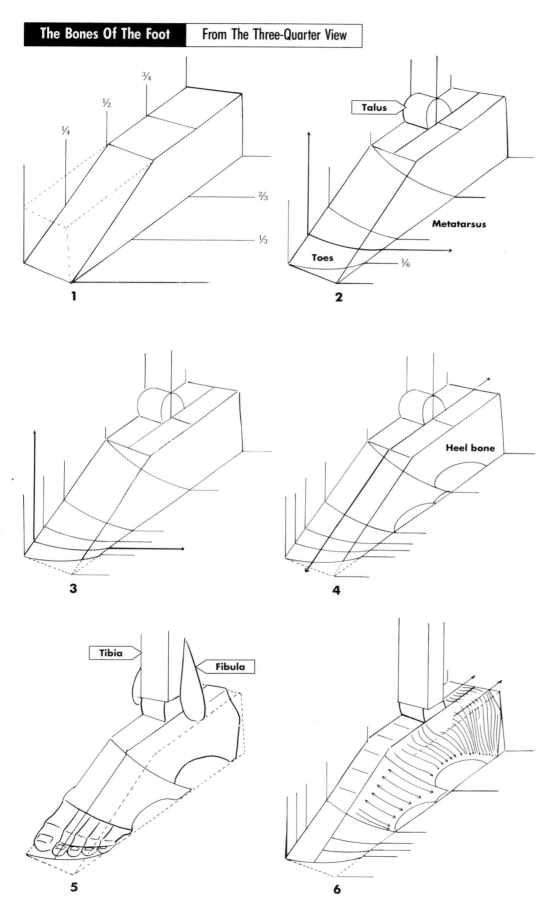

1. Begin with a box. Divide the inside view into quarters. Divide the outside view into thirds. Add two diagonals at the halfway line.

2. Divide the first third in half. Run a curved line connecting the front line of the foot to the first sixth division. Draw a curved line connecting the first quarter line to the first third line to represent the toe area. Draw a curved line connecting the halfway line to the two-thirds line to represent the metatarsus. Place the spool for the talus at the three-quarters line. Place it halfway into the middle.

3. Divide the toe area in half on both sides. Run a curved line from point to point. The top division represents the first phalanx of the toes.

4. Now divide the lower section in half with a curved line to represent the second and third phalanges. Draw the curve for the heel bone in the final third measure. Draw the slight curve of the metatarsal in the second third.

5. Add the fibula. Round out the inside bottom of the tibia. Flesh out and round off the front of the toes.

6. The lines on the surface of the foot schematic represent plane changes and directions.

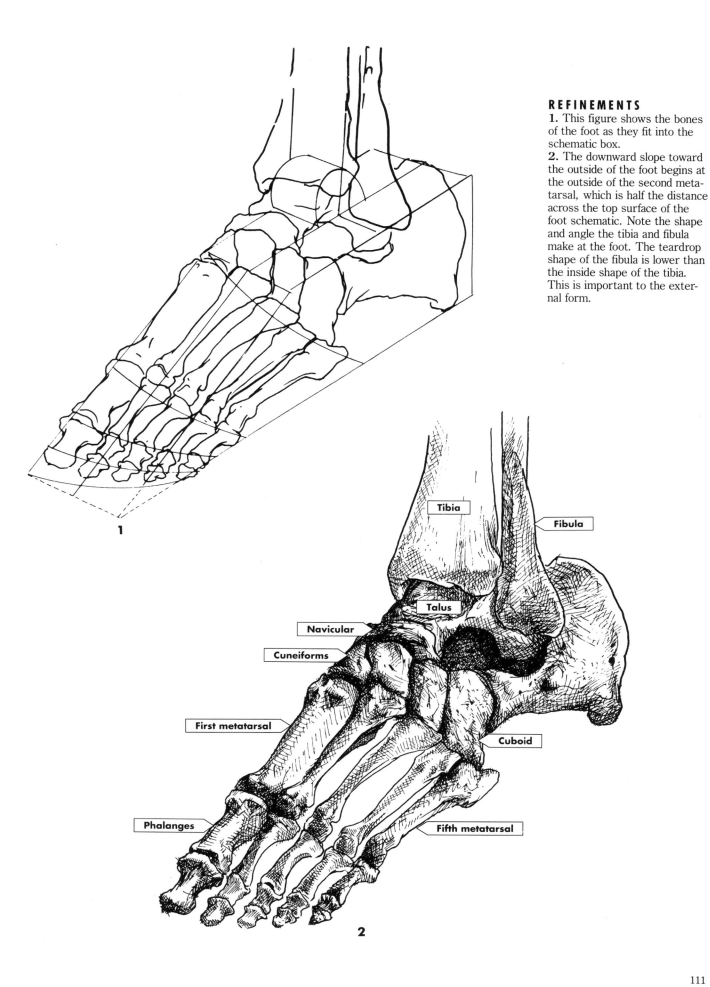

1

2

1. This figure shows the bones of the foot as they fit into the schematic box.
2. The downward slope toward the outside of the foot begins at the outside of the second metatarsal, which is half the distance across the top surface of the foot schematic. Note the shape and angle the tibia and fibula make at the foot. The teardrop shape of the fibula is lower than the inside shape of the tibia. This is important to the external form.

Tibia

Fibula

Talus

Navicular

Cuneiforms

First metatarsal

Cuboid

Phalanges

Fifth metatarsal

The muscles of the lower leg can be reduced to two groups: the calf and the tibia/fibula muscle group ovoid. The calf is represented by an ovoid or teardrop shape. The calf originates at the upper leg, and its function is to lift the heel. The body of the calf measures one head, ending at the seventh head measure. It attaches to the heel bone by the Achilles tendon. Take your hand and place it on your heel. Run your hand up the center of the back of the leg; compare this large, powerful tendon to the one at the biceps.

The tibia/fibula muscle group ovoid consists of four muscles (tibialis anterior, extensor digitorum longus, extensor hallucis, and the peroneal group). In the simple construction of the figure you can think of these muscles as forming a single ovoid. The ovoid is placed in the area of the fibula and the outside plane of the tibia. The inside plane of the tibia is clearly visible from the front and inside view. It reads distinctly as a flat receding plane.

The muscles of the foot are seen in three significant areas: the abductor of the little toe, which creates a highly visible platform; the abductor of the big toe, which is visible as mass at the arch of the foot; and the short extensors of the toes, which give body to the outside portion of the foot. The muscles of the lower leg attach to the foot most significantly as two connecting tendons.

The figures opposite and below, right, show the muscles of the lower leg and foot in their relationship to the fleshed-out figure. The figure below, left, shows the muscles of the lower leg and foot on the simplified skeleton.

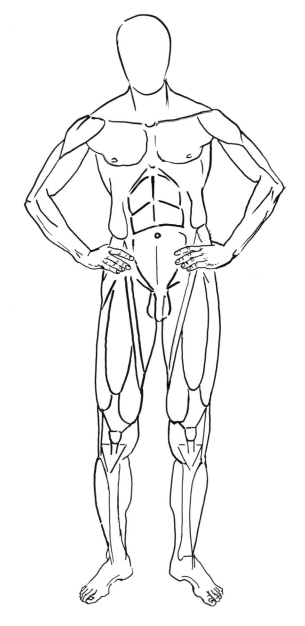

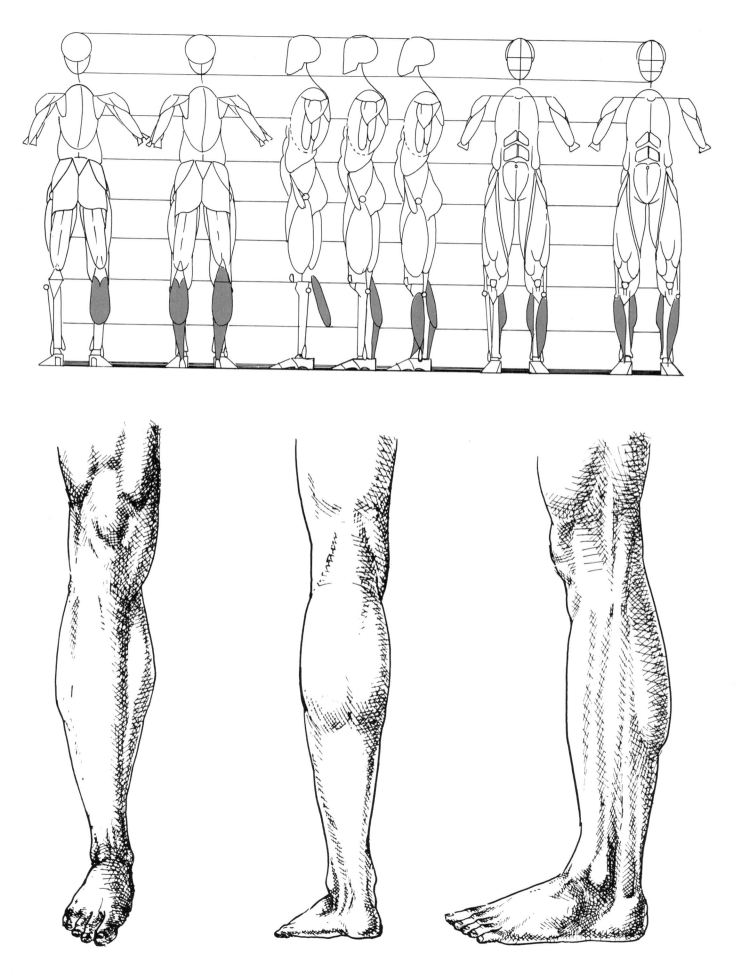

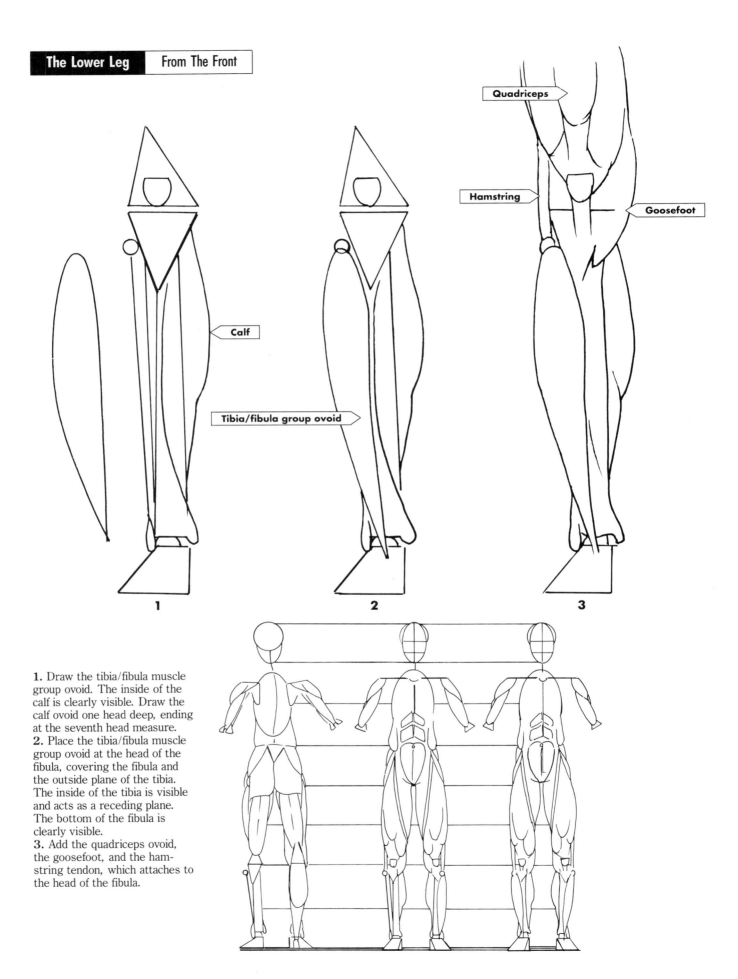

Quadriceps

Hamstring

Goosefoot

Calf

Tibia/fibula group ovoid

1

2

3

1. Draw the tibia/fibula muscle group ovoid. The inside of the calf is clearly visible. Draw the calf ovoid one head deep, ending at the seventh head measure.

2. Place the tibia/fibula muscle group ovoid at the head of the fibula, covering the fibula and the outside plane of the tibia. The inside of the tibia is visible and acts as a receding plane. The bottom of the fibula is clearly visible.

3. Add the quadriceps ovoid, the goosefoot, and the hamstring tendon, which attaches to the head of the fibula.

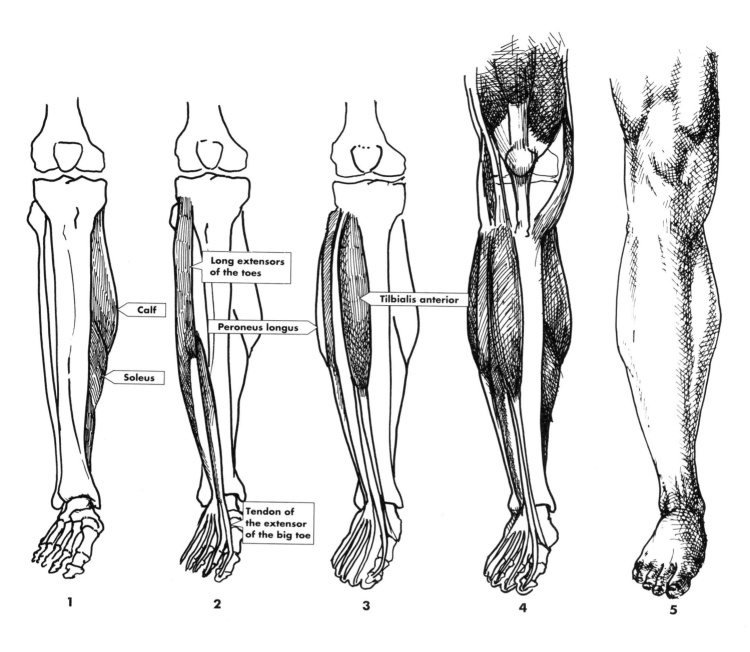

Calf

Long extensors
of the toes

Soleus

Peroneus longus

Tibialis anterior

Tendon of
the extensor
of the big toe

1 2 3 4 5

REFINEMENTS

1. The calf is clearly visible
from the front.
2. In muscular bodies it is pos-
sible to see the distinct forms
created by the tibia/fibula mus-
cle group. At times a division is
visible, but more often it reads
as a single mass. The long ten-
dons of the toes and the tendon
of the extensor to the big toe
are highly visible when the toes
are pulled up.
3. The body and tendon of the
tibialis anterior is pronounced
when the foot is both pulled in-
ward and pulled up.
4. The inside of the tibia is
highly visible and reads as a
receding plane.
5. The outside anklebone and
the inside anklebone are visible
in the exterior form.

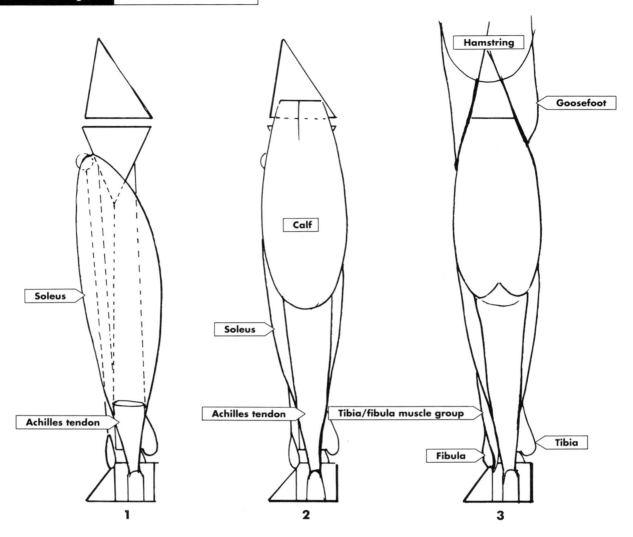

Hamstring

Goosefoot

Calf

Soleus

Soleus

Achilles tendon

Achilles tendon

Tibia/fibula muscle group

Fibula

Tibia

1 **2** **3**

1. Beneath the calf is a flat muscle (soleus) attaching to the Achilles tendon. It is visible in that it is wider than the Achilles tendon. It widens on each side and extends lower than the body of the calf. Draw the soleus as an extension at the width of the Achilles tendon.
2. Draw the calf ovoid from its origin to halfway down the lower leg at the seventh head measure. Draw the Achilles tendon stretching from the body of the calf to the heel bone.
3. Draw the hamstring attaching to the lower leg.

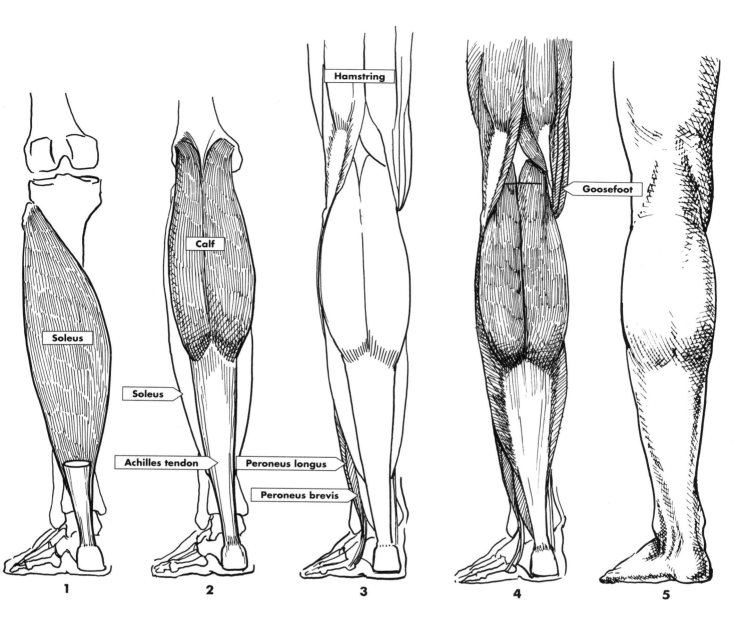

Hamstring

Calf

Soleus

Soleus

Achilles tendon

Peroneus longus

Peroneus brevis

Goosefoot

1 2 3 4 5

REFINEMENTS

1. Since the soleus originates high on the outside at the head of the fibula, it contributes to the appearance of the calf, which looks a little higher on the outside than the inside.

2. The soleus often melds visually with the Achilles tendon.

3. Two other tendons (peroneus longus and peroneus brevis) are often visible when the foot is both pulled up and pulled outward.

4. The goosefoot appears to tuck around toward the front of the calf.

5. In the fleshed-out figure a creased line often appears high on the calf.

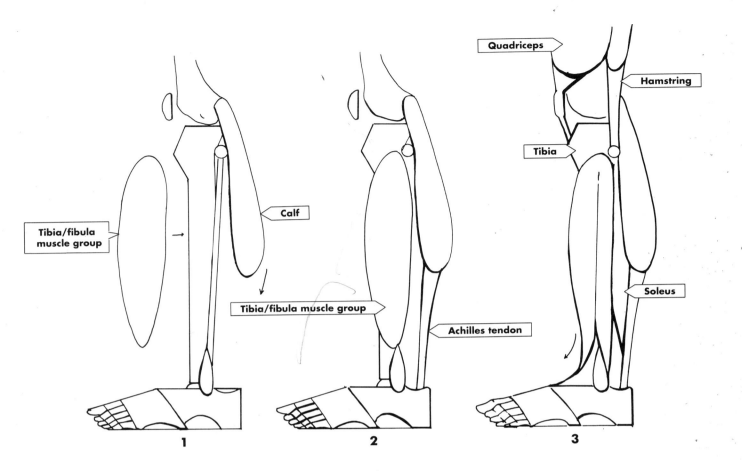

Tibia/fibula muscle group

Calf

Tibia/fibula muscle group

1

2

Quadriceps

Hamstring

Tibia

Achilles tendon

Soleus

3

1. Draw the tibia/fibula muscle group ovoid. Draw the calf ovoid originating at the upper leg.

2. Draw the Achilles tendon originating at the calf and inserting at the heel bone. Place the tibia/fibula muscle group ovoid on the fibula in the back and directly on the tibia.

3. The tibia/fibula muscle group ovoid divides down its center and draws to the front, curving and giving grace to the front ankle. At the back and bottom it tucks behind the anklebone. Draw the soleus squeezed between the tibia/fibula muscle group and the calf. Add the hamstring, which attaches to the head of the fibula. Add the connecting line from the quadriceps to the tibia.

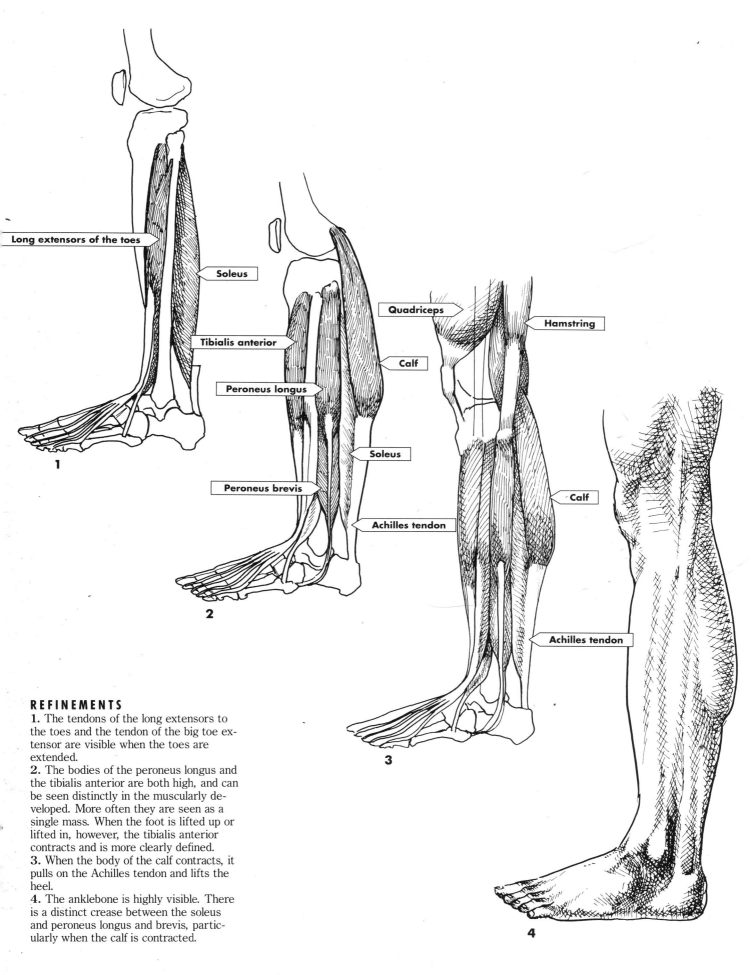

Long extensors of the toes

Soleus

Tibialis anterior

Peroneus longus

Peroneus brevis

Quadriceps

Hamstring

Calf

Soleus

Achilles tendon

Calf

Achilles tendon

1

2

3

4

REFINEMENTS

1. The tendons of the long extensors to the toes and the tendon of the big toe extensor are visible when the toes are extended.

2. The bodies of the peroneus longus and the tibialis anterior are both high, and can be seen distinctly in the muscularly developed. More often they are seen as a single mass. When the foot is lifted up or lifted in, however, the tibialis anterior contracts and is more clearly defined.

3. When the body of the calf contracts, it pulls on the Achilles tendon and lifts the heel.

4. The anklebone is highly visible. There is a distinct crease between the soleus and peroneus longus and brevis, particularly when the calf is contracted.

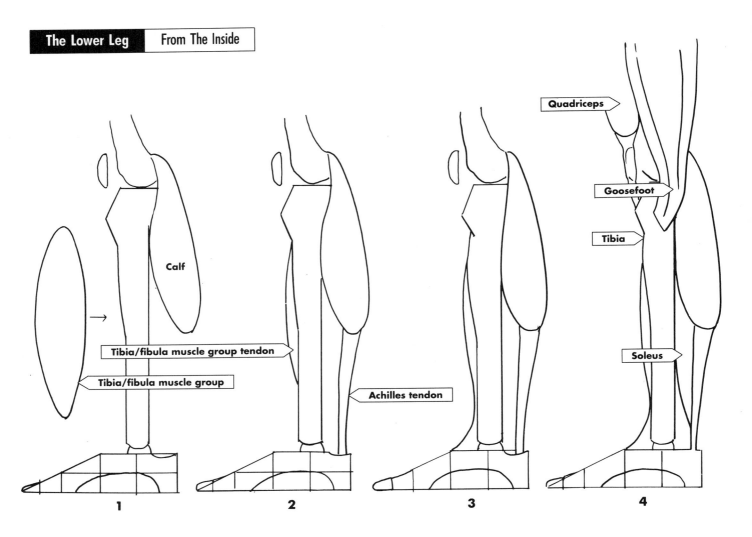

Calf

Tibia/fibula muscle group tendon

Tibia/fibula muscle group

Achilles tendon

Quadriceps

Goosefoot

Tibia

Soleus

1 **2** **3** **4**

1. Draw the tibia/fibula muscle group ovoid. Draw the calf ovoid, which originates at the upper leg.
2. Draw the calf ovoid from its origin to its attachment at the heel bone by way of the Achilles tendon. The tibia/fibula muscle group ovoid sits on the outside of the lower leg. The front portion extends forward beyond the bone. It shapes and rounds the front of the lower leg.
3. Include a line from this ovoid attaching to the foot.
4. Add the goosefoot and the line connecting the quadriceps to the tibia. Include the soleus. Draw the soleus squeezed between the tibia and calf, attaching to the Achilles tendon.

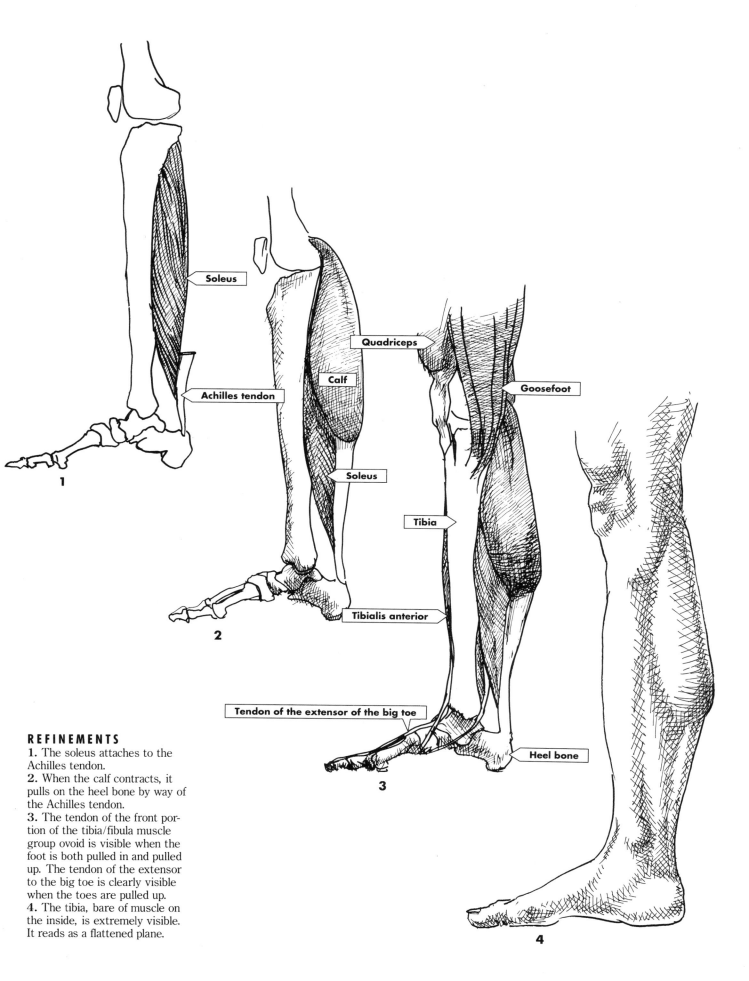

Soleus

Achilles tendon

Quadriceps

Calf

Soleus

Goosefoot

Tibia

Tibialis anterior

Tendon of the extensor of the big toe

Heel bone

1

2

3

4

REFINEMENTS

1. The soleus attaches to the Achilles tendon.

2. When the calf contracts, it pulls on the heel bone by way of the Achilles tendon.

3. The tendon of the front portion of the tibia/fibula muscle group ovoid is visible when the foot is both pulled in and pulled up. The tendon of the extensor to the big toe is clearly visible when the toes are pulled up.

4. The tibia, bare of muscle on the inside, is extremely visible. It reads as a flattened plane.

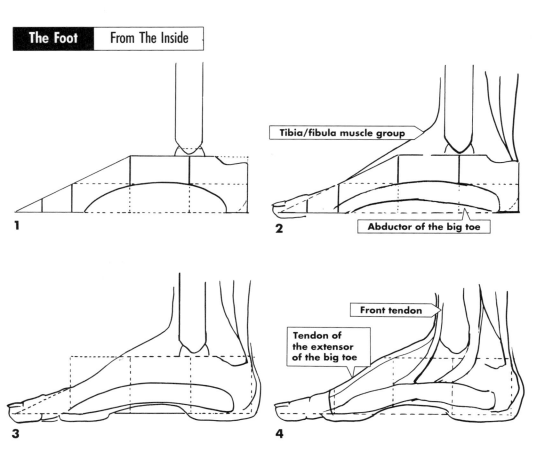

Tibia/fibula muscle group

Abductor of the big toe

1

2

Front tendon

Tendon of the extensor of the big toe

3

4

1. Begin with the foot schematic.
2. Draw a line filling half the arch area. Attach the Achilles tendon to the heel bone. Include the soleus. Draw a curved line from the tibia/fibula muscle group ovoid to the foot at the first quarter.
3. Shape the toes. The top of the toes have a straighter line than the bottom, which are padded and more rounded. Include the fat pads.
4. Draw the extensor to the big toe. Draw the front tendon of the tibia/fibula muscle group inserting at the halfway line at the bottom of the base of the first metatarsal.

REFINEMENTS

5. The front tendon of the tibia/fibula muscle group is particularly visible when the foot is lifted in.
6. The abductor of the big toe is clearly visible. It creates a slight plane change.

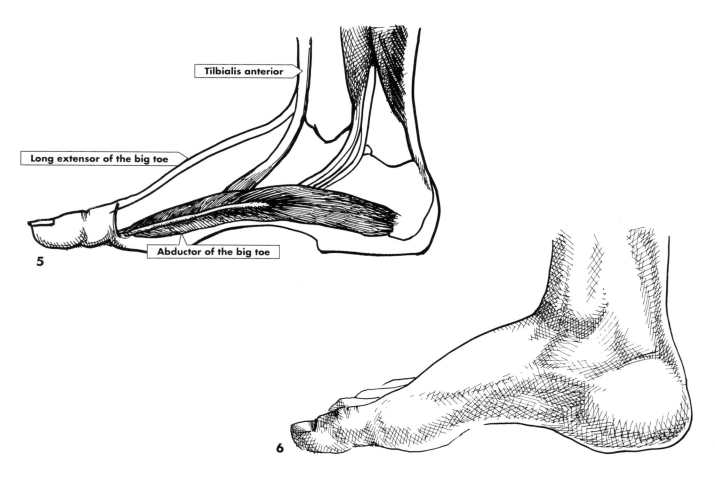

Tilbialis anterior

Long extensor of the big toe

Abductor of the big toe

5

6

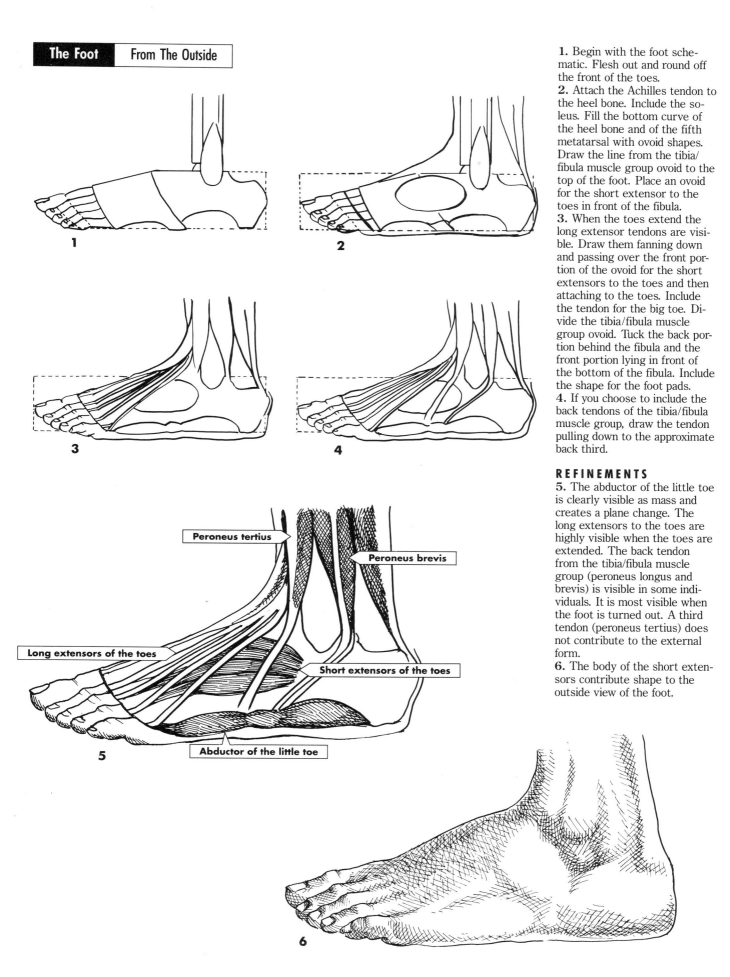

Peroneus tertius

Peroneus brevis

Long extensors of the toes

Short extensors of the toes

Abductor of the little toe

1. Begin with the foot schematic. Flesh out and round off the front of the toes.

2. Attach the Achilles tendon to the heel bone. Include the soleus. Fill the bottom curve of the heel bone and of the fifth metatarsal with ovoid shapes. Draw the line from the tibia/fibula muscle group ovoid to the top of the foot. Place an ovoid for the short extensor to the toes in front of the fibula.

3. When the toes extend the long extensor tendons are visible. Draw them fanning down and passing over the front portion of the ovoid for the short extensors to the toes and then attaching to the toes. Include the tendon for the big toe. Divide the tibia/fibula muscle group ovoid. Tuck the back portion behind the fibula and the front portion lying in front of the bottom of the fibula. Include the shape for the foot pads.

4. If you choose to include the back tendons of the tibia/fibula muscle group, draw the tendon pulling down to the approximate back third.

REFINEMENTS

5. The abductor of the little toe is clearly visible as mass and creates a plane change. The long extensors to the toes are highly visible when the toes are extended. The back tendon from the tibia/fibula muscle group (peroneus longus and brevis) is visible in some individuals. It is most visible when the foot is turned out. A third tendon (peroneus tertius) does not contribute to the external form.

6. The body of the short extensors contribute shape to the outside view of the foot.

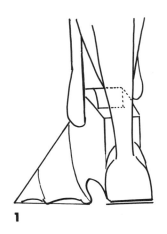
1

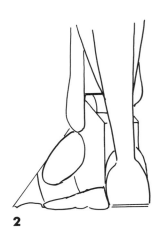
2

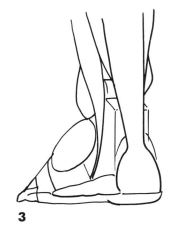
3

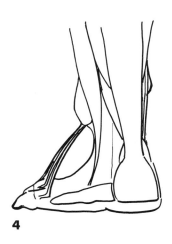
4

1. Begin with the foot schematic. Attach the Achilles tendon to the heel.

2. Place the rounded form for the short extensors in front of the fibula. Fill the curved shape at the bottom of the heel bone and the curved line at the bottom of the fifth metatarsal.

3. Include the shape for the fat pads. Draw the back portion of the tibia/fibula muscle group on the back of the fibula. A good portion of the fibula part of the anklebone is still revealed. Draw the combined tendon of the back portion of the tibia/fibula muscle group down to the base of the fifth metatarsal.

4. It is optional to include the not usually distinct long extensors passing down on top of the short extensors ovoid.

REFINEMENTS

5. The ovoid shape of the short extensors (extensor digitorum brevis) and the mass and plane created by the abductor of the little toe are conspicuous and important to the external form of the foot.

6. The foot from this view has a highly generalized look. The angle of the tibial anklebone is high and the fibular anklebone is low. This angle is extremely apparent.

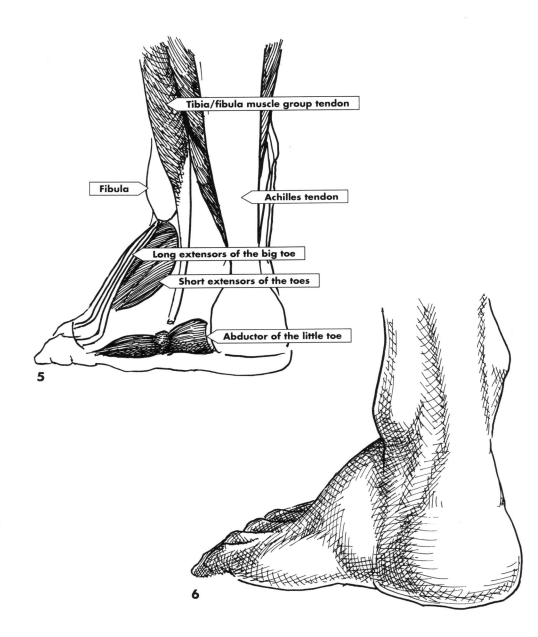

Tibia/fibula muscle group tendon

Fibula

Achilles tendon

Long extensors of the big toe

Short extensors of the toes

Abductor of the little toe

5

6

1 **2** **3** **4**

1. Begin with the foot schematic.

2. Add the ovoid for the short extensors to the toes. Shape the toes, considering their changing planes. Include shapes for the abductor of the little toe and the abductor of the big toe.

3. Bring down the long extensors of the toes and the extensor of the big toe.

4. The short extensors of the toes separate and draw down to each of the toes except the little toe. These divisions are not visible to the external form. The rounded shape of the group is clearly visible as a mass.

REFINEMENTS

5. The abductor of the little toe platforms out from this view very clearly. The body of the short extensor is apparent and rounds the form. The downward slope at the outside of the foot begins at about half the width of the foot. When the toes or foot are extended, the tendons to the toes are highly visible.

6. The angle created by the anklebone of the tibia (high) and the anklebone of the fibula (low) are once again apparent. The tendon of the extensor of the big toe is often very apparent in the external form.

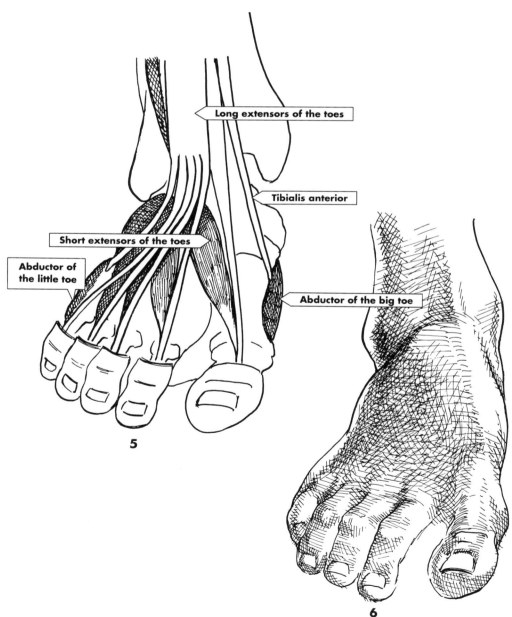

Long extensors of the toes

Tibialis anterior

Short extensors of the toes

Abductor of the little toe

Abductor of the big toe

5

6

12 THE BONES OF THE LOWER ARM AND HAND

The two bones in the lower arm are the radius and the ulna. The radius, which is connected to the hand, rotates. It can turn the palm up or down. The ulna articulates with the upper arm bone. It articulates like a hinge—its only movements are up and down.

The two bones of the lower arm, both long, triangular shapes, can be compared to a block of wood cut diagonally. The ulna is broad at the top and small at the bottom. The radius is small at the top and broad at the bottom.

The hand has three bone segments: the carpus, the metacarpus, and the phalanges (fingers). The carpus consists of eight separate bones that can be considered as a single shape. The metacarpus are the bones connected to the fingers. There is a progressive diminishing in size from the metacarpus through the fingers. The thumb has two phalanges; the other four fingers have three. The construction of the hand begins with a rectangular box that measures three-quarters of a head from the articulation point of the arm (radius) to the tip of the middle finger, which is the longest finger in the hand.

The figures opposite and below, right, show the bones of the lower arm and hand as they appear in refined drawings. The figure below, left, shows the bones of the lower arm and hand on the simplified skeleton.

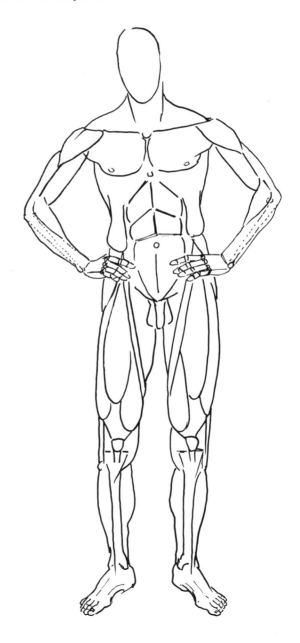

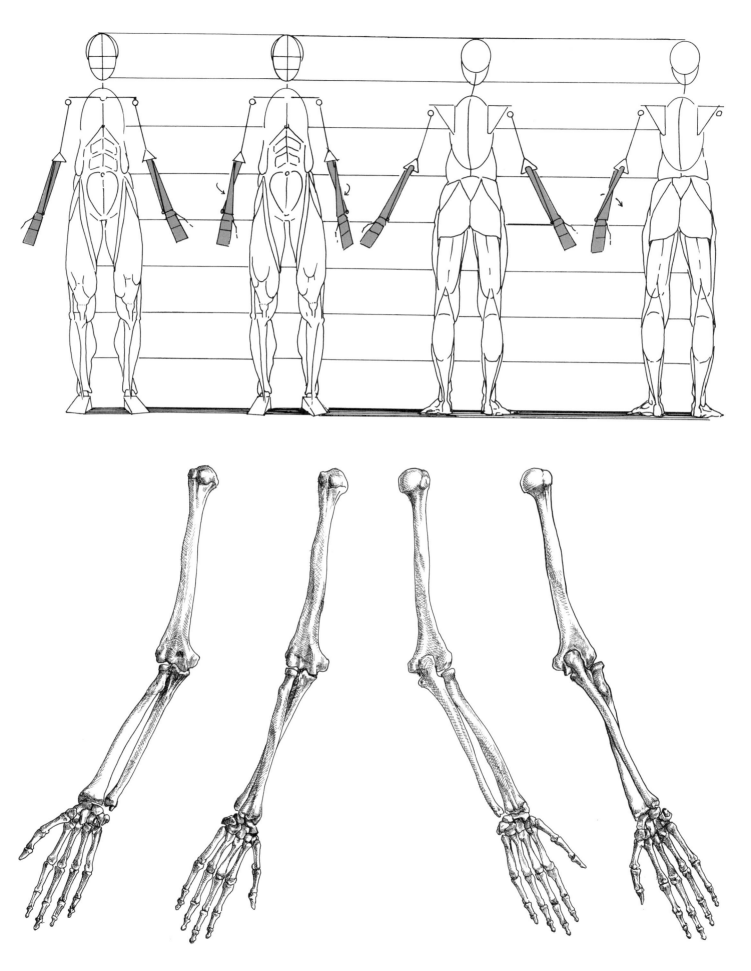

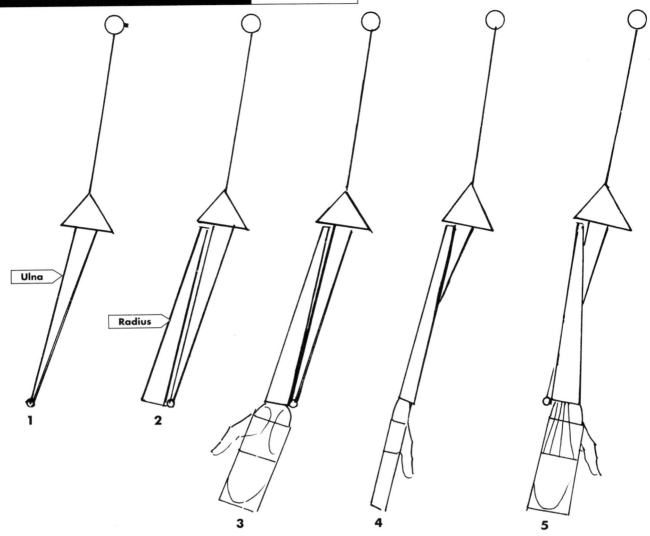

Ulna

Radius

1 **2** **3** **4** **5**

Draw a figure from the front three times developed to the point of the lower arm. Keep in mind that the upper arm measures 1½ heads, the lower arm measures 1¼ heads, and the hand schematic measures three-quarters of a head.

1. Begin with the ulna. Place it directly in the center of the triangle at the bottom of the upper arm bone. Draw the ulna angling out slightly.

2. Place the radius on the outside.

3. The hand attaches to the radius. Draw it as a rectangular box. Divide it in half with a horizontal line. Measure a third of the upper half and curve off the area. Include a line indicating the thumb. When the bones are parallel, the palm is up.

4. Place the radius in half rotation. The radius and the hand are narrow from this view.

5. Draw the radius in full rotation.

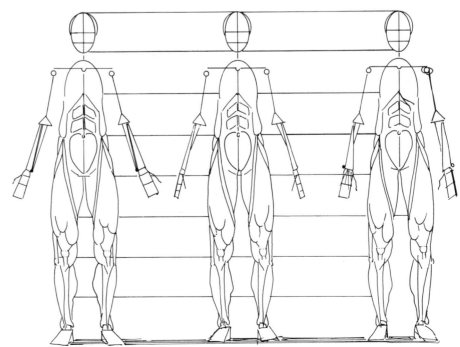

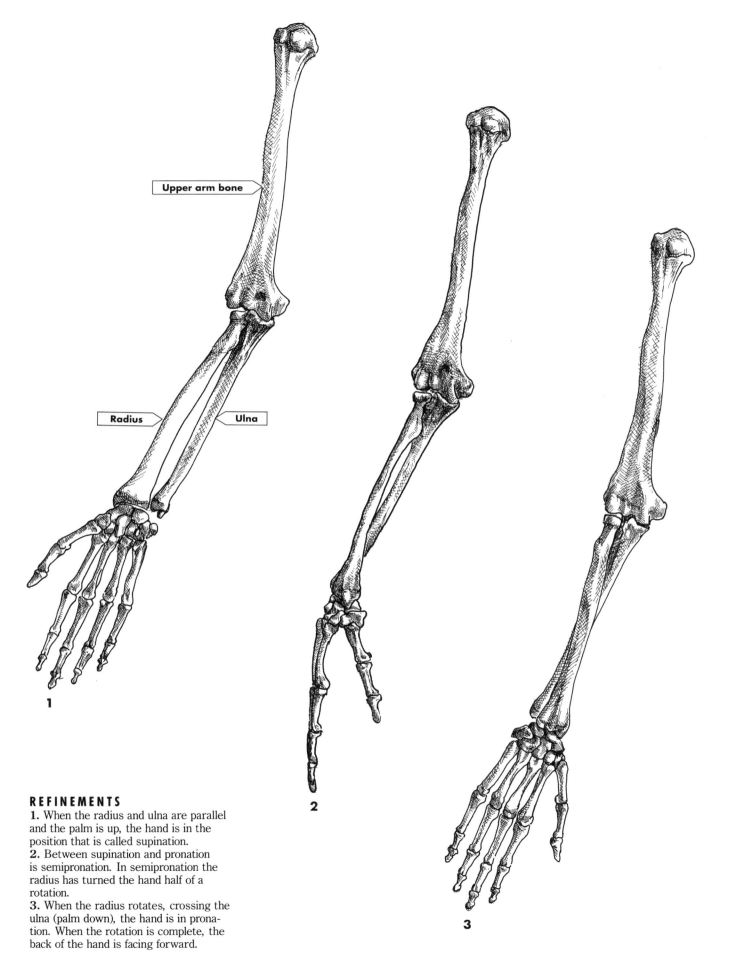

Upper arm bone

Radius **Ulna**

1

2

3

REFINEMENTS

1. When the radius and ulna are parallel
and the palm is up, the hand is in the
position that is called supination.
2. Between supination and pronation
is semipronation. In semipronation the
radius has turned the hand half of a
rotation.
3. When the radius rotates, crossing the
ulna (palm down), the hand is in prona-
tion. When the rotation is complete, the
back of the hand is facing forward.

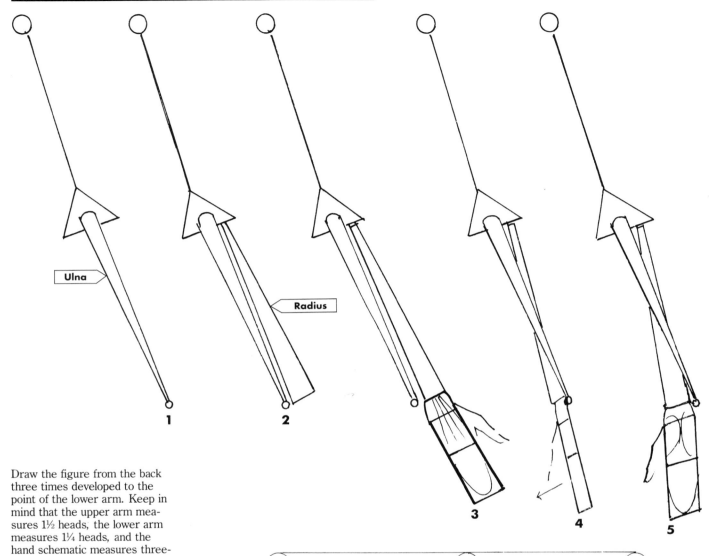

1 **2** **3** **4** **5**

Draw the figure from the back three times developed to the point of the lower arm. Keep in mind that the upper arm measures 1½ heads, the lower arm measures 1¼ heads, and the hand schematic measures three-quarters of a head.

1. Begin with the ulna. It ends in a bump (styloid process). Place it directly in the center of the triangle at the bottom of the upper arm bone. Draw the ulna angling out slightly. At the back, the ulna extends above the bottom line of the upper arm bone to form the elbow.

2. Place the radius on the outside.

3. The hand attaches to the radius. Draw the hand schematic as an oblong box divided in half horizontally. The bottom half representing the fingers should be drawn as a shallow box.

4. Draw the hands turned to show their narrow side. The radius is half rotated.

5. Draw the back of the hand facing forward and the palm facing back. The rotation is complete.

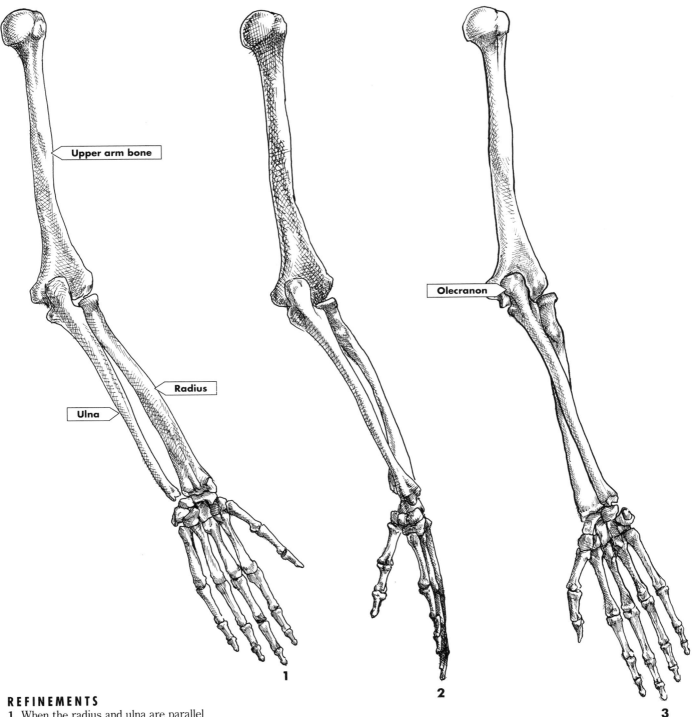

Upper arm bone

Radius

Ulna

Olecranon

1

2

3

REFINEMENTS

1. When the radius and ulna are parallel and the palm is up, the hand is in the position that is called supination.

2. Between supination and pronation is semipronation. In semipronation the radius has turned the hand half of a rotation.

3. When the radius rotates, crossing the ulna (palm down), the hand is in pronation. When the rotation is complete, the back of the hand is facing forward.

At the top of the ulna is a knob (olecranon). This is the elbow. At the bottom of the ulna is a bump (styloid process). Both are highly visible landmarks on the fleshed-out figure.

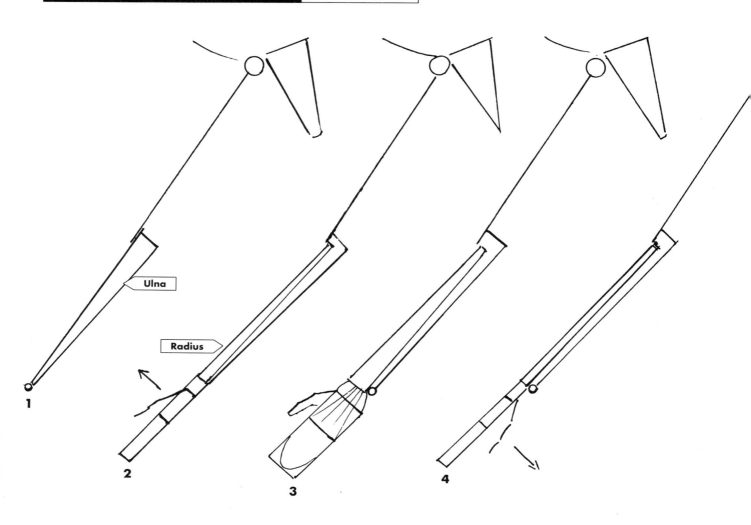

Ulna

Radius

1

2

3

4

Draw the figure from the outside three times developed to the point of the lower arm.

Keep in mind that the upper arm measures 1½ heads, the lower arm measures 1¼ heads, and the hand schematic measures three-quarters of a head long.

1. Draw the ulna, beginning with the elbow.

2. Place the radius, narrow side out, on the outside of the lower arm and attach the hand. Draw the hand as an oblong box and divide it in half.

3. You are now drawing the broad, flat side of the hand. With the radius in half rotation, draw the radius narrow at the top and broad at the bottom. Draw the broad view of the hand with the thumb up. This is the back (dorsal) view of the hand. Draw the radius and hand schematic in a half rotation.

4. When the rotation is complete, the palm of the hand is facing down or back. Draw the narrow side of the radius. Draw the narrow side of the hand schematic, palm down and thumb in.

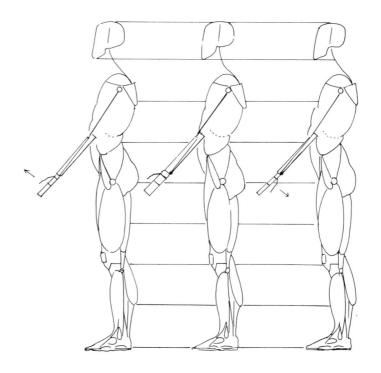

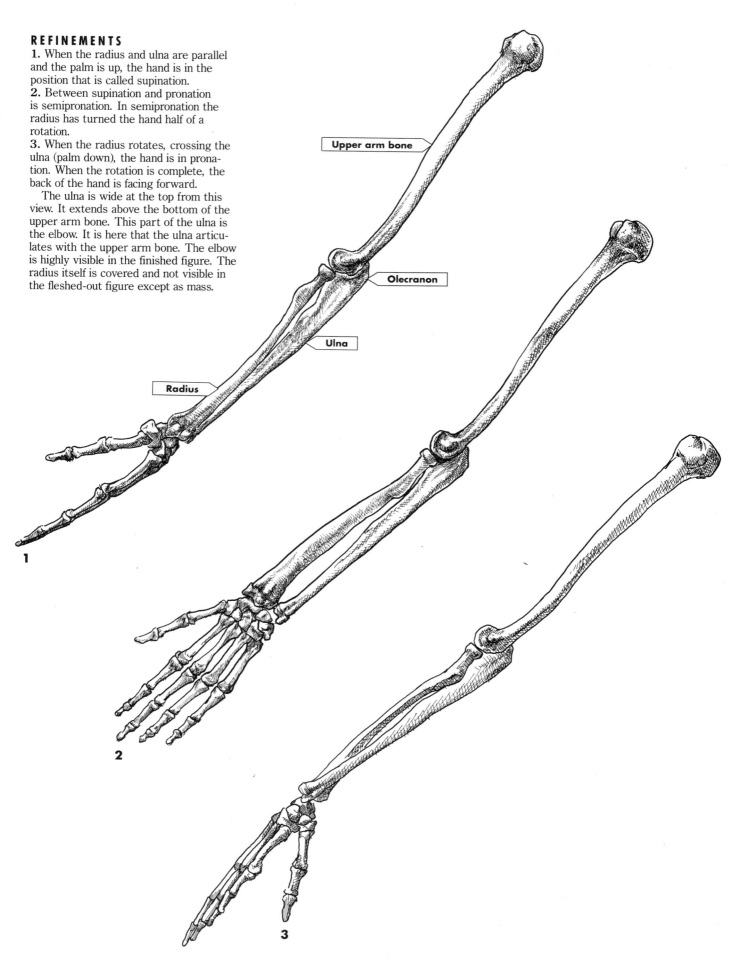

REFINEMENTS

1. When the radius and ulna are parallel and the palm is up, the hand is in the position that is called supination.

2. Between supination and pronation is semipronation. In semipronation the radius has turned the hand half of a rotation.

3. When the radius rotates, crossing the ulna (palm down), the hand is in pronation. When the rotation is complete, the back of the hand is facing forward.

The ulna is wide at the top from this view. It extends above the bottom of the upper arm bone. This part of the ulna is the elbow. It is here that the ulna articulates with the upper arm bone. The elbow is highly visible in the finished figure. The radius itself is covered and not visible in the fleshed-out figure except as mass.

Upper arm bone

Olecranon

Ulna

Radius

1

2

3

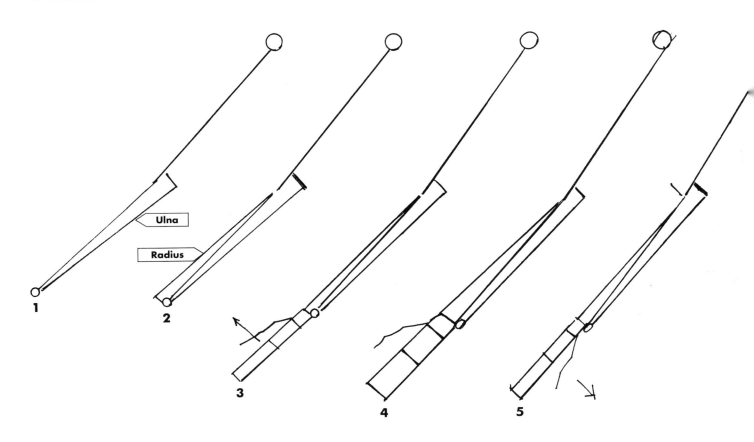

Ulna

Radius

1

2

3

4

5

Draw a figure from the inside three times developed to the point of the lower arm.

Keep in mind that the upper arm measures 1½ heads, the lower arm measures 1¼ heads, and the hand schematic measures three-quarters of a head.

1. Begin with the ulna at the elbow.

2. Draw the radius on the outside of the lower arm.

3. The radius and hand are narrow from this view. Attach the hand to the radius, palm up and thumb out. Draw the hand as an oblong box and divide it in half.

4. You are now drawing the broad, flat side of the hand. With the arm in half rotation, draw the radius narrow at the top and broad at the bottom. Draw the broad view of the hand with the thumb up. This is the palm-side view of the hand. Draw the hand at half rotation.

5. When the rotation is complete, the palm of the hand is facing down or back. Draw the narrow side of the radius. Draw the narrow side of the hand schematic, palm down and thumb in. Draw the hand with the palm down.

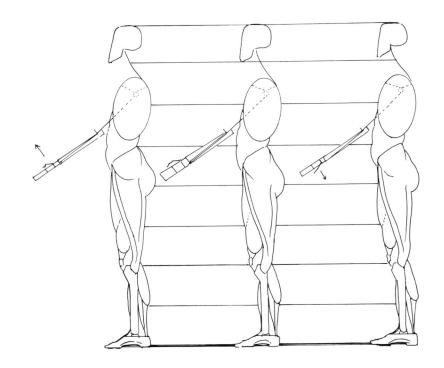

REFINEMENTS

1. When the radius and ulna are parallel and the palm is up, the hand is in the position that is called supination.

2. Between supination and pronation is semipronation. In semipronation the radius has turned the hand half of a rotation.

3. When the radius rotates, crossing the ulna (palm down), the hand is in pronation. When the rotation is complete, the back of the hand is facing forward.

Except for the elbow, the bones of the lower arm do not appear on the surface from this view. The rotating action of the radius affects the muscles of the lower arm and determines the look and character of it.

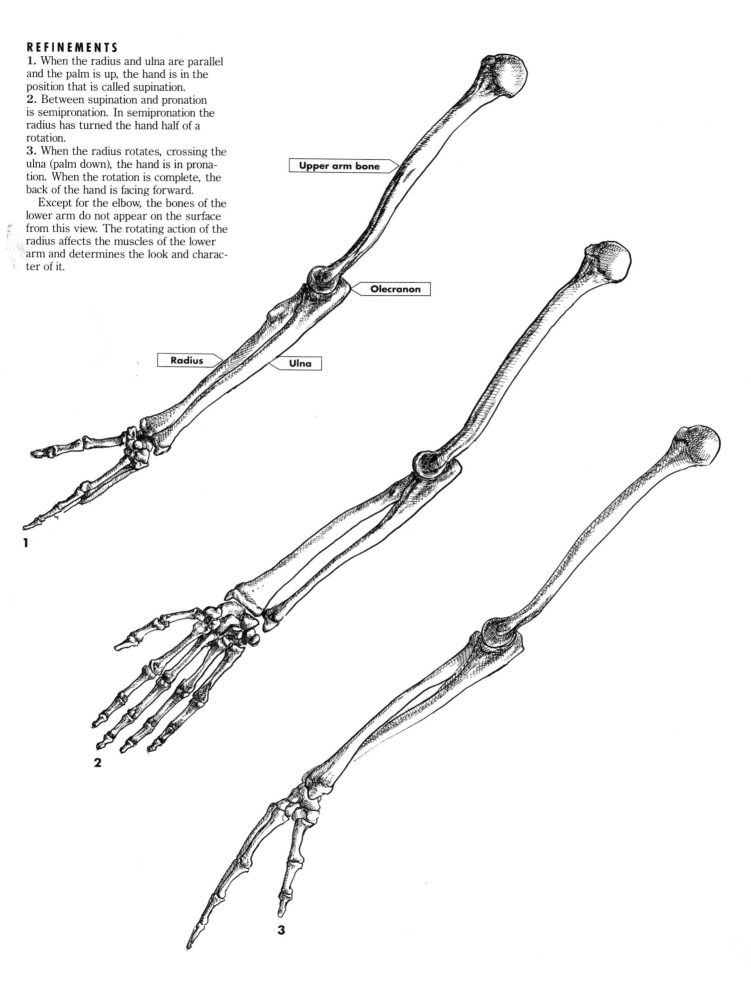

Upper arm bone

Olecranon

Radius

Ulna

1

2

3

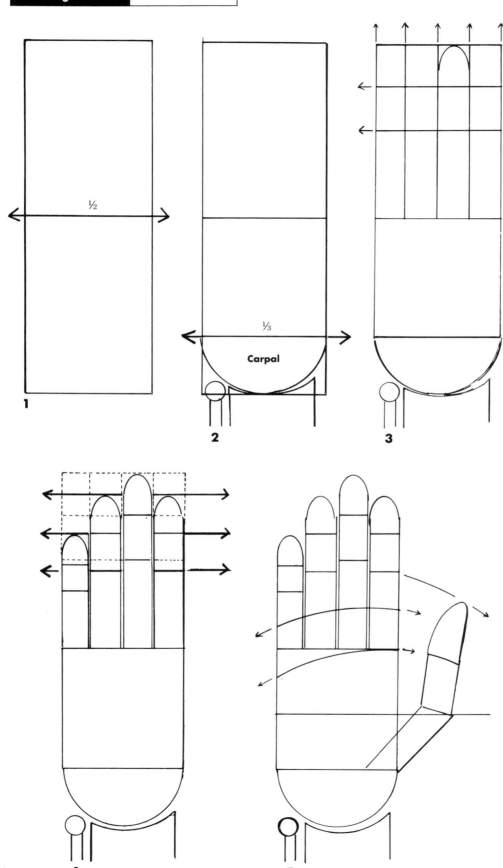

Now you will be drawing the right hand only. Work on a large scale to apply the following information.

1. Begin with a rectangular box three-quarters of a head long. Divide the length in half. The width measures about a third of a head.

2. Measure a third off the bottom of the lower half to represent the carpal area. Above is the metacarpus. Draw the carpal area as a single shape. Curve off the carpal area. It articulates with the radius here. The top line of the carpus is where the thumb begins.

3. Divide the upper half of the rectangle into four parts vertically. Split the upper half horizontally. Split this upper division.

4. The fingers, except for the thumb, have three phalanges of differing lengths. The middle finger is the longest. The index and ring finger reach the middle of the last phalanx of the middle finger. Divide the index finger and the ring finger in half. Divide their upper halves in half. The pinky reaches the line of the beginning of the third phalanx of the ring finger. Divide the pinky in half. Divide the upper half of the pinky in half.

5. The thumb begins at the top of the carpal area. The first unit of the thumb is the metacarpal of the thumb. It measures half the length of the metacarpal area. The second unit of the thumb measures to just below the line at the top of the metacarpal area. The third unit of the thumb measures to just below the line of the top of the first phalanx of the index finger. Divide the first phalanx of the fingers in half.

Note that there are skin and fat pads covering the bottom portion of the fingers, giving them the appearance of being divided into three equal parts on the palm side.

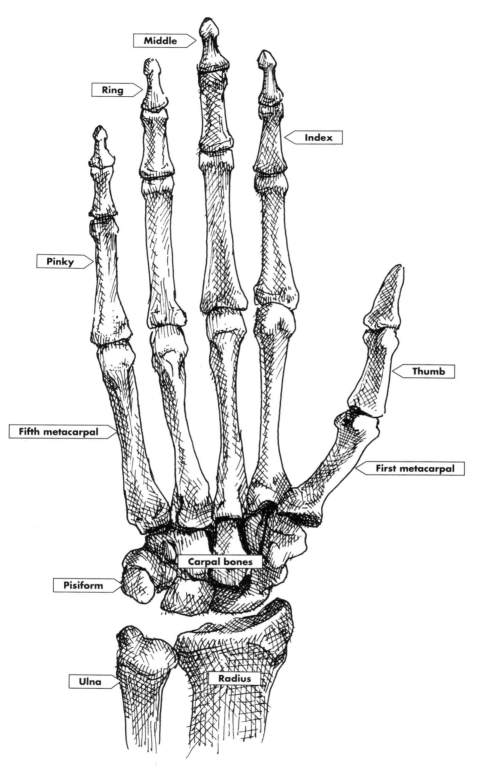

Middle

Ring

Index

Pinky

Thumb

Fifth metacarpal

First metacarpal

Carpal bones

Pisiform

Ulna

Radius

There is, of course, some variation in size relationships of the fingers. The pinky is sometimes smaller, and the ring finger is sometimes longer, and so on. The carpal bones do not contribute to the external form. A pea-shaped carpal bone (pisiform), however, can be seen in the fleshed-out figure. It is slightly out of line with the other carpal bones, and it is also important as a point of origin and insertion for two muscles of the lower arm and hand.

1

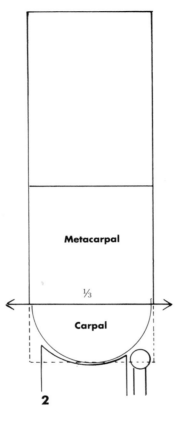

Metacarpal

⅓

Carpal

2

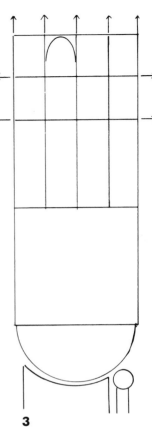

3

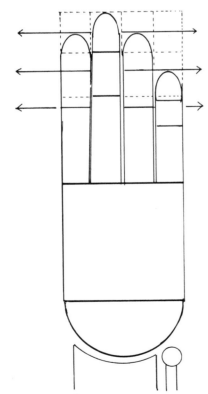

4

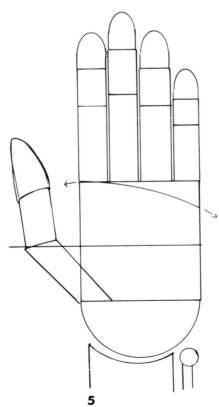

5

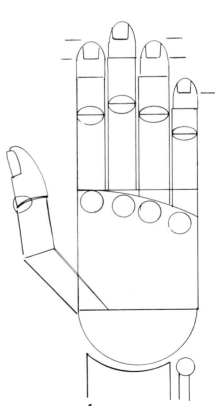

6

1. Begin with a rectangular box three-quarters of a head long. Divide the length in half. The width measures about a third of a hand length.

2. Measure a third off the bottom of the lower half to represent the carpal area. Draw the carpal area as a single shape. Curve the carpal area, which articulates with the radius here. The top line of the carpus is where the thumb begins.

3. Divide the upper half of the rectangle into four parts vertically. Divide the upper half horizontally. Split this upper division.

4. The fingers, except the thumb, have three phalanges of differing lengths. The index finger and ring finger reach the middle of the last phalanx of the middle finger. Divide the index and the ring finger in half. Divide their upper halves. The pinky reaches the line of the beginning of the third phalanx of the ring finger. Divide the pinky in half. Divide the upper half of the pinky in half.

5. The thumb begins at the top of the carpal area. The first unit of the thumb is the metacarpal of the thumb. It measures half the length of the metacarpal area. The second unit of the thumb measures to just below the line at the top of the metacarpal area. The third unit of the thumb measures just below the top of the first phalanx of the index finger.

6. Draw the knuckles, which are the heads of the metacarpals, as circles. Measure half the length of the third phalanx. Draw the nail sitting in that division. There is a slight radiation to the outside borders of the nails. The radiation is from the center of the top of the first phalanx.

REFINEMENTS

7. The heads of the metacarpus are the knuckles. They are clearly visible in the fleshed-out figure. The metacarpus of the thumb is ball-like and highly visible. It contributes to the character of the thumb. At the joints of the first and second phalanges of the fingers there is a mound. This mound is particularly evident when the fingers are bent.

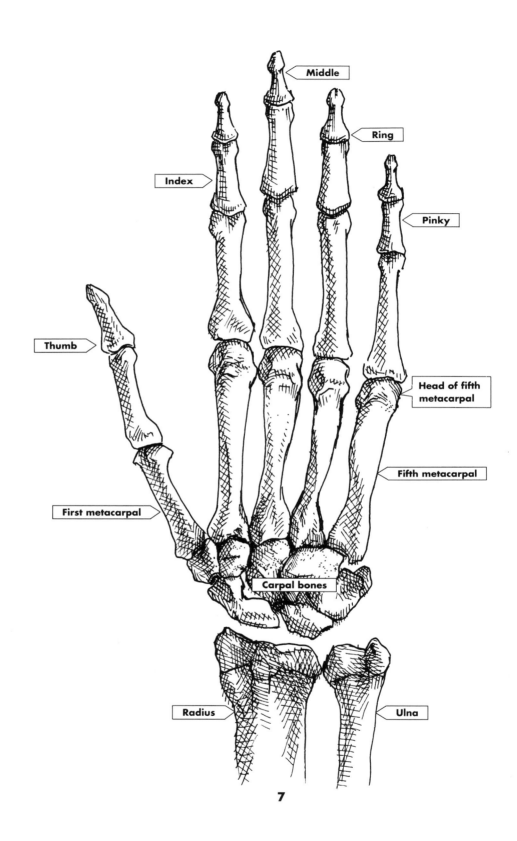

Middle

Ring

Index

Pinky

Thumb

Head of fifth metacarpal

First metacarpal

Fifth metacarpal

Carpal bones

Radius

Ulna

7

13 THE MUSCLES OF THE LOWER ARM AND HAND

The three basic muscle groups in the lower arm are the flexors, the extensors, and what we will call the supinator group, which includes two extensor muscles. They can each be reduced to an ovoid.

When the hand is facing palm down, the supinator group draws the radius back, uncrossing the ulna. The supinator ovoid originates on the outside of the upper arm bone a third of the way up from the bottom, between the biceps and the triceps, and inserts at the bottom of the radius. It is visible from its origin to halfway down the lower arm. The supinator ovoid, which consists of the supinator longus, extensor carpi, and radialis longus and brevis, always follows the direction of the thumb.

The flexors consist of four surface muscles that can be reduced to a single ovoid. The flexors of the lower arm flex the hand and fingers. They originate at the inside of the triangle at the bottom of the upper arm bone and insert at the hand, carpus, palm, and fingers. The flexors follow the direction of the palm.

The two muscles in the extensor ovoid are the extensor digitorum communis and the extensor carpi ulnaris. The extensors of the lower arm straighten the hand and fingers. They originate on the outside of the back of the triangle at the bottom of the lower arm bone and insert on the back of the hand and fingers. The extensors follow the direction of the back of the hand. The tendons of the extensors fan out at the wrist and attach at the knuckles and continue to the fingers.

The figures opposite show the muscles of the lower arm and hand in their relationship to the fleshed-out figure.

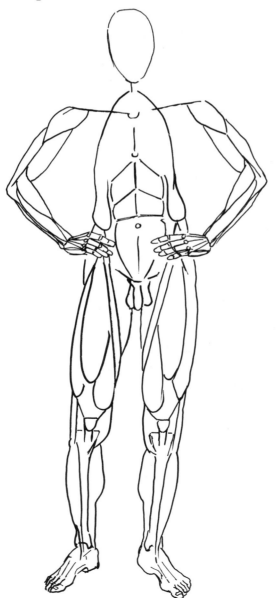
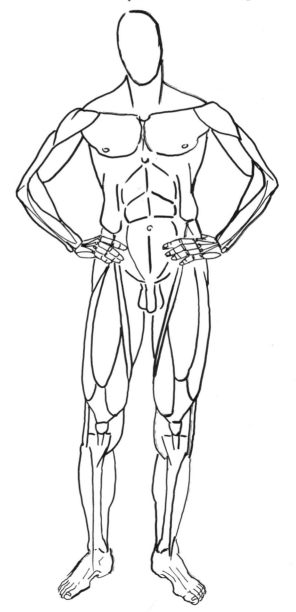

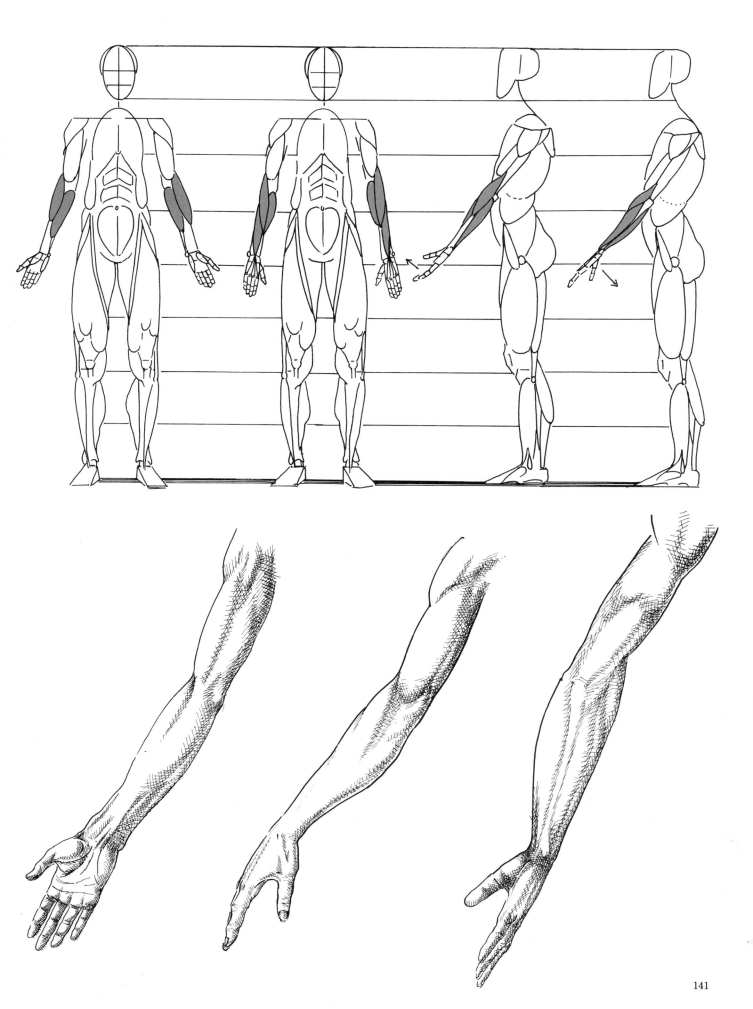

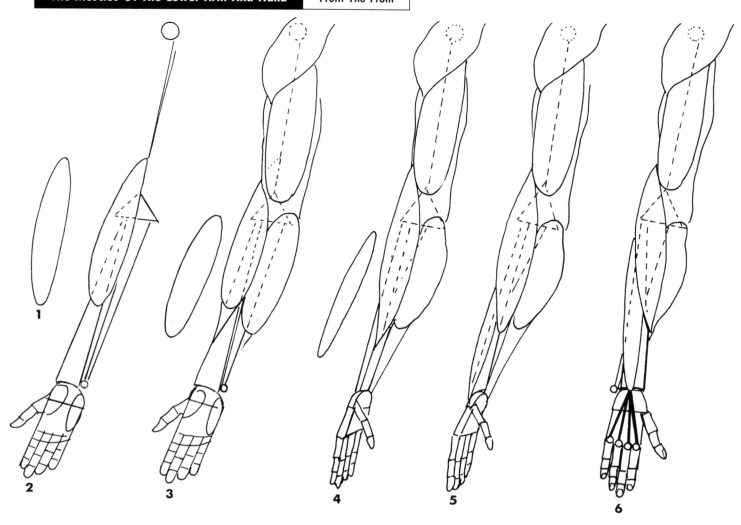

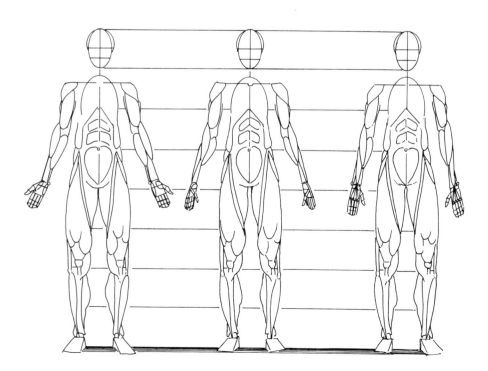

1. Draw the supinator ovoid.

2. Place the supinator ovoid on the outside of the arm a third of the way up from the bottom of the upper arm bone. The bottom of the supinator ovoid should reach halfway down the length of the lower arm. Draw the flexor ovoid.

3. Place the flexor ovoid on the front of the inside of the triangle at the bottom of the upper arm. The bottom of the flexor ovoid should reach about two-thirds of the way down the lower arm. The flexor group attaches to the palm side of the hand.

4. Draw the supinator ovoid following the direction of the thumb. It is pulled inward with the rotation of the radius. Draw the flexor ovoid narrowing slightly toward the

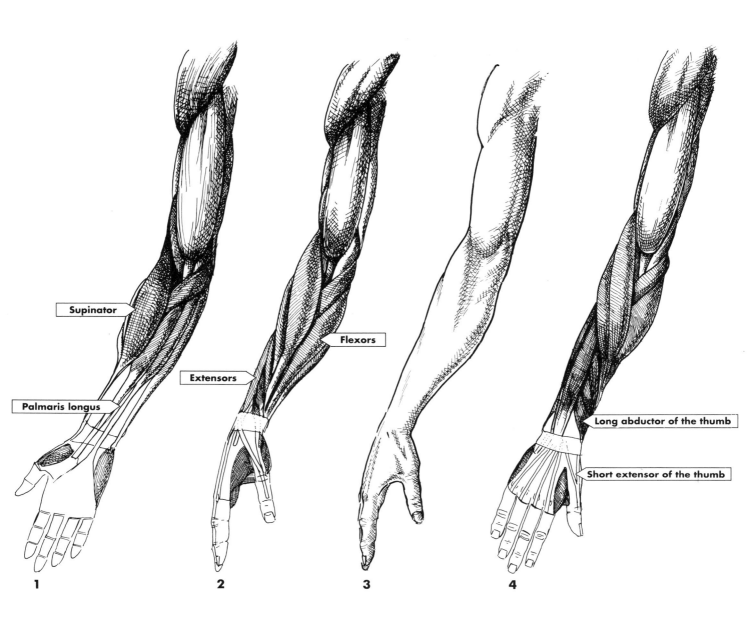

Supinator

Palmaris longus

Extensors

Flexors

Long abductor of the thumb

Short extensor of the thumb

1 2 3 4

bottom as it follows the direction of the palm. Draw the extensor ovoid.

5. Draw the extensor ovoid pulling out from behind the supinator. It attaches to the back of the hand, widening the wrist.

6. Draw the extensor ovoid coming out from behind the supinator. Draw the extensor tendons fanning out at the wrist and attaching at the knuckles of the fingers. Draw the supinator ovoid pulled over the lower arm. It is attached to the narrow side of the radius and is brought completely over when the radius rotates. Only the upper portion of the flexor group is visible as a result of the rotation of the radius. Draw the flexor ovoid, showing it a little squeezed by rotation, causing some bulging.

REFINEMENTS

1. The tendon of the palm (palmaris longus) is highly visible at the wrist. The other tendons of the flexors are obscured by a wristband.

2. In rotation, you might see a slight pulling in at the top of the flexor ovoid.

3. In the thin and the muscularly developed you can often observe muscle divisions within the flexors and the extensors and the supinator groups, but as a rule you do not.

4. The thumb side of the lower arm is broadened by muscles that are not seen as distinct forms (long abductor of the thumb; short extensor of the thumb).

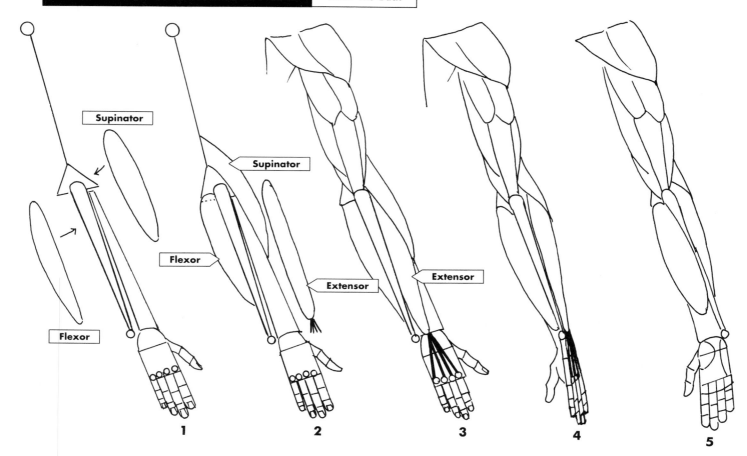

Supinator

Supinator

Flexor

Flexor

Extensor

Extensor

Flexor

1

2

3

4

5

1. Draw the supinator ovoid.

2. Draw the flexor ovoid on the inside of the upper arm triangle. Attach it along the ulna, ending at the carpus. Draw the extensor ovoid.

3. Add the extensor ovoid. It originates on the outside of the upper arm triangle and ends at the top of the hand, where the extensor tendons fan out to the knuckles. Add the supinator ovoid on the outside a third of the way up from the bottom of the upper arm bone. It covers the top of the extensor ovoid and reaches a little less than halfway down the length of the lower arm.

4. The supinator is pulled inward in half rotation. Draw the shape tighter and higher on the upper arm. Draw a fuller flexor ovoid on the inside of the upper arm triangle. Attach it along the ulna, ending at the carpus. The flexor ovoid always follows the direction of the palm. Show the extensors being drawn around to the back of the hand. The extensor ovoid always follows the direction of the back of the hand.

5. Add the supinator, which is stretched further in full rotation and should be high on the lower arm. Draw the flexor ovoid. Give it a full look. Draw the extensor as a smaller and tighter shape. The rotation of the radius is thus complete.

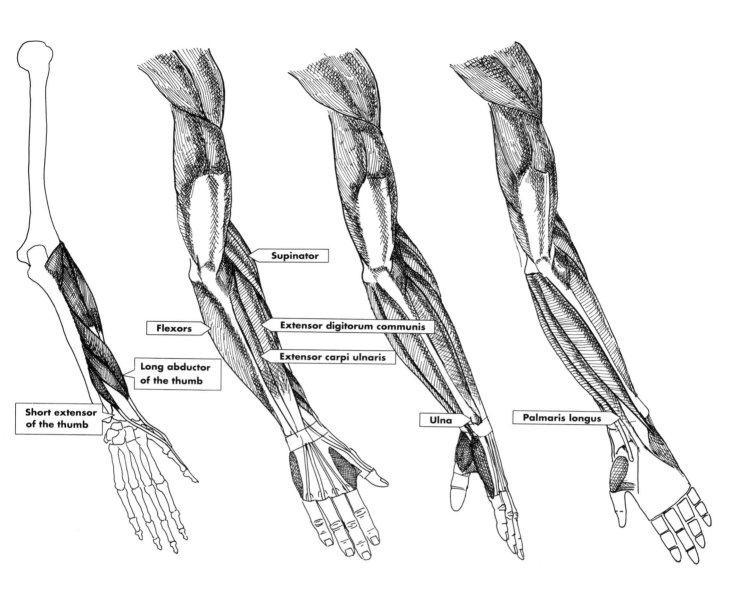

Short extensor
of the thumb

Long abductor
of the thumb

Flexors

Supinator

Extensor digitorum communis

Extensor carpi ulnaris

Ulna

Palmaris longus

REFINEMENTS

1. The long abductor and short extensor of the thumb are largely covered by the extensor group. They act to slightly broaden the lower arm area just above the wrist, and their tendons are highly visible and significant to the hand.

2. The anconeus, an extensor of the lower arm, is sometimes visible. The distinguishing line between the two parts of the extensor group (digitorum communis and carpi ulnaris) is most apparent when the hand is fully extended.

3. A sliver of ulna is also visible. It appears as an indentation.

4. The styloid process of the ulna is always visible. The tendon of the palm (palmaris longus) is highly visible at the wrist.

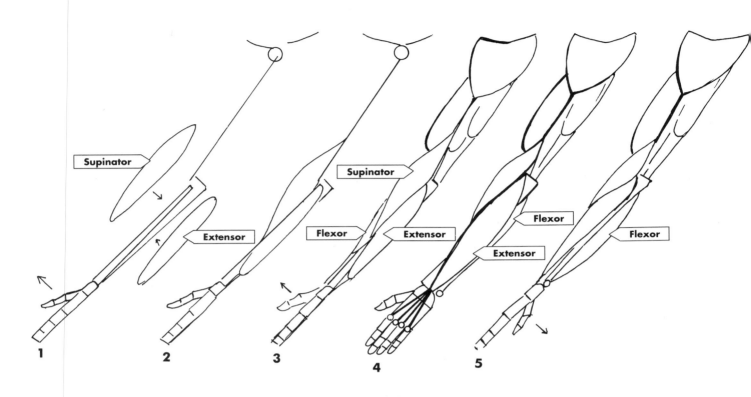

Supinator

Supinator

Flexor

Extensor

Extensor

Flexor

Extensor

Flexor

1 **2** **3** **4** **5**

1. Draw the supinator and extensor ovoids.

2. Draw the supinator ovoid on the outside of the upper arm bone. The ovoid originates a third of the way up the bone, and it reaches halfway down the radius. Add the extensor ovoid below the supinator ovoid. It originates on the outside of the upper arm triangle and inserts at the back of the hand.

3. Draw the flexor ovoid emerging from behind the supinator ovoid.

4. Draw the supinator ovoid following the direction of the thumb in half rotation. Draw the small visible portion of the flexor ovoid attached to and hanging a little below the ulna. Draw the extensor ovoid a little wider.

5. Draw the supinator stretched over the lower arm in full rotation. Draw the flexor ovoid fuller. Draw the extensor ovoid pulled further over the lower arm following the direction of the back of the hand. The rotation is now complete.

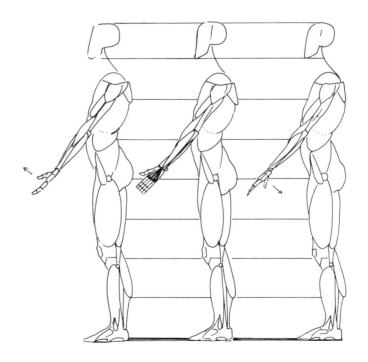

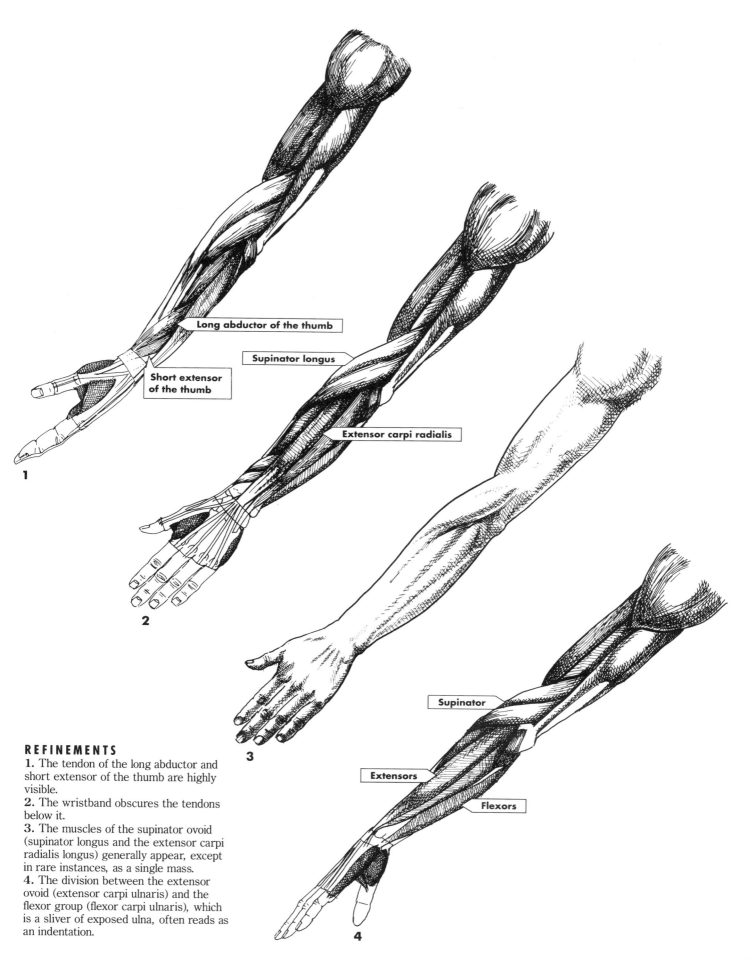

Long abductor of the thumb

Supinator longus

Short extensor of the thumb

Extensor carpi radialis

1

2

3

Supinator

Extensors

Flexors

4

REFINEMENTS

1. The tendon of the long abductor and short extensor of the thumb are highly visible.

2. The wristband obscures the tendons below it.

3. The muscles of the supinator ovoid (supinator longus and the extensor carpi radialis longus) generally appear, except in rare instances, as a single mass.

4. The division between the extensor ovoid (extensor carpi ulnaris) and the flexor group (flexor carpi ulnaris), which is a sliver of exposed ulna, often reads as an indentation.

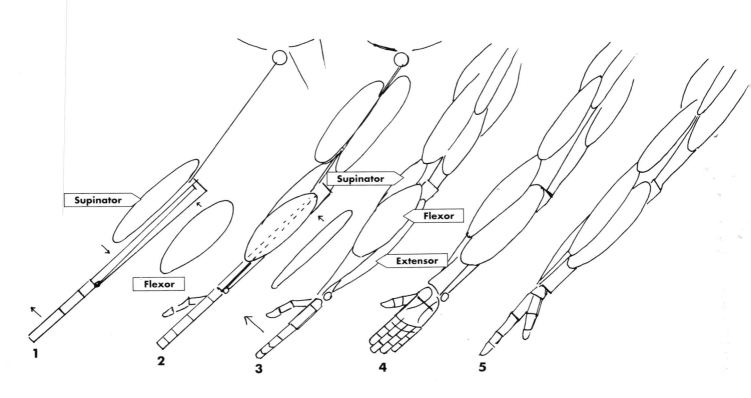

1 **2** **3** **4** **5**

1. Draw the supinator ovoid. Draw the flexor ovoid.

2. Place the supinator ovoid outside the elbow a third of the way up from the bottom of the upper arm bone. It should reach halfway down the radius. Draw it coming from behind the biceps. Place the flexor ovoid on the inside of the front of the arm. It originates at the inside of the upper arm triangle and covers about two-thirds of the lower arm. Draw the extensor ovoid.

3. Place the extensor ovoid on the lower arm. It originates on the outside of the upper arm triangle and inserts at the back of the hand.

4. In half rotation, draw the supinator ovoid connected to the narrow side of the radius. It follows the direction of the thumb. Draw the flexor ovoid following the direction of the palm. The extensors are not visible from this view.

5. Draw the supinator ovoid stretched over the lower arm in full rotation. Draw the flexor ovoid on the underside of the lower arm. Draw the extensor ovoid coming from behind the supinator and attaching to the back of the hand.

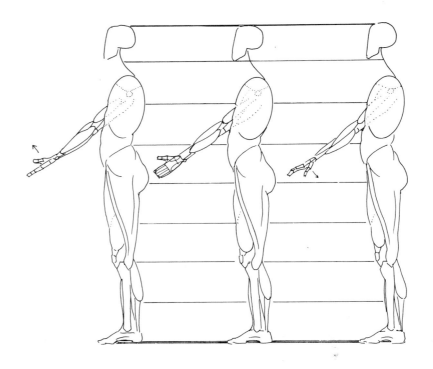

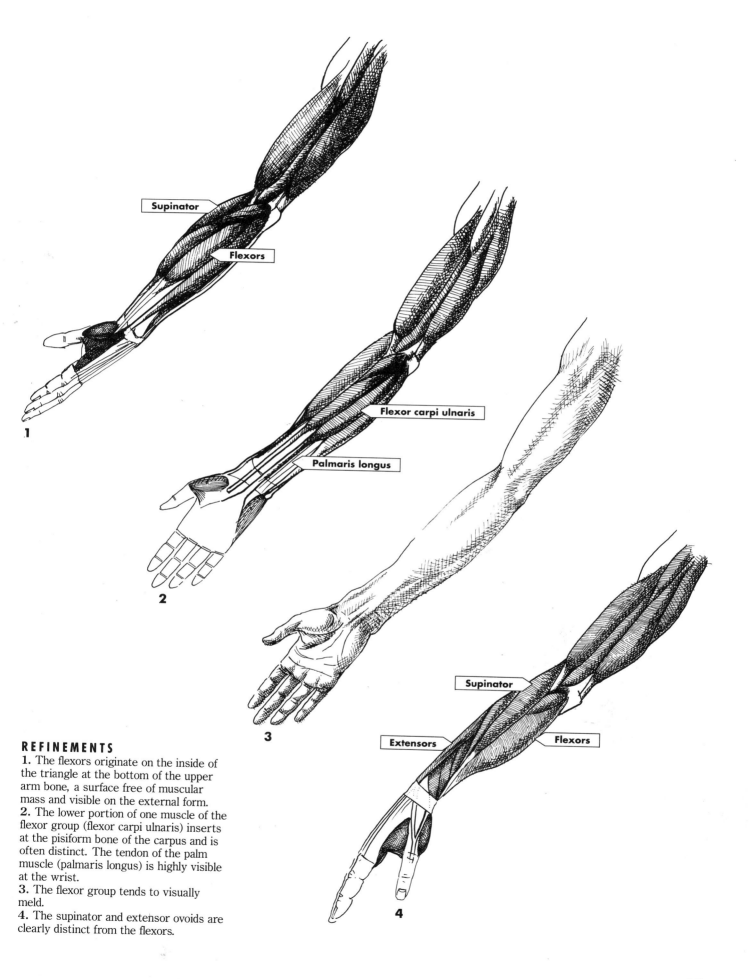

Supinator

Flexors

1

Flexor carpi ulnaris

Palmaris longus

2

3

Supinator

Extensors

Flexors

4

REFINEMENTS

1. The flexors originate on the inside of the triangle at the bottom of the upper arm bone, a surface free of muscular mass and visible on the external form.

2. The lower portion of one muscle of the flexor group (flexor carpi ulnaris) inserts at the pisiform bone of the carpus and is often distinct. The tendon of the palm muscle (palmaris longus) is highly visible at the wrist.

3. The flexor group tends to visually meld.

4. The supinator and extensor ovoids are clearly distinct from the flexors.

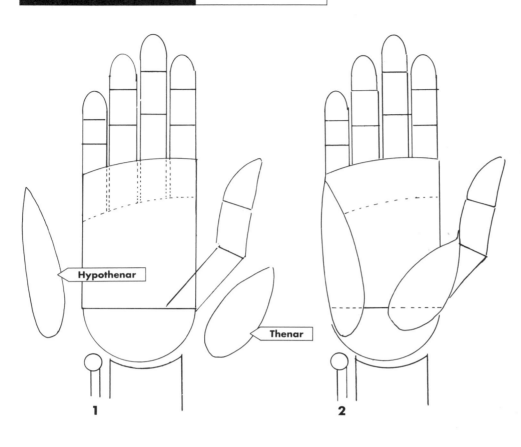

1

2

In drawing the muscles of the hand, work on a large scale. The right hand is our example. Traditionally the hand is studied in the direction it falls with fingers pointing down. In this book the hand is placed with the fingers pointing up so that you can use your own hand more easily for comparison.

1. Begin with the hand schematic. There are three major surface muscle groups on the palm. They are the thenar, the hypothenar, and the adductor of the thumb. The thenar and hypothenar are both teardrop-shaped ovoids.

2. Place the thenar ovoid on the metacarpal of the thumb. Place the hypothenar ovoid on the pinky side of the hand.

3. Draw the adductor to the thumb as a triangular shape. It attaches to the first phalanx of the thumb. Draw the curved thenar line (life line) from about halfway up the hand down to the thenar ovoid. Draw the tendon of the palm muscle in the middle of the wrist.

4. Add the lines of the hand.

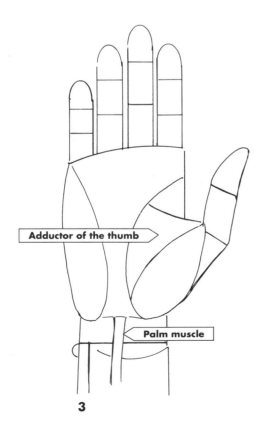

3

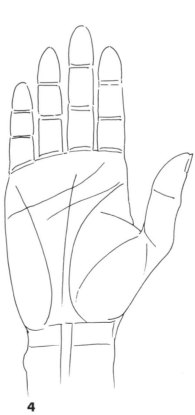

4

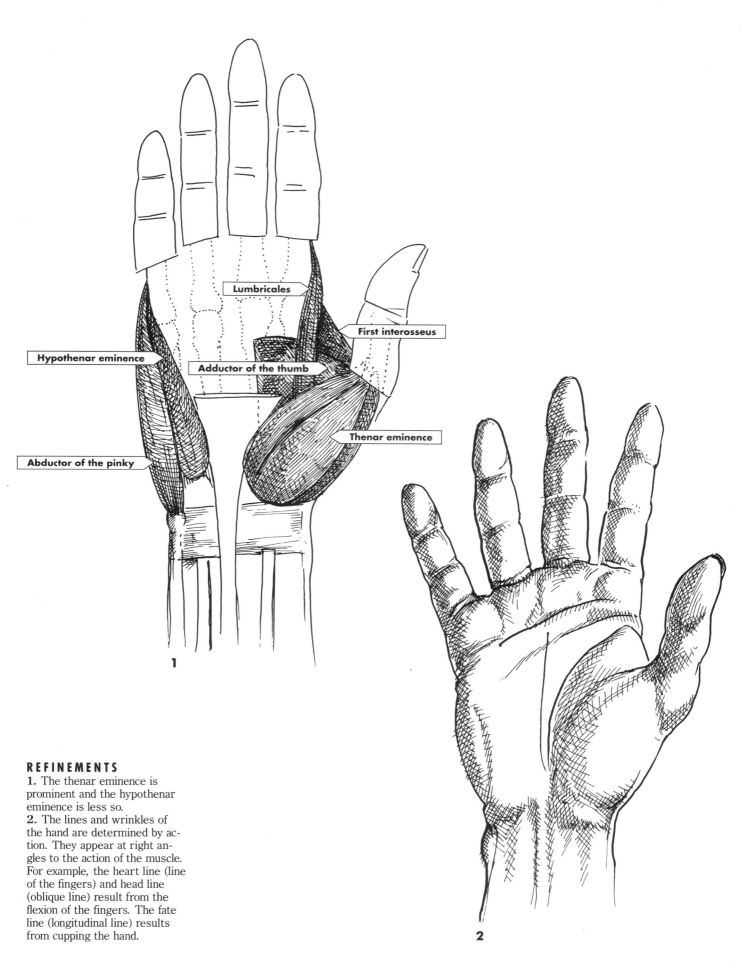

Lumbricales

First interosseus

Hypothenar eminence

Adductor of the thumb

Abductor of the pinky

Thenar eminence

1

REFINEMENTS

1. The thenar eminence is
prominent and the hypothenar
eminence is less so.

2. The lines and wrinkles of
the hand are determined by ac-
tion. They appear at right an-
gles to the action of the muscle.
For example, the heart line (line
of the fingers) and head line
(oblique line) result from the
flexion of the fingers. The fate
line (longitudinal line) results
from cupping the hand.

2

1. The interosseus are muscles that connect the metacarpal bones. The visually significant one is the teardrop-shaped interosseus of the first metacarpal. The abductor of the pinky is another teardrop shape.

2. Place the teardrop-shaped interosseus on the first metacarpal of the thumb. Attach it to the side of the hand schematic (second metacarpal) and base of the first phalanx of the index finger. Place the teardrop shape of the abductor of the pinky on the hand schematic (fifth metacarpal).

3. The upper portion of the triangular adductor of the thumb is visible. Place it on the first phalanx of the thumb. Draw the extensor tendons fanning out in the middle at the bottom of the hand schematic.

4. From the thumb side, the snuffbox (tabatière) is a triangular hollow found between the tendons of the extensors of the thumb. Draw the tendons.

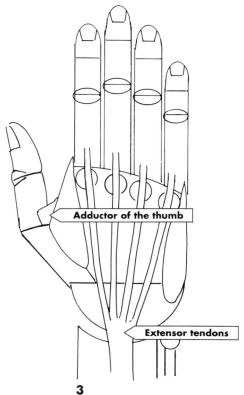

First interosseus

Abductor of the pinky

1

2

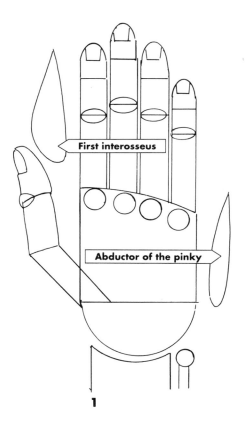

Adductor of the thumb

Extensor tendons

3

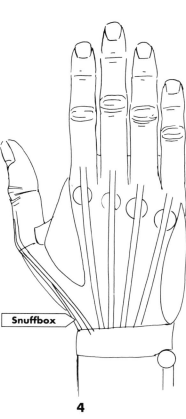

Snuffbox

4

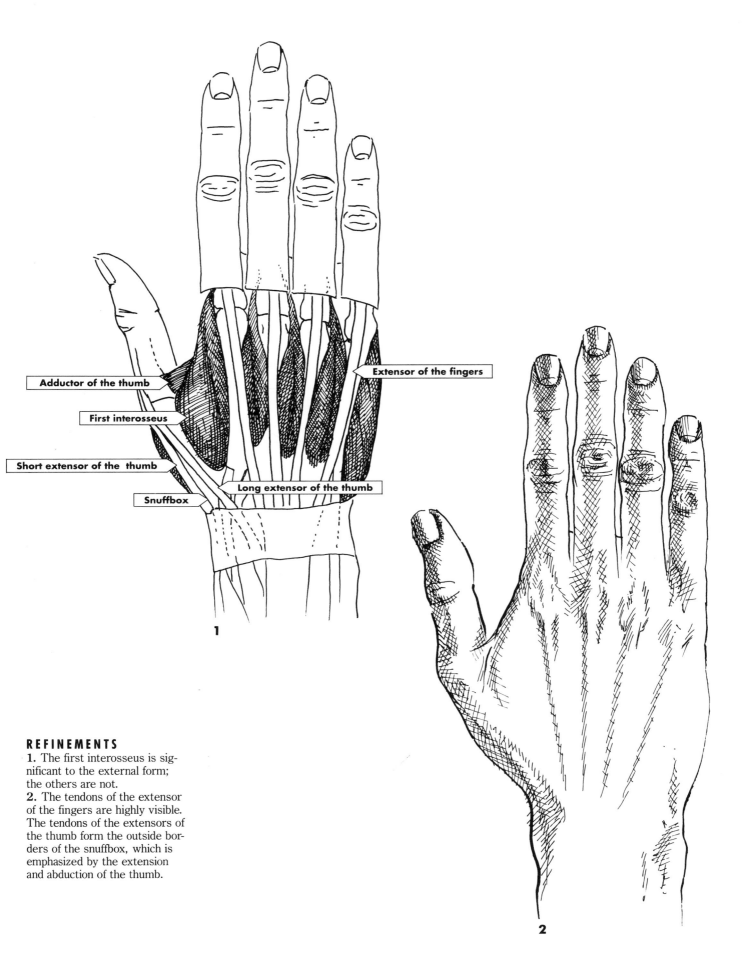

Adductor of the thumb

First interosseus

Short extensor of the thumb

Snuffbox

Long extensor of the thumb

Extensor of the fingers

1

REFINEMENTS

1. The first interosseus is sig-
nificant to the external form;
the others are not.

2. The tendons of the extensor
of the fingers are highly visible.
The tendons of the extensors of
the thumb form the outside bor-
ders of the snuffbox, which is
emphasized by the extension
and abduction of the thumb.

2

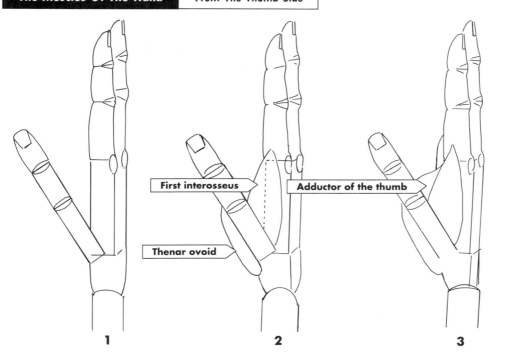

First interosseus

Thenar ovoid

Adductor of the thumb

Fat pads

Snuffbox

1 **2** **3** **4**

1. Begin with the hand schematic. The width of each finger is a quarter of the width of the hand.

2. Draw the teardrop shape of the first interosseus on the first metacarpal, attaching to the second metacarpal and at the base of the first phalanx (unit) of the index finger. The bottom portion of the thenar eminence ovoid is visible from this view. Draw it at the bottom of the first unit of the thumb.

3. Draw the top of the triangular adductor to the thumb at the base of the first unit of the thumb. Attach it to the metacarpus (it inserts at the third metacarpal).

4. Draw fat pads halfway up the first unit. The snuffbox is a triangular hollow found between two tendons of the extensors of the thumb. Draw the tendons of the extensors of the thumb converging at the base of the first unit of the thumb to form the snuffbox. Draw the extensor tendons to the fingers from the wristband to and over the knuckles.

REFINEMENTS

5. The teardrop-shaped first interosseus and the thenar eminence are highly visible.

6. The snuffbox (tabatière) is apparent when the thumb is adducted.

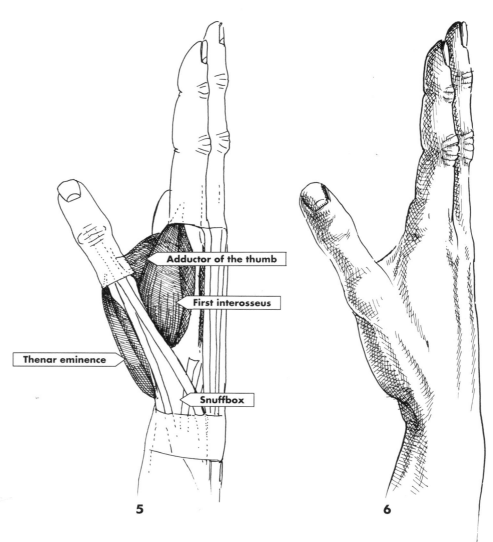

Adductor of the thumb

First interosseus

Thenar eminence

Snuffbox

5 **6**

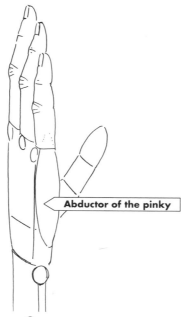

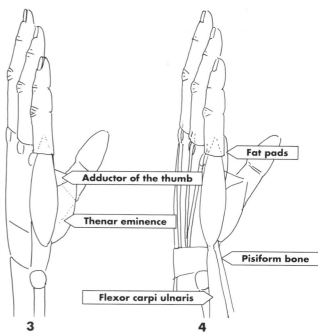

Abductor of the pinky

Adductor of the thumb

Fat pads

Thenar eminence

Flexor carpi ulnaris

Pisiform bone

1 **2** **3** **4**

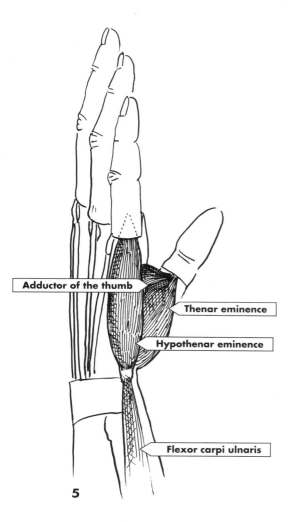

Adductor of the thumb

Thenar eminence

Hypothenar eminence

Flexor carpi ulnaris

5

6

1. Begin with the hand schematic. The depth is a quarter of the width of the hand.

2. Place the ovoid for the abductor of the pinky on the hand schematic.

3. Place the thenar ovoid on the metacarpal of the thumb, inserting at the first phalanx of the thumb. Draw the triangular shape of the adductor of the thumb. Attach it to the first phalanx of the thumb.

4. Draw one of the flexor muscles (flexor carpi ulnaris) attaching at the pisiform bone. Draw the line of the fat pads extending up half the length of the first phalanx. Draw the tendons of the extensors from the knuckles to and beneath the wristband. Include the tendon of the palm muscle.

REFINEMENTS

5. The heel of the hand is the palm side of the carpal bones. The attachment of a flexor muscle to the pisiform bone is analogous to the Achilles tendon inserting at the heel.

6. The muscles of the hypothenar contribute to the movement of the fifth metacarpal and the pinky. The movement is limited compared to the thumb, and it occupies less space. The fingers are basically straight on the top and rounded by fat pads on the bottom.

14 THE HEAD

Most bones in the skeleton can be reduced to a simplified form or line. The skull is one of the exceptions. It is important to understand the skull not merely as understructure but as a significant contributor to the external form. The eye sockets (orbital cavity), for example, are highly visible in the external form, as are the cheekbone (zygomatic bone), the brow (superciliary crest), the nasal bone, the teeth, and many other points on the skull.

This chapter follows a very measured approach to the construction of the skull. It is wise to begin with precise calculations. When the information and measurements are learned, you should approach the construction of the skull more quickly with indicated lines. Don't get rigid!

There is, of course, great variation in skull shape from individual to individual, but as a rule the skull of a female, relative to the male, is smaller and has slightly smaller features with a less conspicuous brow ridge. The standard described here simply provides a gauge that allows you to determine variations.

With the establishment of the skull, the features and muscles of the head and neck can be applied directly to it. When drawing the skull, neck, and shoulders, work on a large scale.

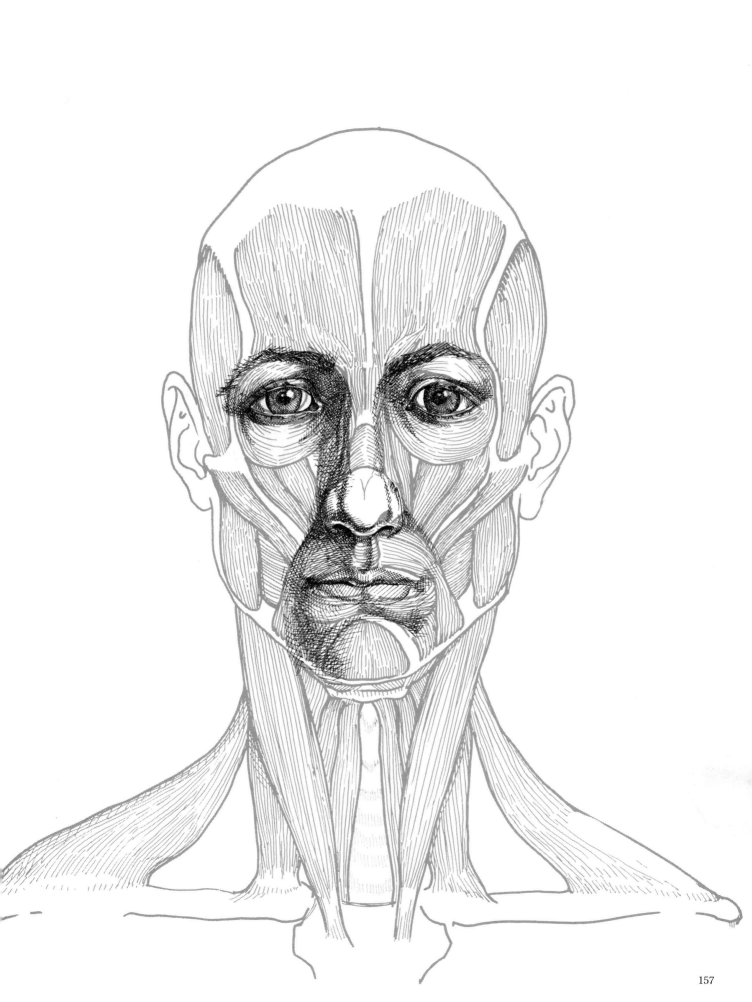

Median line

½

¾

1

2

3

4

5

6

7

8

9

↓ ↓ **10** ↓ ↓

11

⅔

12

13

14

1. Begin with an oval. Establish the median line. Divide the oval horizontally. Divide the lower half of the oval, establishing the three-quarters line.

2. The base of the skull is established by a circle. The bottom of the circle touches the three-quarters line.

3. The side planes are established by straightening the sides of the oval.

4. Divide the area between the half and three-quarters lines vertically into five equal parts. The middle fifth part represents the nose. The base of the skull should measure about equal to one of the five divisions on each side.

5. Divide the third-quarter area in half horizontally. Run a diagonal line to the lower half of this area from the middle (nose) division to represent the cheekbone.

6. The area above the cheekbone represents the area of the eye sockets. Each eye-socket area should be square; therefore, bring the top line up to the point where it is square.

7. Place the eye sockets in the squares. Observe that the eye sockets are upended (as opposed to horizontal).

8. The cheekbone angles up, creating an apex-down triangle. Stop the outside upward line at about the width of the base of the skull.

9. Divide the remaining lower area, the area from the three-quarters line, down into thirds using horizontal lines.

10. Now divide that area vertically into thirds.

11. Define the angle of the jaw by running a diagonal from the two-thirds line to the outside of the middle vertical third.

12. Run an imaginary line down from the middle of the eye socket to the first horizontal third line. This represents the width of the teeth area.

13. The teeth (upper and lower together) are the height of a third of the lower head. Divide that measure in half horizontally to separate the upper and lower teeth. You can adjust for the natural overbite of the teeth later; for now, think of them as equal. The teeth rest on the first horizontal third line. This line is in the middle of the upper teeth, and it divides the lips.

14. The teeth on the front plane (middle section) consist of incisors and canine teeth. The top and bottom reflect one another. The incisors are shovel-shaped. The canines are pointed or rounded. The canines are in the corners of the front plane. On the receding plane are the premolars and molars.

REFINEMENTS

15. This figure shows the refined bones of the skull in the schematic box.

16. There are visible landmarks on the skull. The muscle is thin on the frontal bone, revealing the character of that part of the skull. The brow ridge is particularly evident as form. The eyeball sits high in the eye socket. The lower surface of the socket defines the area beneath the eye. This is referred to as the "bags" under the eyes. These bags sit directly on the line of the bottom of the eye socket. The curved temple line is evident and acts as a corner, creating a plane change. Also apparent is the inward diagonal thrust of the cheekbone.

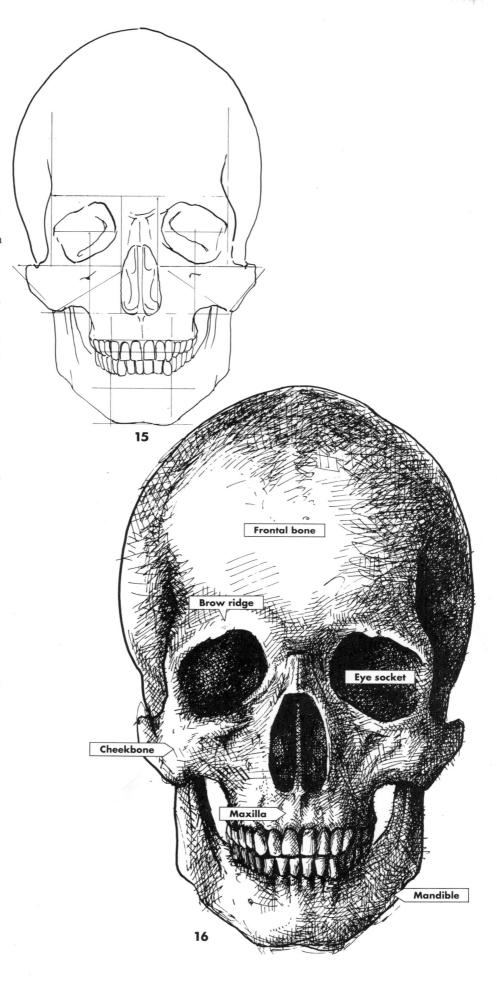

15

16

Frontal bone

Brow ridge

Eye socket

Cheekbone

Maxilla

Mandible

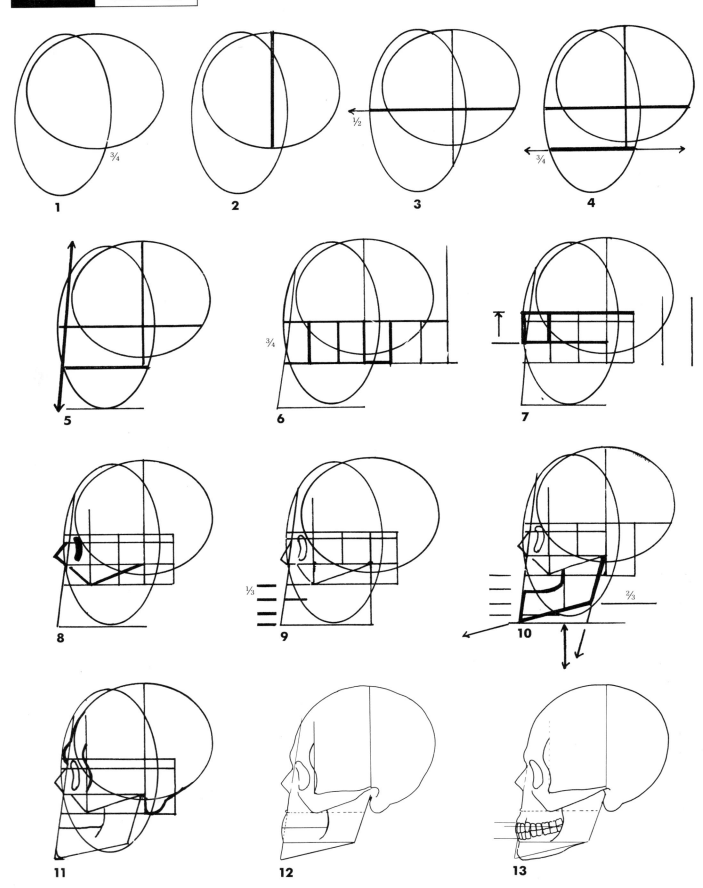

1. Begin with an oval. Add the oval for the base of the skull. The depth of the base of the skull oval reaches three-quarters of the length of the first oval.
2. Run a line vertically determining the approximate center.
3. Run a horizontal line across the halfway point.
4. In the lower half, draw the three-quarters line.
5. The face is not vertical but angles down and forward. Determine the angle of the face, straightening the front of the oval.
6. Divide the third-quarter area of the face across to the center line at the edge of the face into three equal parts. Divide the back of the skull from the halfway line at the edge of the face into two-and-a-half parts. (The half part comes at the rear of the skull.) The first part after the center line represents the area of the ear.
7. Run a line horizontally through the center of the three-quarters area. Add an additional third to the top of the three-quarter area. These slightly larger units show the placement of the eye sockets.
8. Draw the eye socket in the first unit on the left. Draw the nasal bone to the left of this unit. Run a diagonal line down from left to right through the square below the first unit. Run the line back up diagonally through the adjacent two squares.
9. Divide the area below the three-quarters line into three equal parts. The first-third area is where the lips meet.
10. Draw the back of the jawbone angling forward slightly from the center line. At the two-thirds point, angle the line of the jaw forward to the front line.
11. Curve the line of the brow. Include the temporal lines. Add the mastoid.
12. The teeth (upper and lower together) are the height of a third of the lower head. Divide that measure in half to determine the upper and lower teeth.
13. The teeth rest on the first-third line. The two incisors and canines, visible from the side, are followed by two premolars, which are squarish and often come to a point, that in turn are followed by three molars shaped like double premolars.

REFINEMENTS

14. An important landmark is the mastoid process. It is the point of insertion for the sternomastoid, which is an important neck muscle. The auditory meatus is the opening of the ear. It is located in the front portion of the middle of the ear.
15. The angle of the face, the acuity of the brow ridge, the size and character of the nasal bone, and the amount of protrusion at the dental bulge (maxilla) varies and is evident in external form.

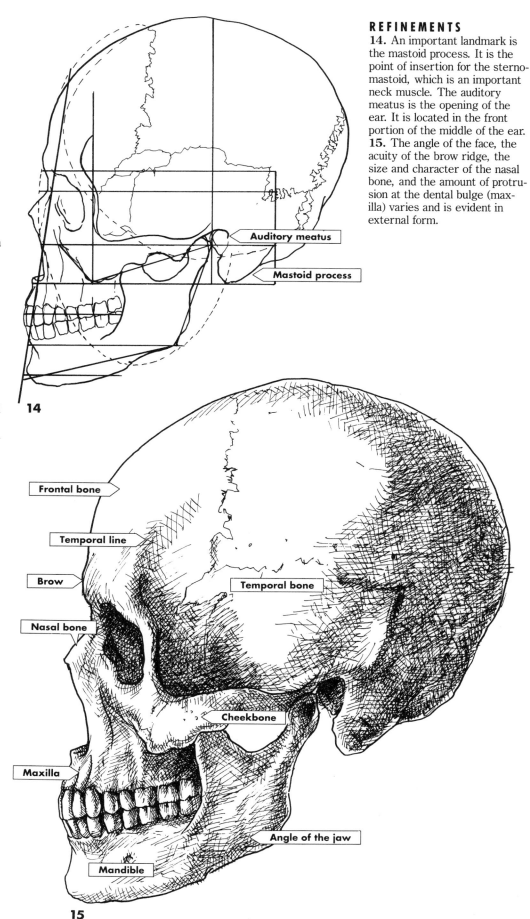

Auditory meatus

Mastoid process

14

Frontal bone

Temporal line

Brow

Nasal bone

Temporal bone

Cheekbone

Maxilla

Angle of the jaw

Mandible

15

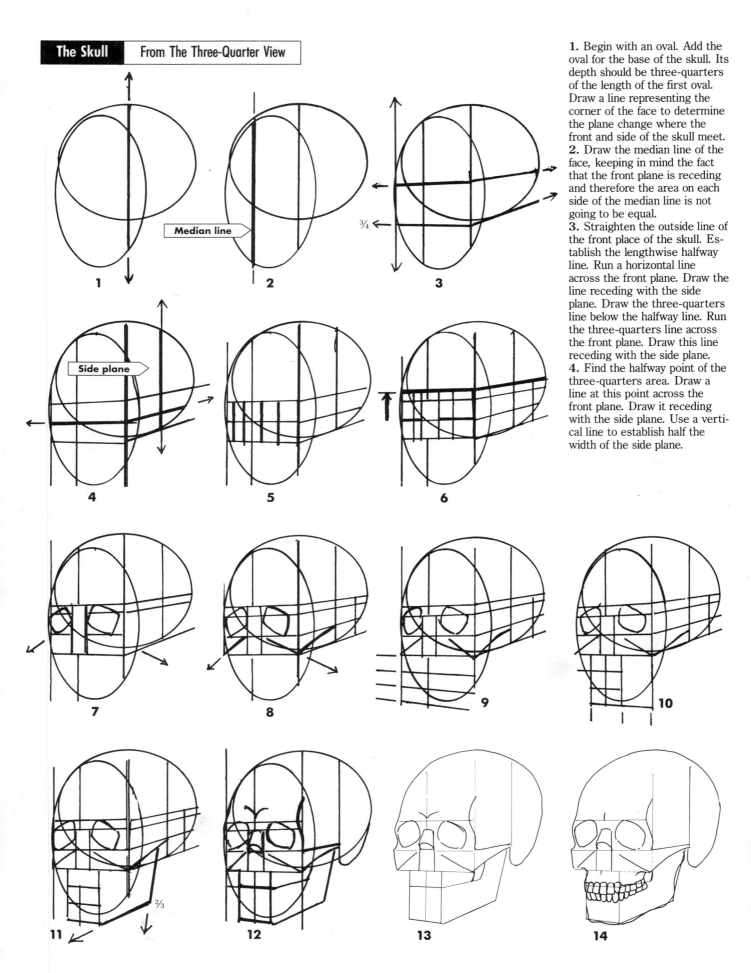

1. Begin with an oval. Add the oval for the base of the skull. Its depth should be three-quarters of the length of the first oval. Draw a line representing the corner of the face to determine the plane change where the front and side of the skull meet.
2. Draw the median line of the face, keeping in mind the fact that the front plane is receding and therefore the area on each side of the median line is not going to be equal.
3. Straighten the outside line of the front place of the skull. Establish the lengthwise halfway line. Run a horizontal line across the front plane. Draw the line receding with the side plane. Draw the three-quarters line below the halfway line. Run the three-quarters line across the front plane. Draw this line receding with the side plane.
4. Find the halfway point of the three-quarters area. Draw a line at this point across the front plane. Draw it receding with the side plane. Use a vertical line to establish half the width of the side plane.

Median line

3/4

Side plane

1

2

3

4

5

6

7

8

9

10

11

2/3

12

13

14

5. Divide the front three-quarters area into five sections. Begin at the median line. Establish the middle (nose) section. Then divide the two surrounding sections in half.

6. Add another line above the top half of the three-quarters area so that the two side sections are relatively square (eye sockets). This line should recede along with the side plane.

7. Draw the eye sockets in the square sections. They should be upended.

8. Run a diagonal coming out of either side of the nose.

9. Divide the bottom quarter into thirds.

10. Using vertical lines, divide the front plane of this bottom quarter of the head in half.

11. Draw the back of the jawbone angling forward slightly from the vertical line in the center of the side plane. At the two-thirds point, angle the line of the jaw forward until it reaches the front plane of the lower head.

12. The line defining the plane change should be curved around the eye sockets on both sides. Place the wedge shape of the nasal bone at the top of the middle (nose) division. Add the mastoid.

13. The teeth (upper and lower together) are the height of a third of the lower head. Divide that measure in half horizontally to determine the upper and lower teeth.

14. The teeth rest on the first-third line, which is in the middle of the upper teeth, and the lips divide there. On the front plane, the canines sit in the corners, and eight incisors show. On the receding plane are the maxilla and mandible. On both the top and bottom are two premolars followed by three molars.

REFINEMENTS

15. This figure shows the rounded-out skull as it fits into the schematic box.

16. Many of the same visual landmarks are significant that were significant from the front and side. In particular, the cheekbone, from which muscles attach to the mouth area, creates a visible angular downward thrust, as well as the temple line and the brow ridge.

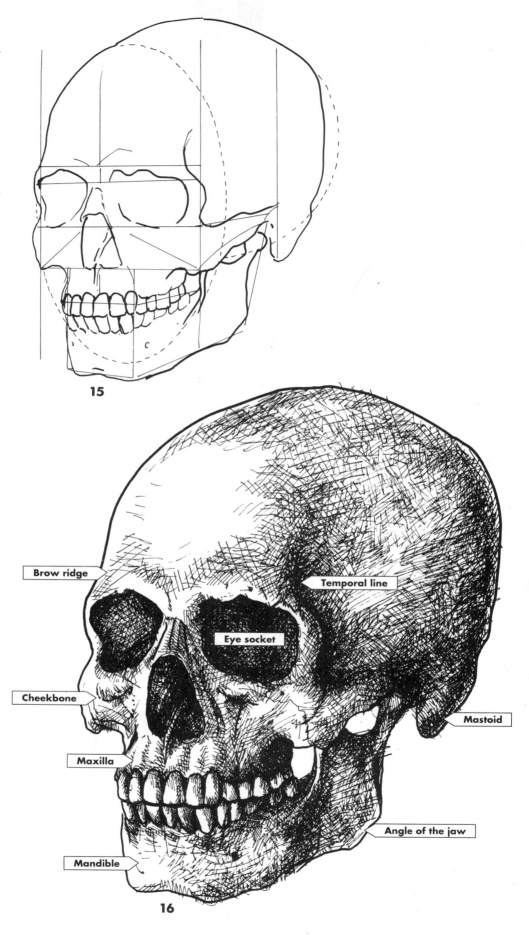

15

16

Brow ridge

Temporal line

Eye socket

Cheekbone

Mastoid

Maxilla

Angle of the jaw

Mandible

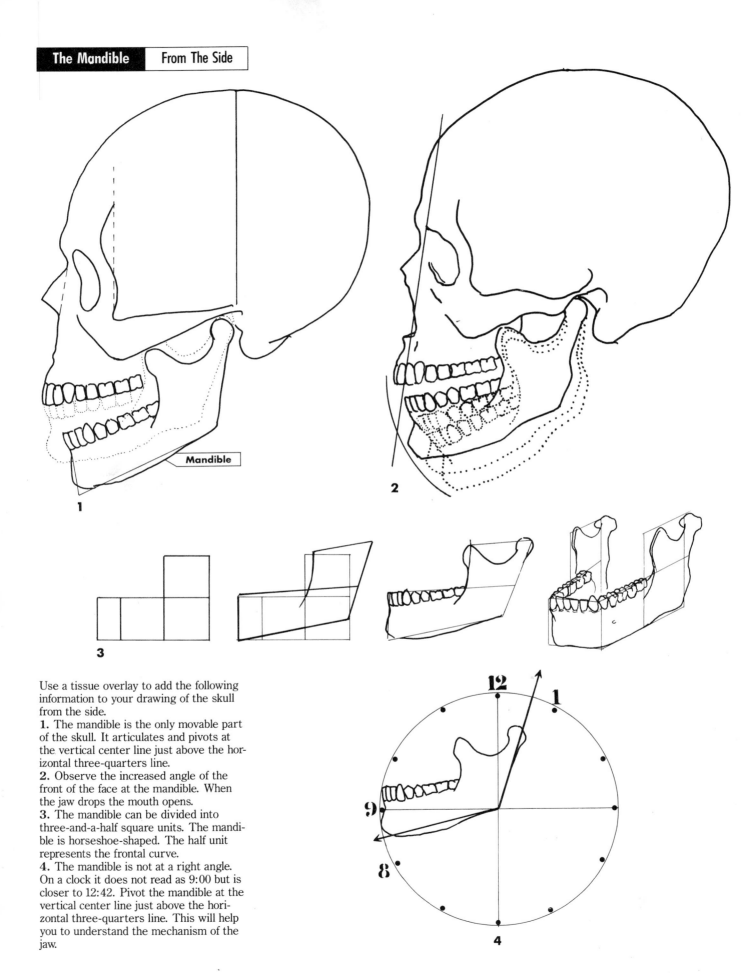

Mandible

1

2

3

4

Use a tissue overlay to add the following information to your drawing of the skull from the side.

1. The mandible is the only movable part of the skull. It articulates and pivots at the vertical center line just above the horizontal three-quarters line.

2. Observe the increased angle of the front of the face at the mandible. When the jaw drops the mouth opens.

3. The mandible can be divided into three-and-a-half square units. The mandible is horseshoe-shaped. The half unit represents the frontal curve.

4. The mandible is not at a right angle. On a clock it does not read as 9:00 but is closer to 12:42. Pivot the mandible at the vertical center line just above the horizontal three-quarters line. This will help you to understand the mechanism of the jaw.

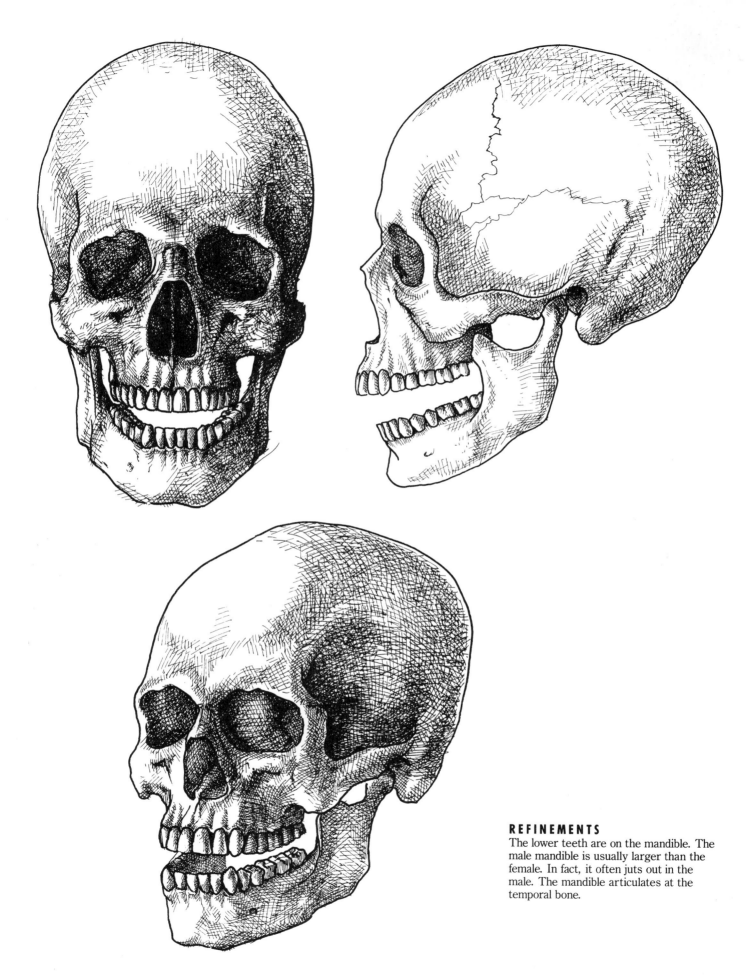

REFINEMENTS

The lower teeth are on the mandible. The male mandible is usually larger than the female. In fact, it often juts out in the male. The mandible articulates at the temporal bone.

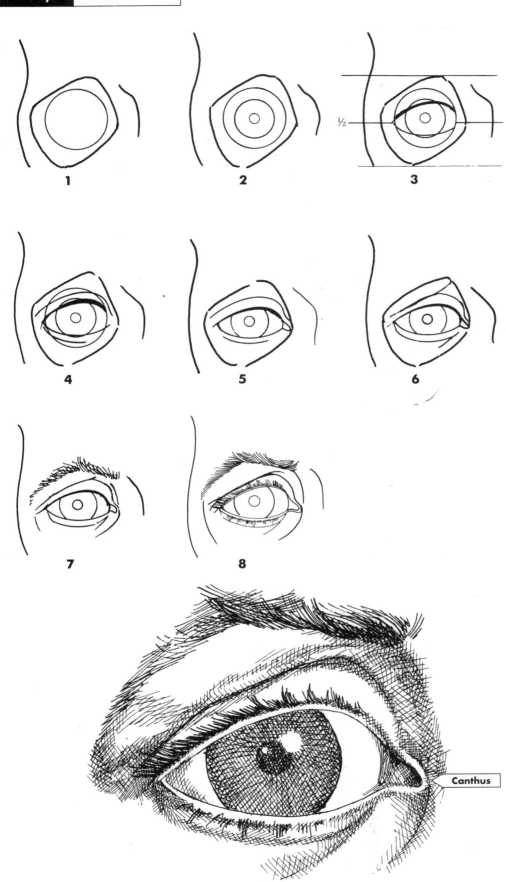

Use a tissue overlay to add the following information to your drawings of the skull.

1. Draw the eyeball in the eye socket. It sits a little high in the socket.

2. Draw the iris and the pupil; place the pupil directly in its center.

3. Measure half the length of the eye socket. The upper and lower lids begin there on each side. The upper lid swings up more acutely. Draw the lower lid as a tighter line. Draw the upper lid line highest on the inside.

4. Draw the upper and lower lid plates with a feeling for the form of a ball beneath. Draw the upper lid plate swinging up highest on the inside following the upper lid line. It is an uneven almond shape.

5. Draw the canthus pointing down slightly. It is located at half the length of the socket.

6. There is a fold sitting on and covering part of the upper lid plate. Draw the fold as a curved line sitting on the upper lid.

7. There is great variation in the eyebrow. It tends to follow the brow ridge. Draw it on the top line of the eye socket.

8. Draw the lid plates as if they were sculpture. Give width to the top of the bottom lid plate and a width to the bottom of the top lid plate.

REFINEMENTS

The amount of lid covered by the fold that sits on the upper lid plate varies among individuals and tends to increase with age. This fold generally obscures the upper lid in Asian people. The upper lid is capable of more movement than the lower lid.

Canthus

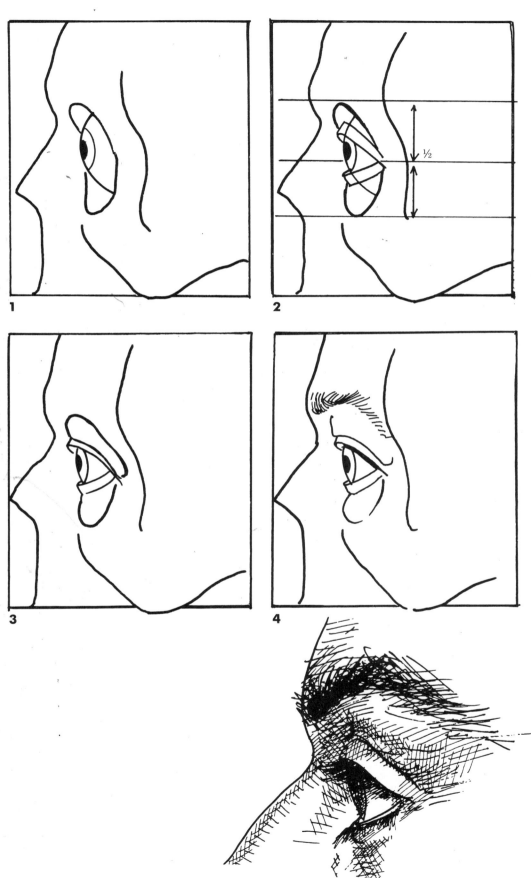

1. Draw the eyeball in the eye socket. It sits a little high. The surrounding bone acts as protection and therefore it should not exceed beyond it in the front. There are individual exceptions. We are dealing with general rules.
2. Measure half the length of the eye socket. It is this point at which the lid plate begins. The upper lid plate has a greater height and curve. The lower lid plate is less angled and more stationary.
3. Draw the tissue that hangs from the upper portion of the socket.
4. The eyebrow, both natural and altered, tends to take the direction of the orbital ridge. Draw it on the top line of the eye socket.

REFINEMENTS

The upper lid usually protrudes more than the lower lid from this view. The tissue below the lower lid is the part that tends to become "baggy." That area can, depending on the artist's preference and needs, be abbreviated, understated, or even eliminated.

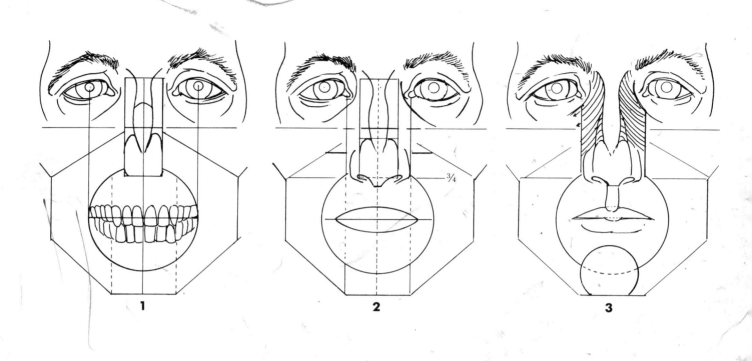

1 2 3

THE NOSE

1. Visualize the nasal bone by thinking of it as if it were made of clay and you were squeezing it at the top. Draw the nasal bone with a pinched, curved line. Draw the upper cartilage as a continuation of the nasal bone extending to and ending at about the three-quarters point of the nose. Draw the lower cartilage (bulbous portion) beginning a bit below the halfway line.

2. Draw the wings beginning at the three-quarters point. The septum extends below the bottom line of the nose area. Draw the nostrils rising up and out from the septum. The width of the nose at its broadest (at the wings) should measure to the inside of the eyes.

3. At about the half measure the nose often widens (triangular cartilage). There is a slight plane change here. There is also a plane change from the top plane to the receding side planes.

REFINEMENTS

The lower cartilage of the nose is movable. It is an area that changes with expression. The nostrils can flare and the wings can rise. When the wings rise, wrinkles form downward and inward along the nasal bone.

THE MOUTH

1. Draw a circle around the mouth area (orbicularis oris). The outer edges of the circle should extend to the width of the center of the eyes. The circle should begin at the bottom of the nose area. The line dividing the lips is found at the middle of the upper teeth. When drawing the lips, it is important to begin with that first line rather than beginning with the final shape of the lips. It is better to determine the direction of the plane and shape it later.

2. Begin the lips as two equal arches above and below the mouth line.

3. The philtrum, an indentation running down from the septum, appears to push on the top of the upper arch of the upper lip, which in turn pushes down on the bottom of the arch of the upper lip. Draw the chin muscle (mentalis) as a circle. The circle intrudes on the lower part of the mouth circle. It creates the appearance of a platform for the mouth.

REFINEMENTS

The upper lip is usually wider than the lower lip. The lips do not extend out to the edge of the mouth circle (orbicularis oris).

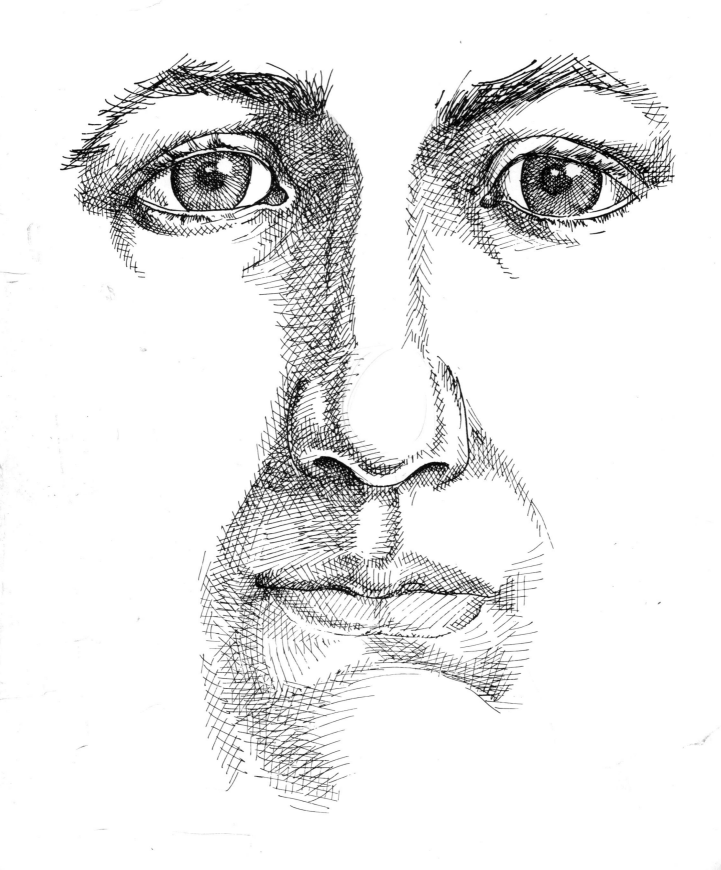

169

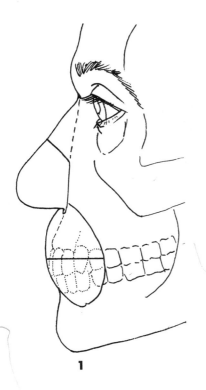

1

2

3

Wing (ala)

½

¾

THE NOSE

1. Draw the triangular, wedge-shaped nose in the nose area, which is the three-quarters area of the skull.

2. About halfway down the nose the bulbous, round fatty portion begins (lower cartilage). About halfway down from there at the three-quarters line is about where the wing (ala) begins. Curve the line of the wing at that point.

3. Draw the curve of the nostril a little above the three-quarters line. (When the nose is drawn from the three-quarter view, the same information applies but the triangular wedge has rotated so that the side plane is larger relative to the front plane.

REFINEMENTS

The nasal bone is responsible for the bump on the nose. All noses have a bump even if they appear to be straight.

THE MOUTH

1. Begin with the mouth circle (orbicularis oris). Draw it protruding slightly. The line that divides the lips is located at half the height of the upper teeth.

2. Draw the upper and lower arch of the lips.

3. Draw the philtrum, which straightens the curve of the mouth circle and affects the shape of the upper lip by pushing the center of the upper lip down. Draw the chin muscle as an ovoid giving a convex line to the front of the chin.

REFINEMENTS

As a rule, consider the upper lip as protruding out slightly over the lower lip. The chin muscle (mentalis) pushes up on the mouth circle (orbicularis oris) causing the bottom of the mouth circle to appear as a curved platform to the mouth.

1 **2** **3** **4**

1. Divide the ear area into thirds by using horizontal lines. Divide the width in half using a vertical line. Draw the shape of the ear as an inverted *C*. The ear is widest at the middle and pushes out slightly to the back from that point. It is narrower at the bottom. The lowest front section represents the lobe.

2. Draw the tragus as a half ovoid at the front of the middle section. There is a rim on the ear running along the outside and ending just above the lobe called the helix. Draw the bottom of the helix as a line running parallel to the contour of the ear ending at about the one-third point.

3. Draw a curved shape in the inside middle section to reflect the shape of the tragus. This is the concha. Draw the upper line of the antihelix, which is a plat-formed mass below the helix, leaving some space between the two. Draw the line as a reflection of the helix. There is an indentation at the top of the antihelix. Draw the triangular shape facing diagonally down.

4. Draw an opposing shape to the tragus going down diagonally and facing the tragus. This is the antitragus. Draw the antitragial notch, which appears as a concave shape squeezed out from between the tragus and the antitragus. There is very often a bump. Draw it as a curved line located below the helix at the middle of the upper rear section.

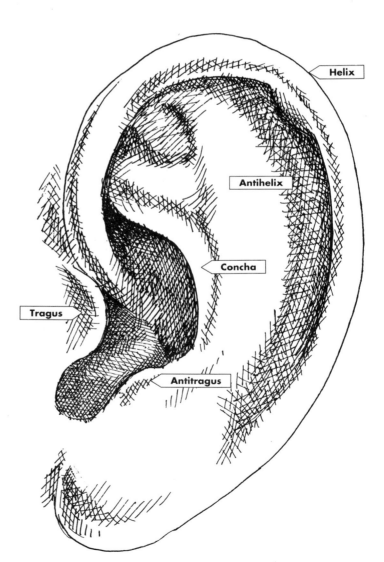

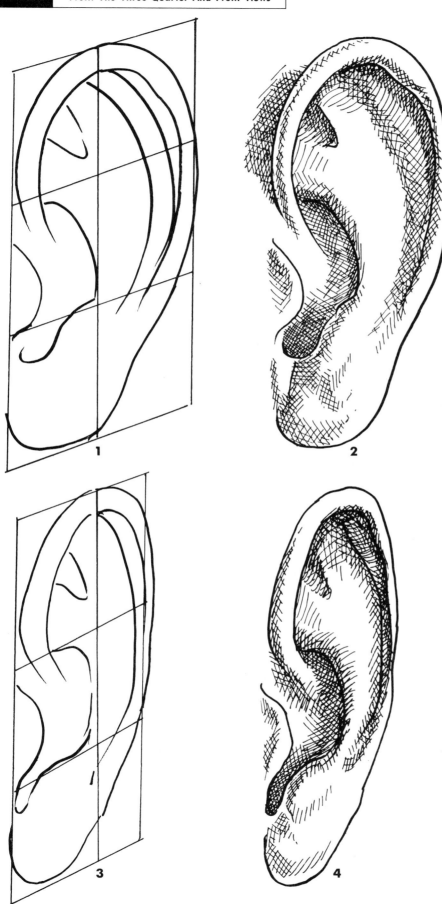

1. In the three-quarter view, the original rectangle for the ear is placed at an angle.
2. Rounded out, this view is similar to the side view.
3. In the front view, the original rectangle is compressed.
4. The sapha, which is the space between the helix and the antihelix, varies in size from individual to individual.

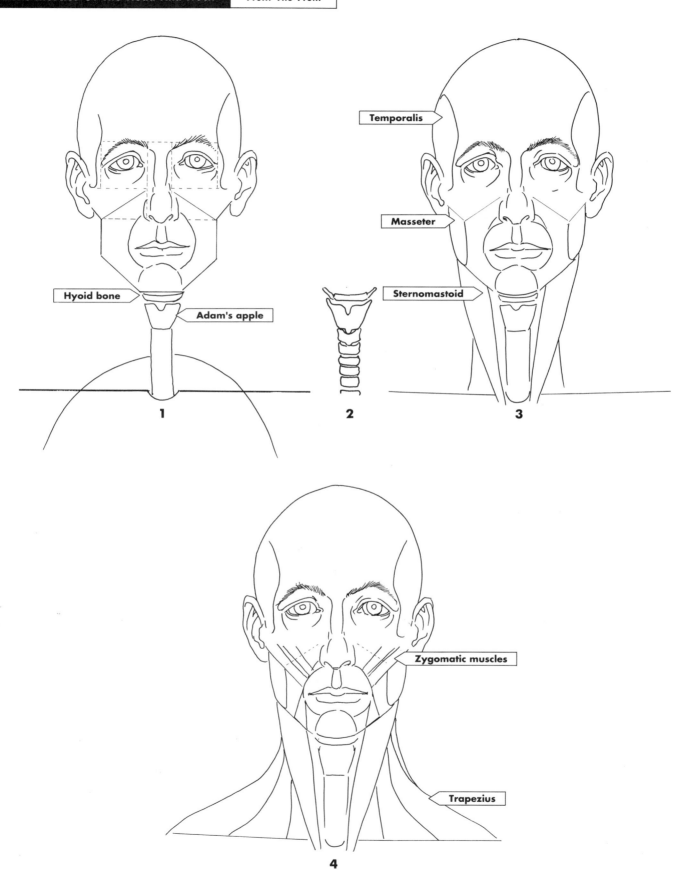

Hyoid bone

Adam's apple

1

2

Temporalis

Masseter

Sternomastoid

3

Zygomatic muscles

Trapezius

4

1. Draw the rings as a column topped by the hyoid bone and the Adam's apple.

2. Just below the chin is the hyoid bone. Running down just below it is the Adam's apple (thyroid cartilage), cricoid cartilage, and trachea, with its cartilaginous rings. Draw the masseter (chewing muscle) as an outside line filling the jaw area. The temporalis, a muscle that helps the masseter lift the jaw, rounds and fills the side planes of the head. The lines of the temples are always visible. Draw the sternomastoid, a neck muscle, as a long ovoid narrowing downward as it nears the sternum.

3. The muscles of the cheekbone (zygomatic muscles) attach to the mouth circle. They are never seen as distinct, separate muscles. Eliminate any dividing lines.

4. Draw the cheek muscles as a single line. A shoulder muscle, the trapezius, which follows the line of the neck and turns out to follow the line of the shoulder, completes the lower portion of the neck. Draw the trapezius turning out at about half the height of the neck.

REFINEMENTS

5. The temporalis is not visible as defined mass but fills the temporal cavity. It rounds and fills the side planes of the head. The sternomastoid must be considered as a convex form. It originates from the sternum and clavicle and inserts into the mastoid process. The clavicular aspect of the sternomastoid is rarely visible except in older people. The trapezius inserts at the outside third of the clavicle. It sits on the top of the bone.

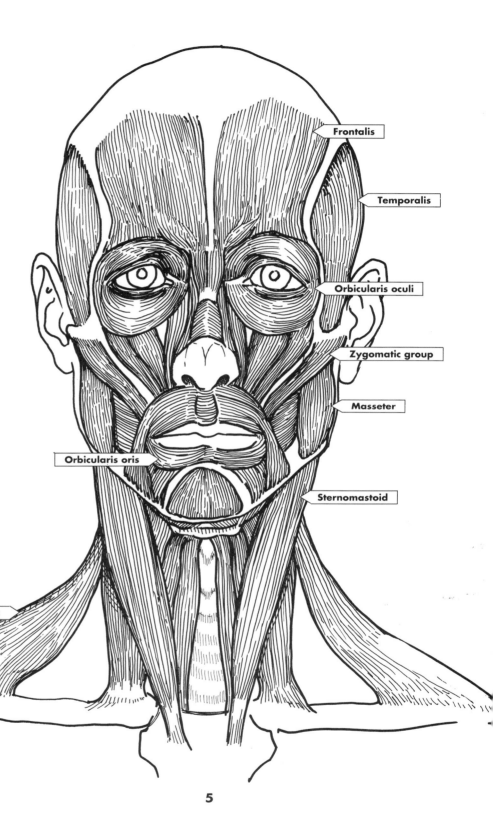

Frontalis

Temporalis

Orbicularis oculi

Zygomatic group

Masseter

Orbicularis oris

Sternomastoid

Trapezius

5

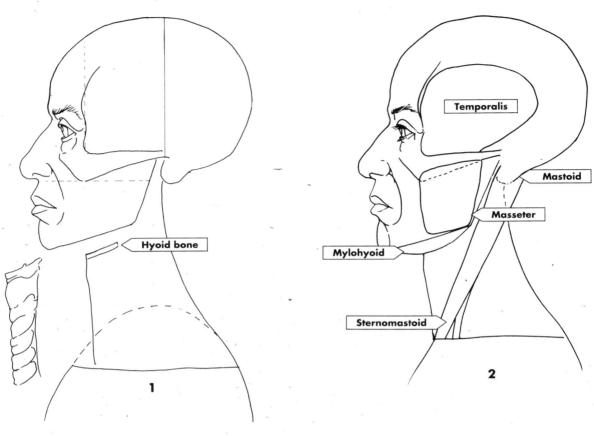

Hyoid bone

Temporalis

Mastoid

Masseter

Mylohyoid

Sternomastoid

1

2

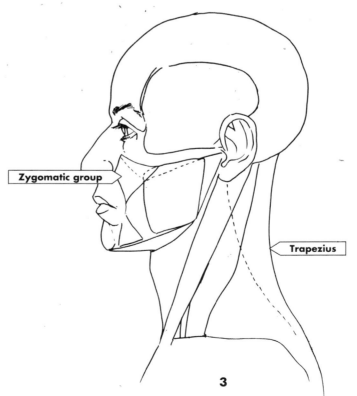

Zygomatic group

Trapezius

3

1. Draw the hyoid bone, Adam's apple, cricoid cartilage, and rings of the trachea as a single line just below the jaw. The line begins at half the width of the jaw.

2. The two muscles at the bottom of the jaw (mylohyoid and digastric) can be reduced to one mass. Draw it as a curved line from the chin to the hyoid bone, curving up to the back of the jaw. Draw the masseter rounding and filling the jaw area. The temporalis rounds or fills the side planes of the head. The lines of the temples are always visible. The sternomastoid originates at the mastoid and inserts at the sternum. Draw the sternomastoid as a long ovoid narrowing toward the bottom.

3. Draw the bottom line of the muscles of the cheekbone (zygomatic group) attaching to the mouth circle. Draw the trapezius running down from the base of the skull and attaching on the outside third of the clavicle and on the spine of the scapula.

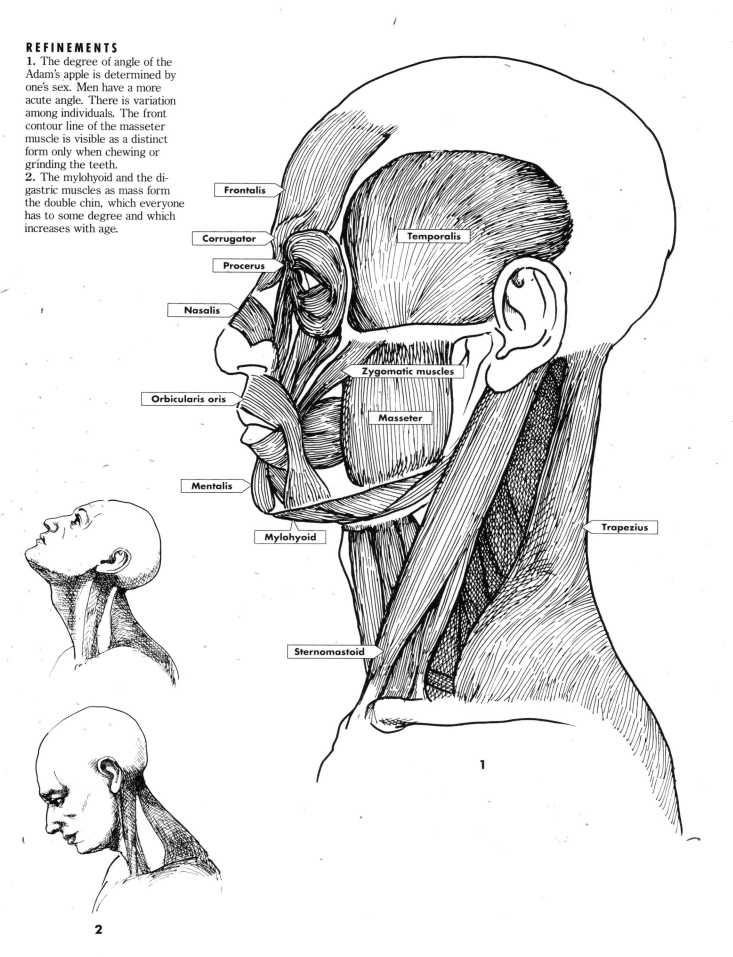

REFINEMENTS

1. The degree of angle of the Adam's apple is determined by one's sex. Men have a more acute angle. There is variation among individuals. The front contour line of the masseter muscle is visible as a distinct form only when chewing or grinding the teeth.

2. The mylohyoid and the digastric muscles as mass form the double chin, which everyone has to some degree and which increases with age.

Frontalis

Corrugator

Procerus

Nasalis

Orbicularis oris

Mentalis

Mylohyoid

Temporalis

Zygomatic muscles

Masseter

Trapezius

Sternomastoid

1

2

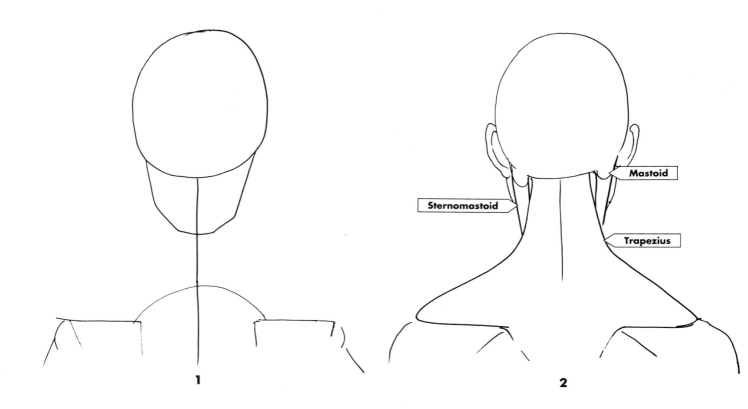

1

2

Mastoid

Sternomastoid

Trapezius

1. Begin with the schematic for the back of the head, neck, and the upper portion of the rib cage. Include the scapula.
2. The ear from the back is clearly bowl-like. Draw the rim of the ear at an angle from the head. Draw the trapezius originating at the base of the skull and sitting on the top of the shoulder girdle at half the distance from the base of the skull to the top of the shoulder girdle. Draw the trapezius, which follows the line of the neck and turns out to follow the line of the shoulder. The sternomastoid from this view is the outside portion of the neck. Draw the sternomastoid widening the neck.

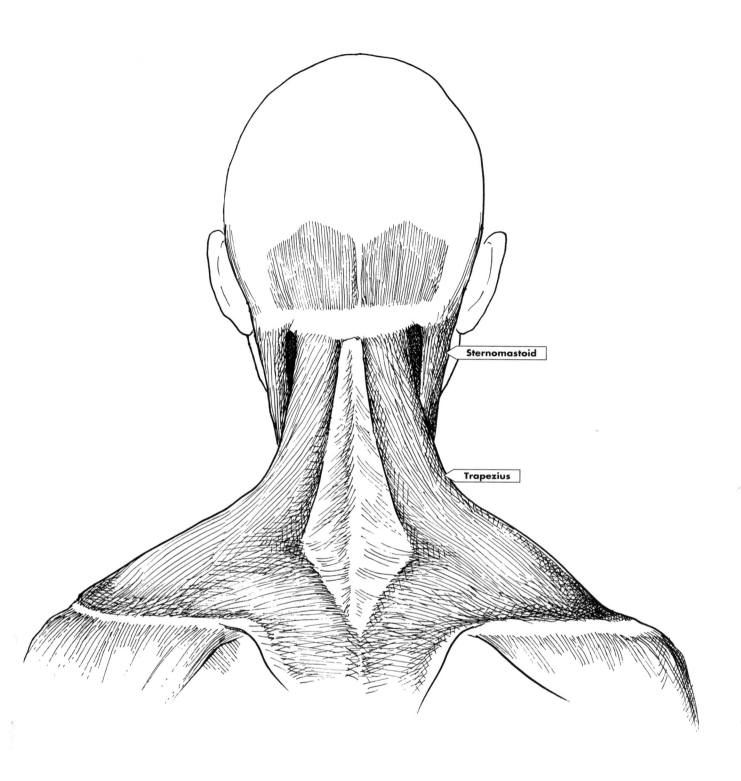

Sternomastoid

Trapezius

REFINEMENTS
The two sides of the trapezius descend from the base of the skull as two distinct columns. The columnar shape disappears as the sides follow the curve of the shoulder. The seventh neck vertebra is often visible as a bump.

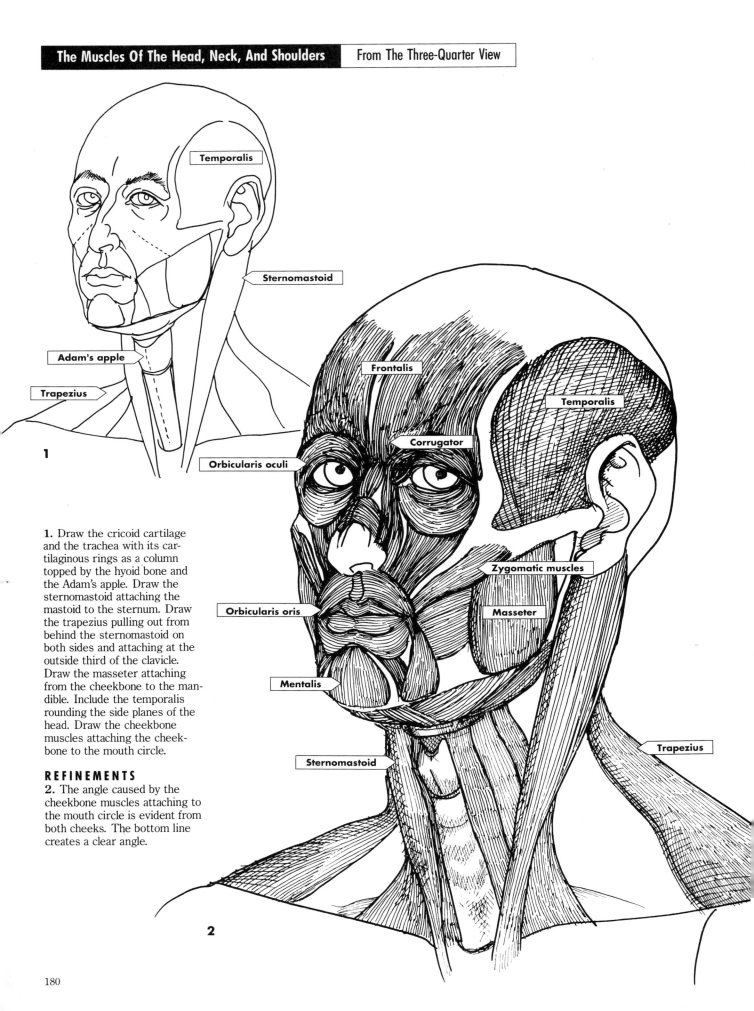

Temporalis

Sternomastoid

Adam's apple

Trapezius

1

Frontalis

Temporalis

Corrugator

Orbicularis oculi

Zygomatic muscles

Masseter

Orbicularis oris

Mentalis

Trapezius

Sternomastoid

1. Draw the cricoid cartilage and the trachea with its cartilaginous rings as a column topped by the hyoid bone and the Adam's apple. Draw the sternomastoid attaching the mastoid to the sternum. Draw the trapezius pulling out from behind the sternomastoid on both sides and attaching at the outside third of the clavicle. Draw the masseter attaching from the cheekbone to the mandible. Include the temporalis rounding the side planes of the head. Draw the cheekbone muscles attaching the cheekbone to the mouth circle.

REFINEMENTS
2. The angle caused by the cheekbone muscles attaching to the mouth circle is evident from both cheeks. The bottom line creates a clear angle.

2

Lines and wrinkles are formed at right angles to the action of a muscle. For example, when the eyebrows are raised, the muscle, which is the bottom part of the frontalis, draws the eyebrows up, causing lines to form at right angles to the direction of the action. The vertical lines caused by the knitting of the eyebrows are the result of action or contraction of the corrugator. When the eyes are squinting the lines occur in opposition to the action of the orbicularis oculi. Smile lines are formed in opposition to the zygomaticus muscles and levator labii superior. The variations, combinations, and possibilities of facial expression are endless, but the line is always formed at a right angle to the action.

Lay a tissue on two of your previously drawn skulls. On one skull, draw the expressions of an angry face; on the other, draw the expressions of a happy face.

The wrinkles of the elderly, as with the lines of expression, lie at right angles to the direction of the action of the muscle.

15 THE TRUNK

The remaining muscles of the trunk are the latissimus dorsi, pectoralis (chest muscle), and the muscles of the scapula (teres major, teres minor, and infraspinatus). Also important are the serratus anterior, the strong chords (sacrospinalis), and the tail of the trapezius.

The latissimus dorsi is a large, triangular muscle. Its principal function is to bring the arm down laterally and in toward the body. When raised it also brings the arm back and rotates it. The latissimus dorsi originates on the spine and pelvic basin and inserts at the upper arm bone. From the front it forms mounds on sides. From the back it covers the bottom of the scapula and is broad and triangular. The apex of the triangle attaches to the pelvic crest. It visually melds with the external oblique.

The serratus anterior is largely covered by the latissimus dorsi. What is left visually are four knobs on the front, outside area of the rib cage. The serratus anterior connects the underside of the scapula to the uppermost eight or nine ribs. Its function is to bring the scapula forward. It is only visible on extremely athletic bodies.

The pectoralis is triangular. Its principal purpose is to pull the arm into the body and draw the raised arm down. The female breast is connected to the pectoralis by fascia. The pectoralis attaches the upper arm to the chest. It originates on the inside two-thirds of the clavicle and along the sternum and inserts on the upper arm bone below the head of the bone. The pectoralis inserts halfway down the deltoid.

On the back of the trunk, the three muscles of the scapula appear initially as a triangle. They cover and fill out the scapula and connect the scapula to the upper arm. Visually, the significant muscle here is the teres major, which appears as an ovoid at the bottom of the scapula muscle group triangle forming a division on the triangle. It is a long ovoid and is often apparent in the external form. The teres major is partially covered by the latissimus dorsi. It is basically an adductor and rotator of the upper arm.

Largely hidden from view by the latissimus dorsi are the strong chords, which consist of three muscles that basically help hold the body erect. Appearing as two columns, they are sometimes visible through the diamond-shaped window left in the middle of the bottom of the latissimus dorsi. It might show when there is exertion in extending the spine, for example, when lifting or carrying, and so forth.

The tail of the trapezius sits on the inside corner and upper border of the scapula. It comes to rest at about the point of the triangular division of the latissimus dorsi. The tail is rarely visible in the external form.

The figure, right, shows the completed trunk. The figures opposite show the refined trunk on the fleshed-out figure.

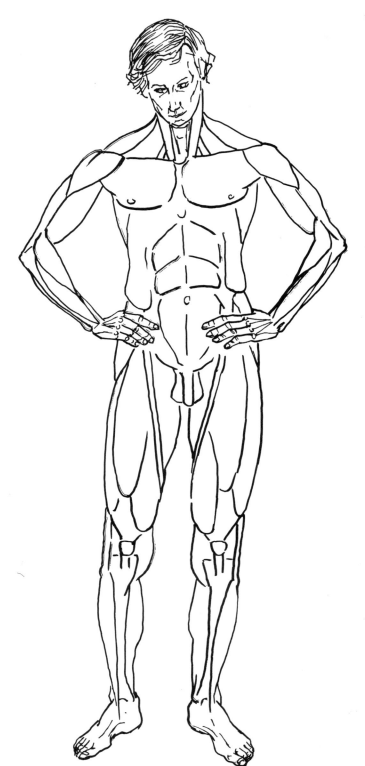

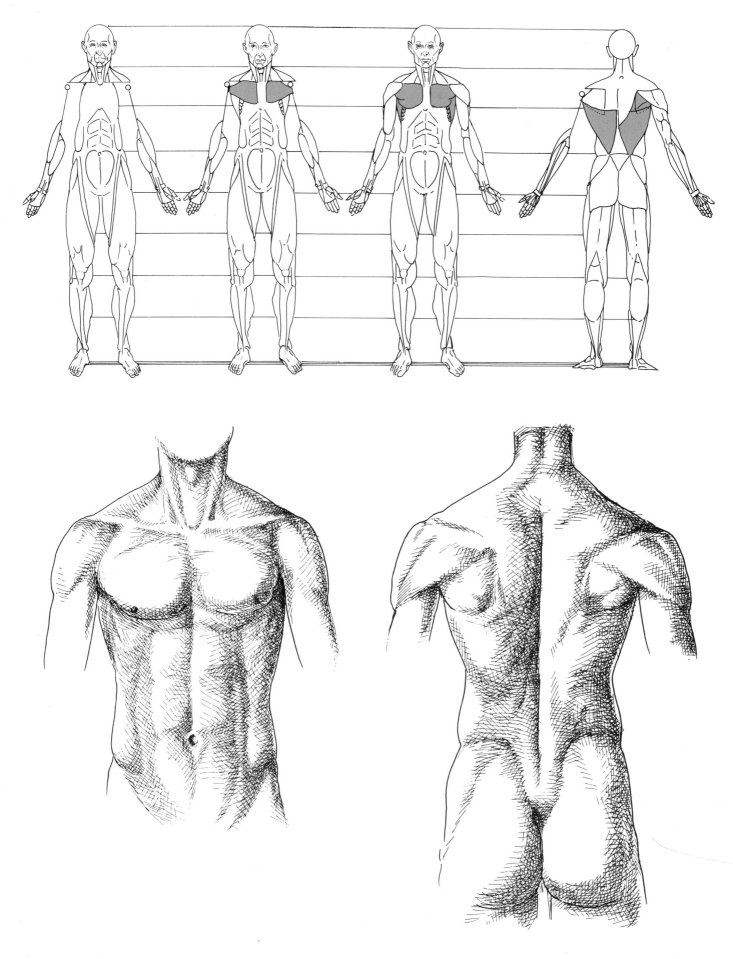

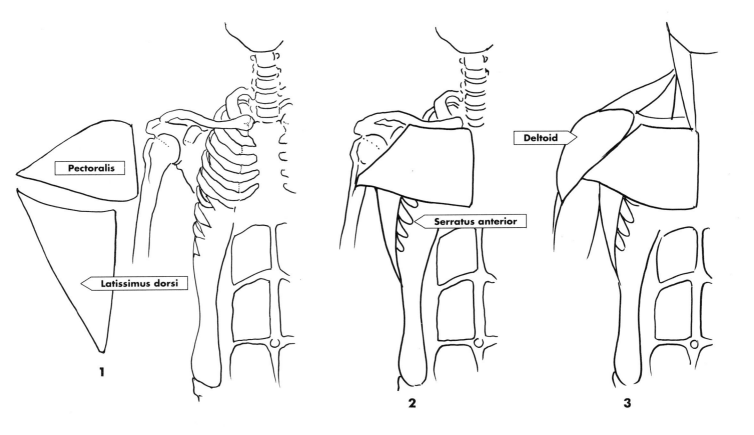

1. Draw the latissimus dorsi as a triangle. Draw the pectoralis triangle.

2. Attach the latissimus dorsi to the upper arm. The triangle shape is less apparent from the front. It is seen from the front as a mounding on the sides. Add the pectoralis triangle. Insert it below the ball of the upper arm bone. Draw it originating at the inner two-thirds of the clavicle and along the sternum. Draw the serratus anterior as four knobs, like the ends of four fingers.

3. Add the deltoid and the biceps. The pectoralis, at its insertion, measures half the length of the deltoid.

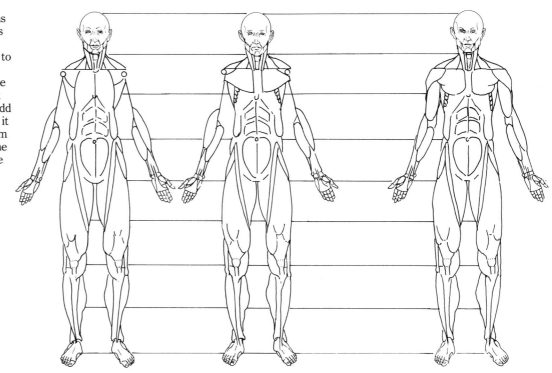

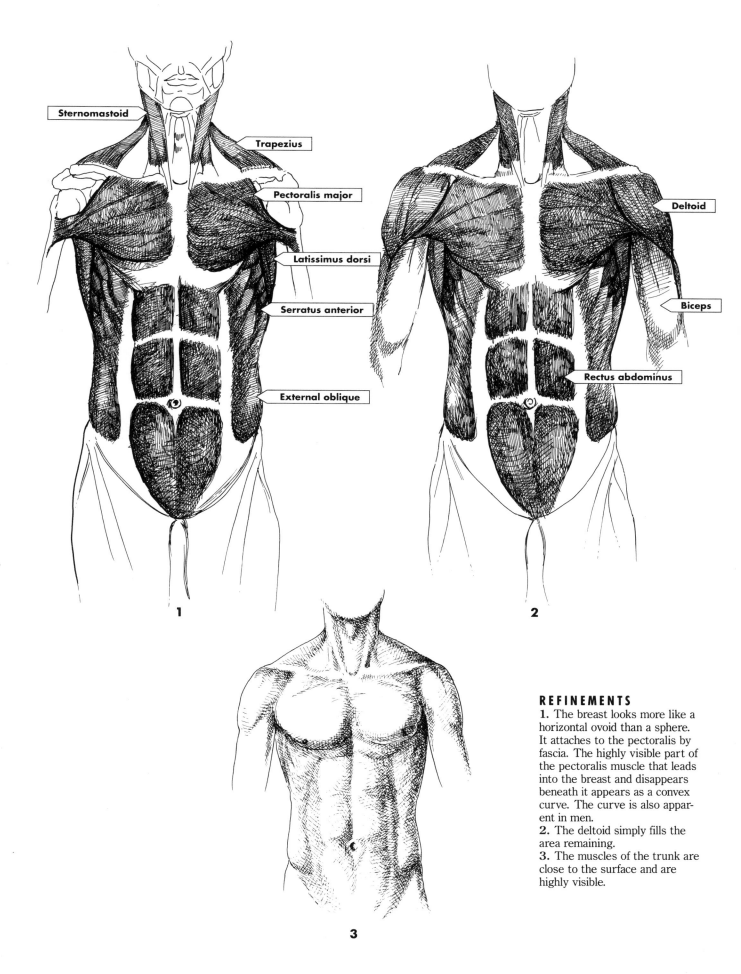

Sternomastoid

Trapezius

Pectoralis major

Latissimus dorsi

Serratus anterior

External oblique

Deltoid

Biceps

Rectus abdominus

1

2

3

REFINEMENTS
1. The breast looks more like a horizontal ovoid than a sphere. It attaches to the pectoralis by fascia. The highly visible part of the pectoralis muscle that leads into the breast and disappears beneath it appears as a convex curve. The curve is also apparent in men.
2. The deltoid simply fills the area remaining.
3. The muscles of the trunk are close to the surface and are highly visible.

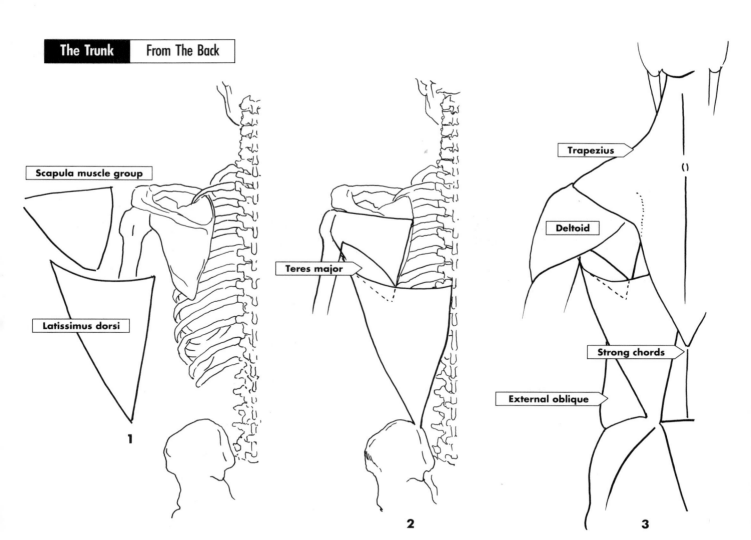

Scapula muscle group

Latissimus dorsi

1

Teres major

2

Trapezius

Deltoid

Strong chords

External oblique

3

1. Draw the scapula muscle group as a triangle. Draw the latissimus dorsi as a triangle.
2. Attach the scapula triangle from the upper arm bone just below the ball. Define the teres major as an ovoid at the bottom of the triangle. Add the triangular shape of the latissimus dorsi to each side, inserting at the upper arm bone just below the ball. The latissimus dorsi covers the bottom of the scapula and a small portion of the teres major.
3. Add the deltoid and the triceps. Include the tail of the trapezius, which sits on the inside corner and upper border of the scapula. The strong chords are represented by a line on each side of the median line. The strong chords are not always seen. If you choose to include them, consider them as two vertical columns.

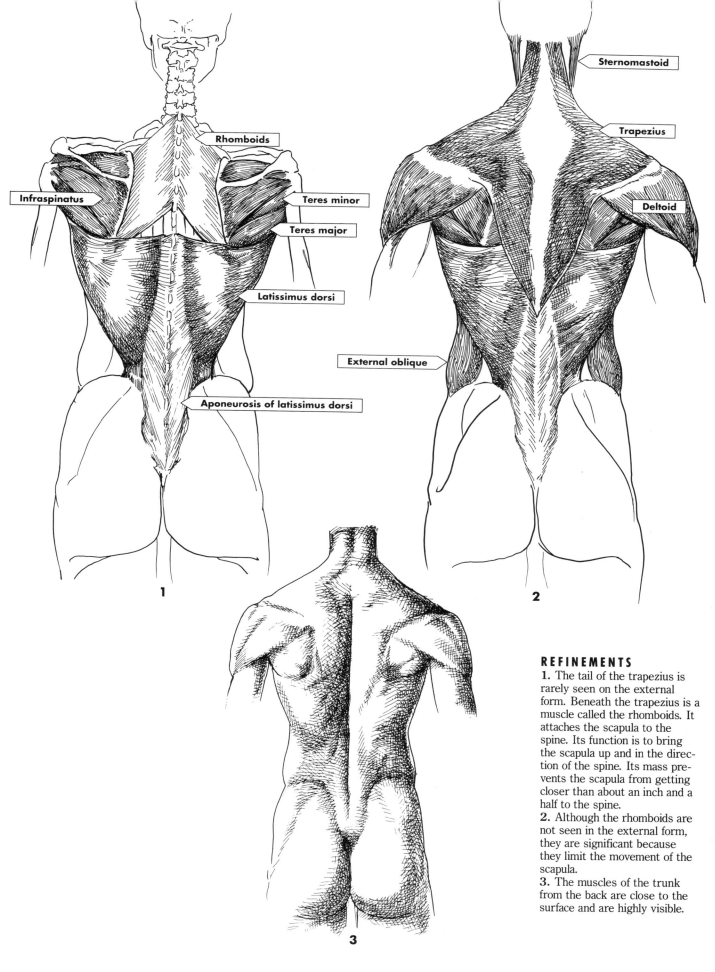

Rhomboids

Infraspinatus

Teres minor

Teres major

Latissimus dorsi

Aponeurosis of latissimus dorsi

1

Sternomastoid

Trapezius

Deltoid

External oblique

2

3

REFINEMENTS

1. The tail of the trapezius is rarely seen on the external form. Beneath the trapezius is a muscle called the rhomboids. It attaches the scapula to the spine. Its function is to bring the scapula up and in the direction of the spine. Its mass prevents the scapula from getting closer than about an inch and a half to the spine.

2. Although the rhomboids are not seen in the external form, they are significant because they limit the movement of the scapula.

3. The muscles of the trunk from the back are close to the surface and are highly visible.

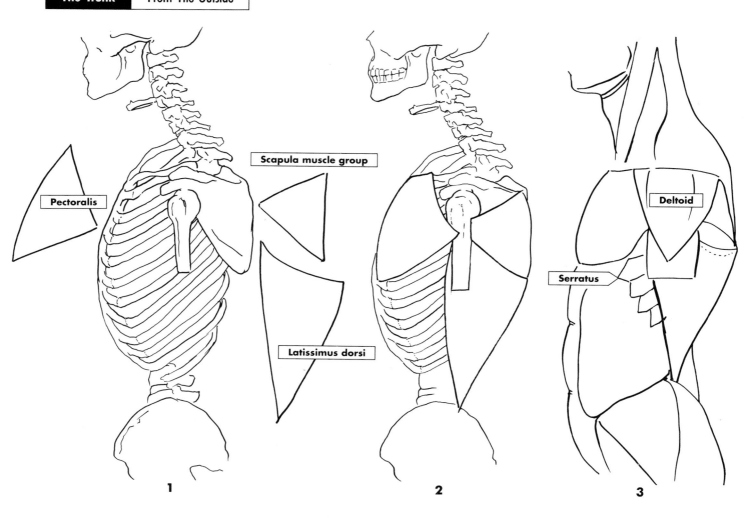

Pectoralis

Scapula muscle group

Latissimus dorsi

Deltoid

Serratus

1 **2** **3**

1. Draw the scapula muscle group triangle, as well as the triangles representing the pectoralis and latissimus dorsi.

2. Add the scapula muscle group triangle to connect the inside border of the scapula to the inside front of the upper arm. Place the latissimus dorsi triangle on the back half of the rib cage, inserting on the inside of the upper arm bone and attaching on the back of the pelvic basin. Add the pectoralis triangle, inserting on the upper arm and originating on the inside two-thirds of the clavicle.

3. Draw the serratus as four knobs. Place the biceps and the triceps on the arm. Draw the deltoid.

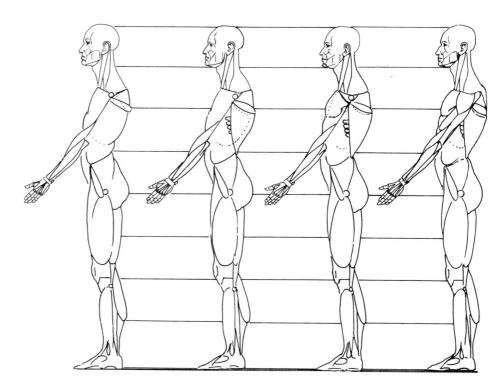

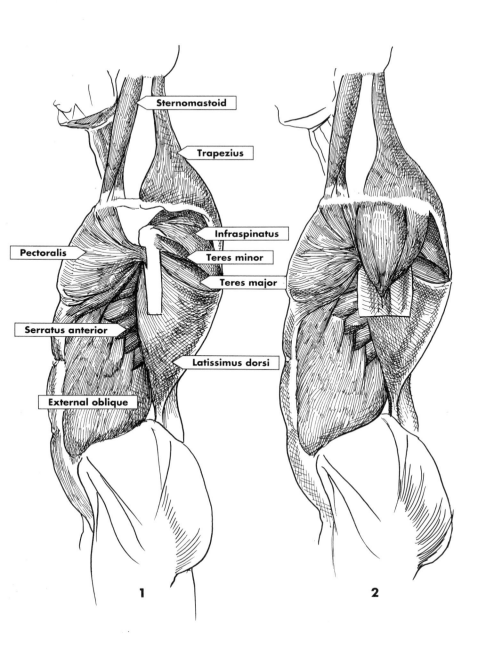

Sternomastoid

Trapezius

Infraspinatus

Teres minor

Teres major

Pectoralis

Serratus anterior

Latissimus dorsi

External oblique

1

2

3

REFINEMENTS
1. The inside line of the latissimus dorsi is never visible in the external form, but the mass of the muscle is.
2. The deltoid covers the insertion of the pectoralis and the scapula muscles.
3. Except for the dividing line of the latissimus dorsi and the serratus anterior, the muscles of the trunk are highly visible from this view.

16 DRAW FROM YOUR HEAD

Now that all the parts are in place and you understand how the human body is constructed, we want to cover the flayed figures in a sheath of skin.

The illusion of three dimensions is traditionally accomplished by the use of light and shade. The principle behind this is: Light strikes an object and proceeds from white to graduated tones to darkness or shade. Next to the shade is a reflected light. The object is to completely control the light source.

When drawing the figure from a model where light is coming from various sources and directions, it is advisable to control the direction of the light in the drawing and to treat every part of the figure with the principle of light and shade.

Rather than simply removing the dividing lines between the muscle groups, place a tissue over your final drawings. Direct the light source from right to left. Now model each group. Avoid cast shadows. They tend to disrupt the form and create the illusion of deep scars and holes. For example, if there is an arm over a breast, do not draw the shadow the arm would cast. Instead, render the breast as if the light simply penetrated the arm. Wherever possible follow the shade with reflected light. Draw the contour lines. You have now eliminated the dividing lines between the muscle groups.

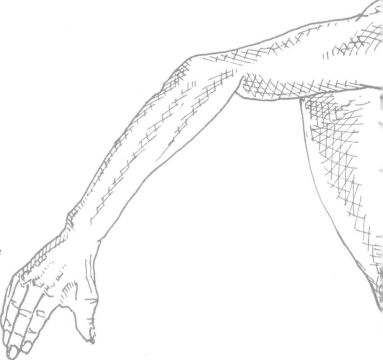

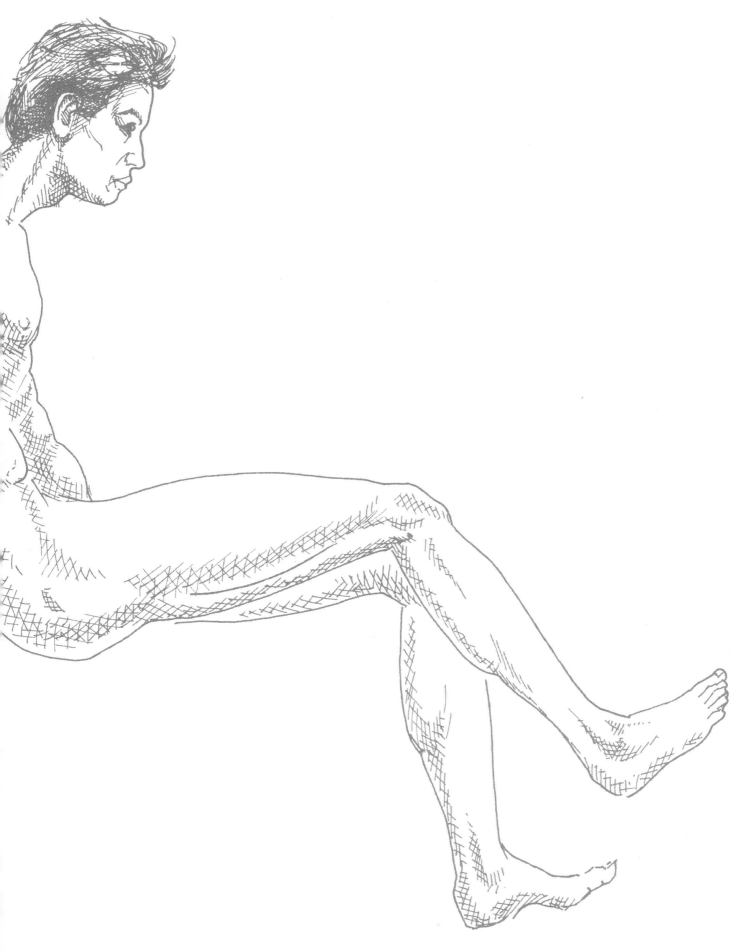

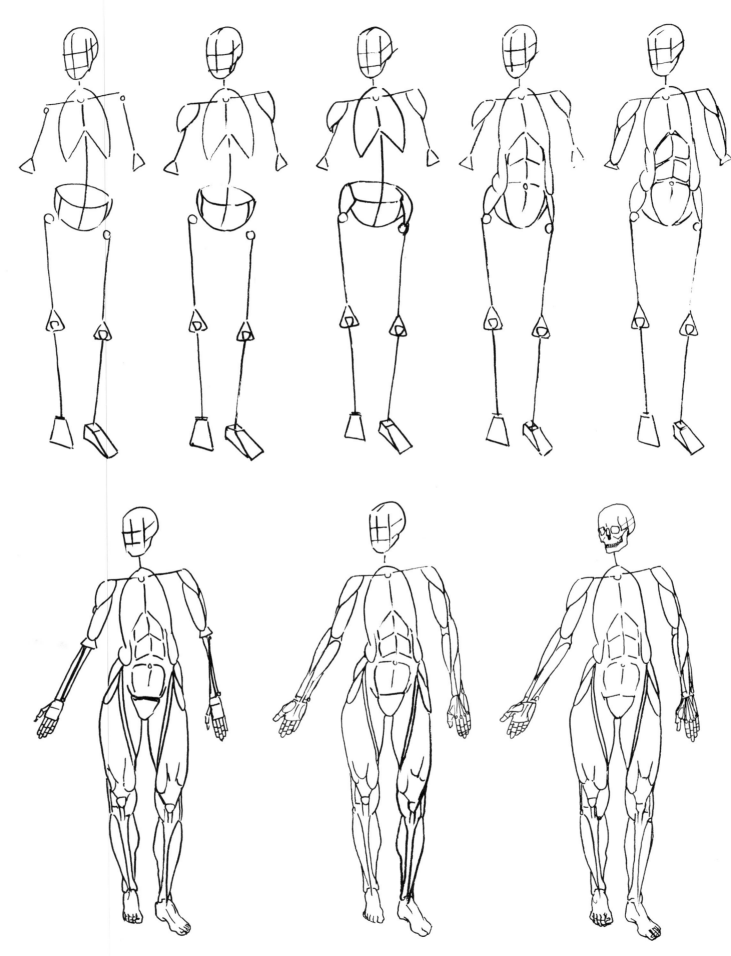

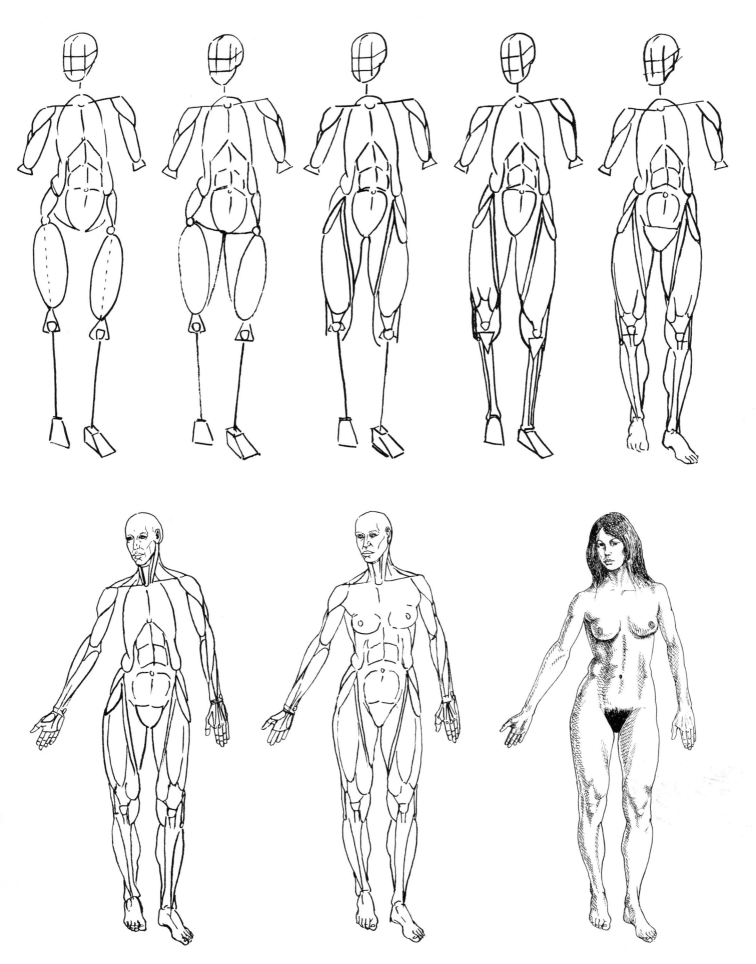

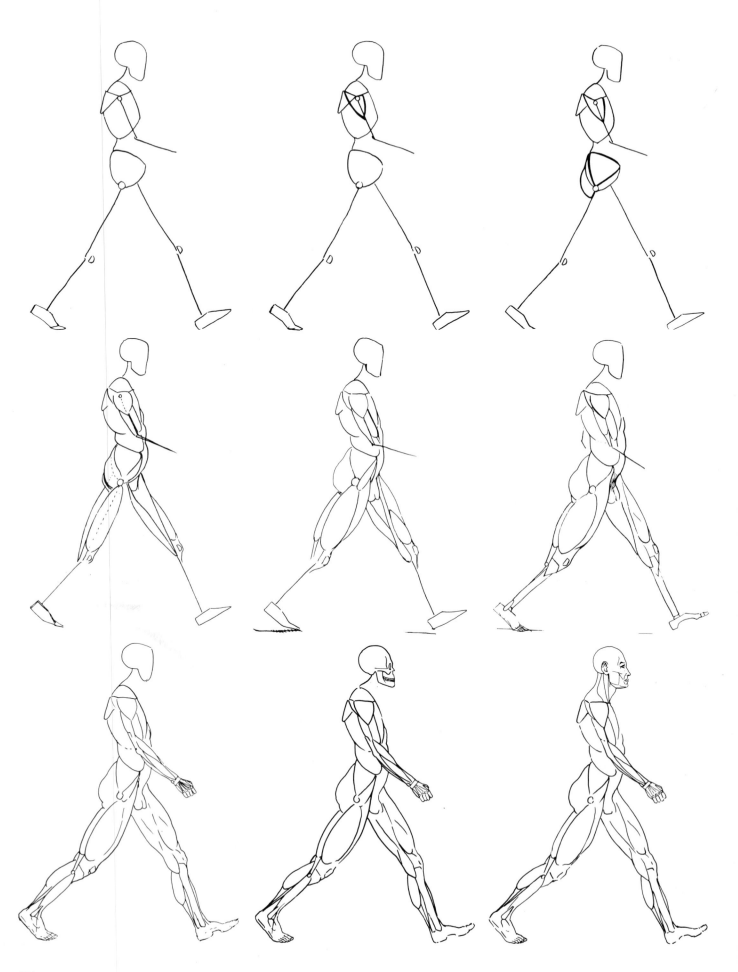

194

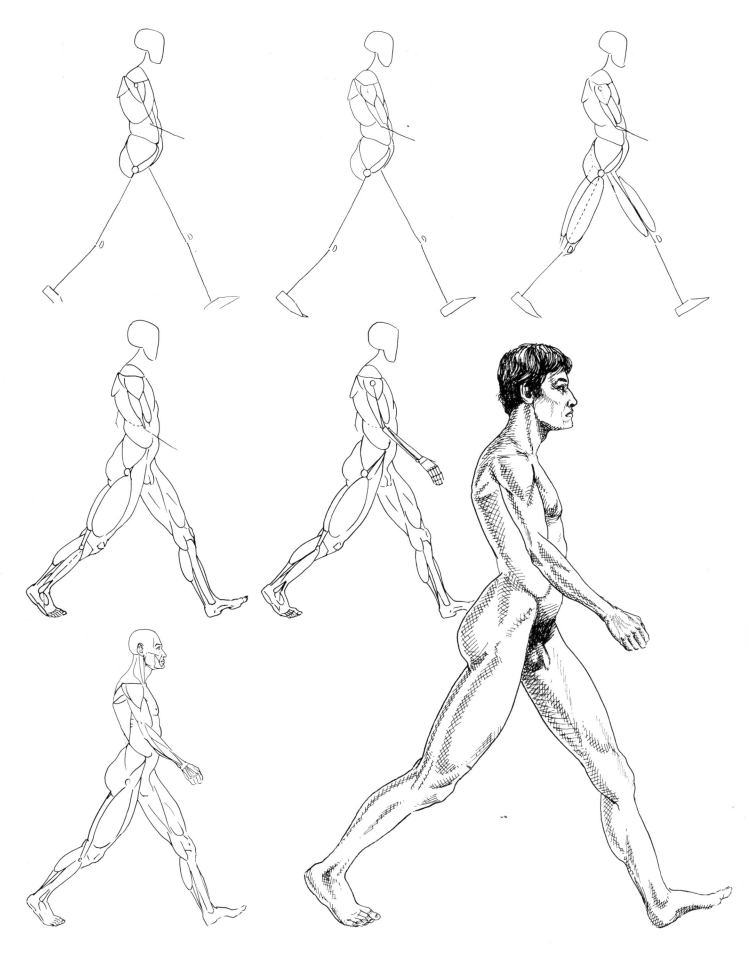

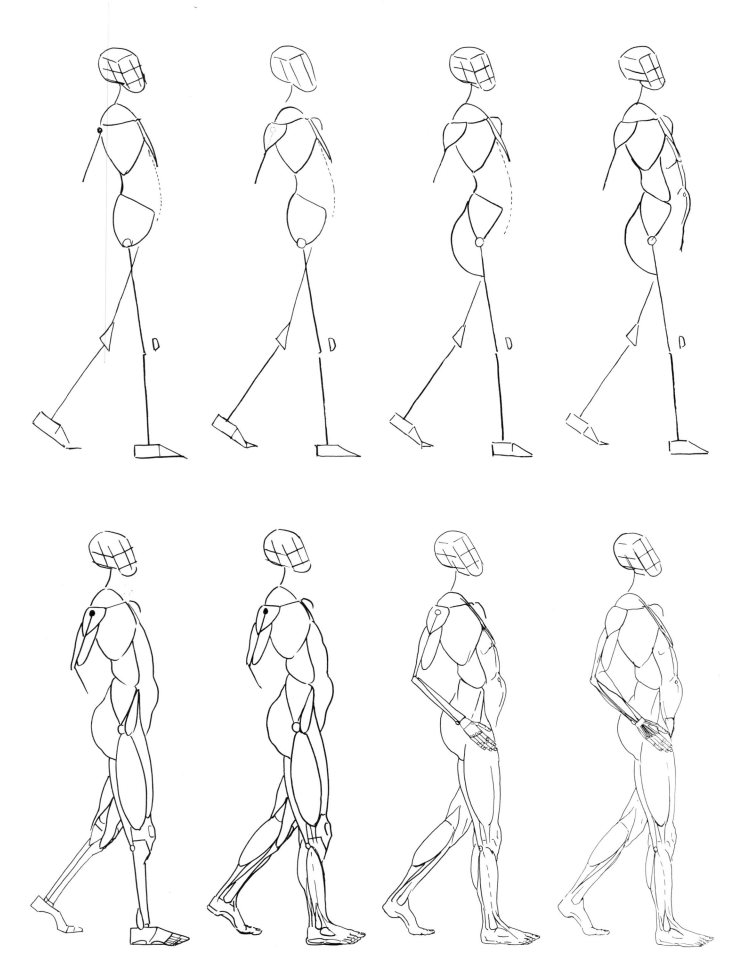

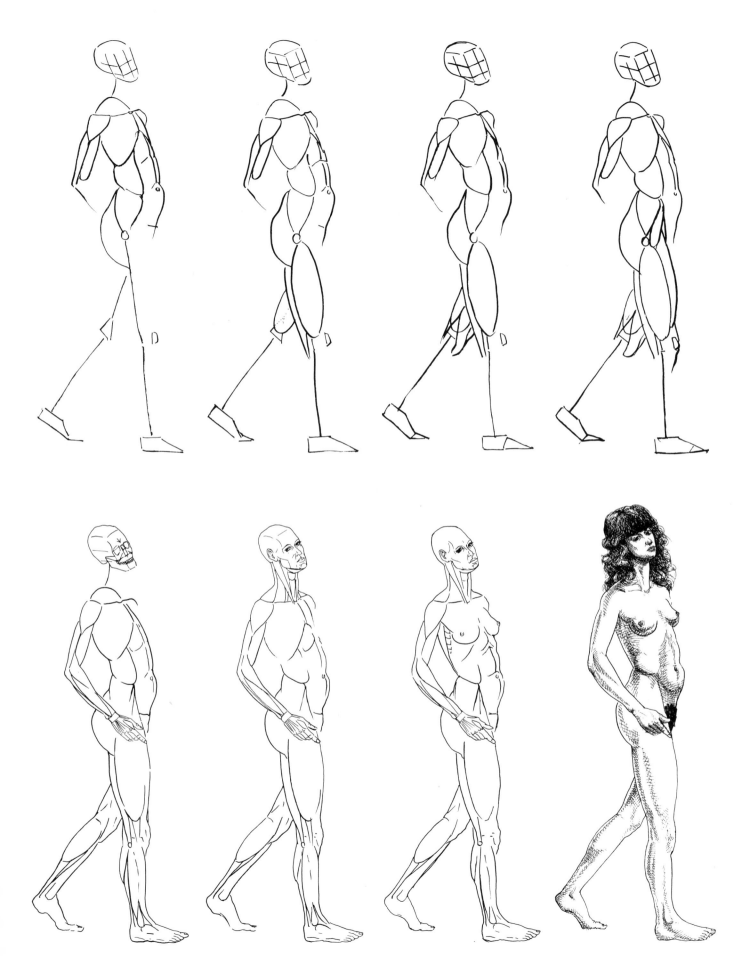

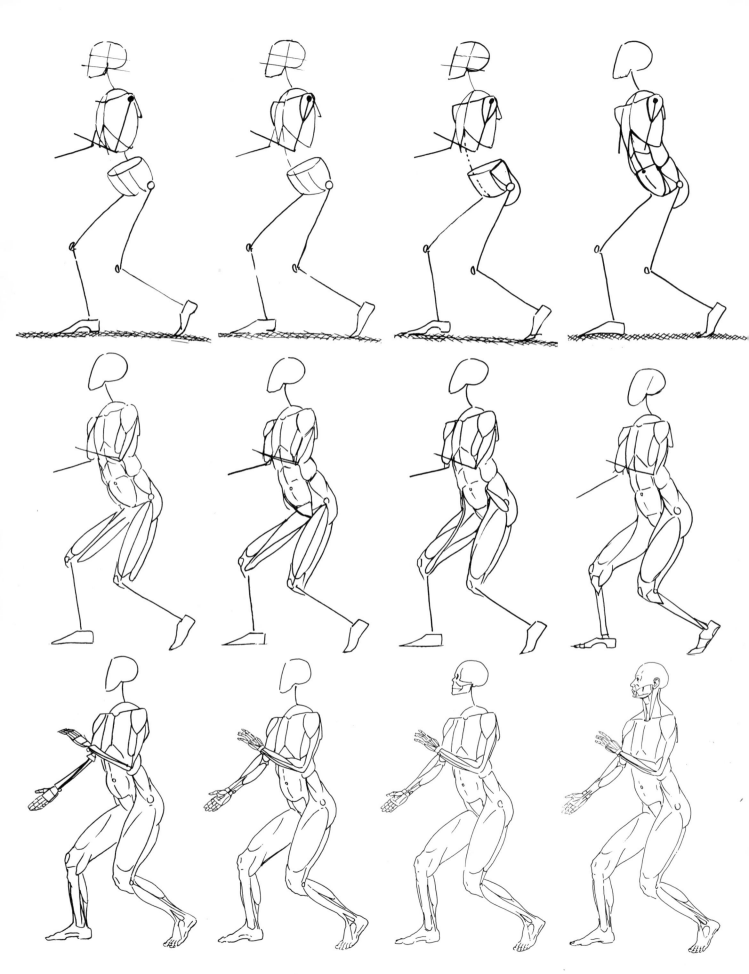

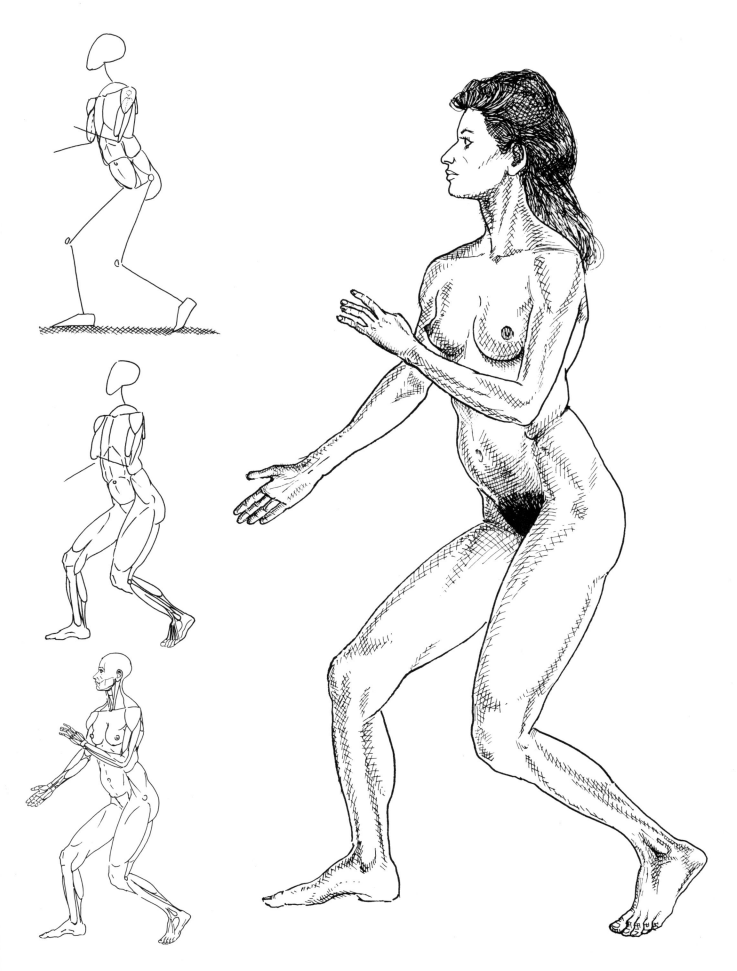

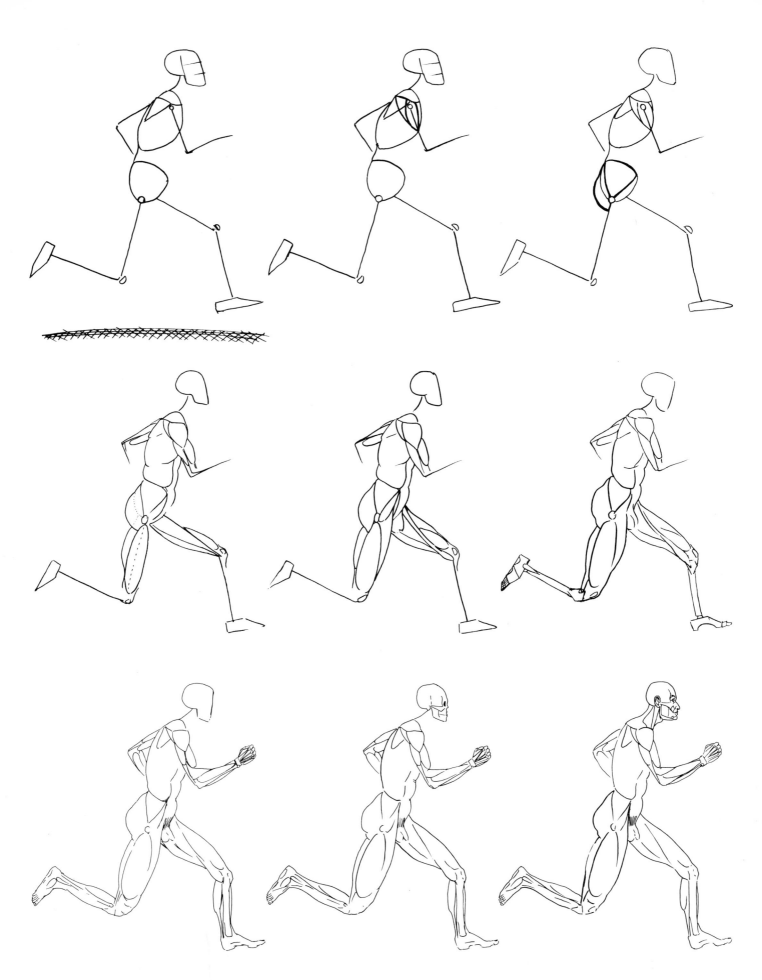

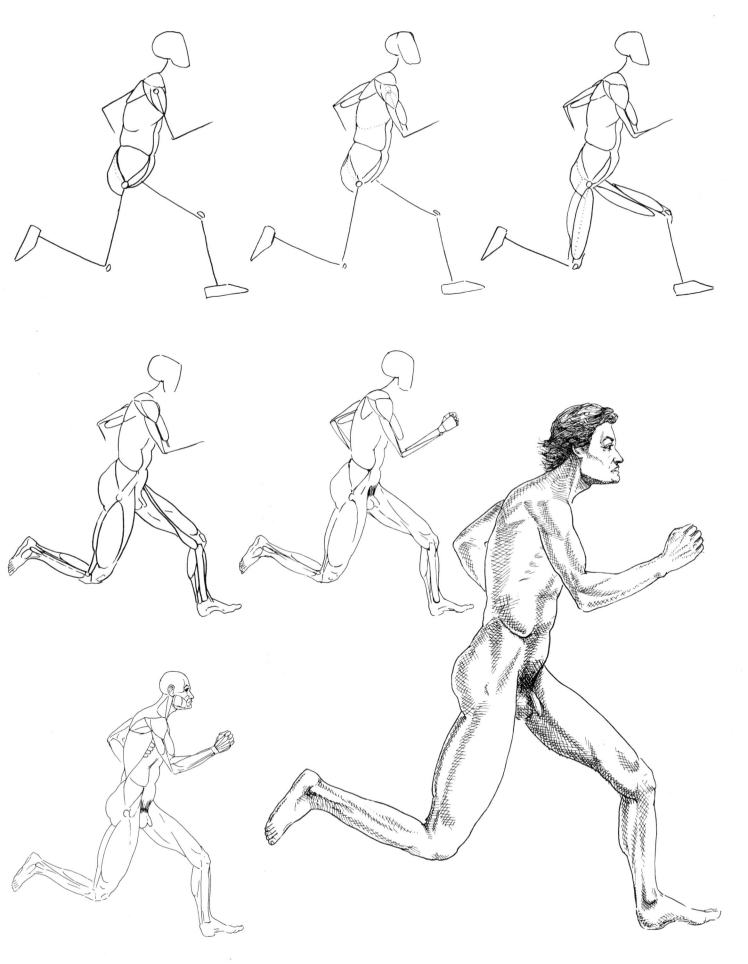

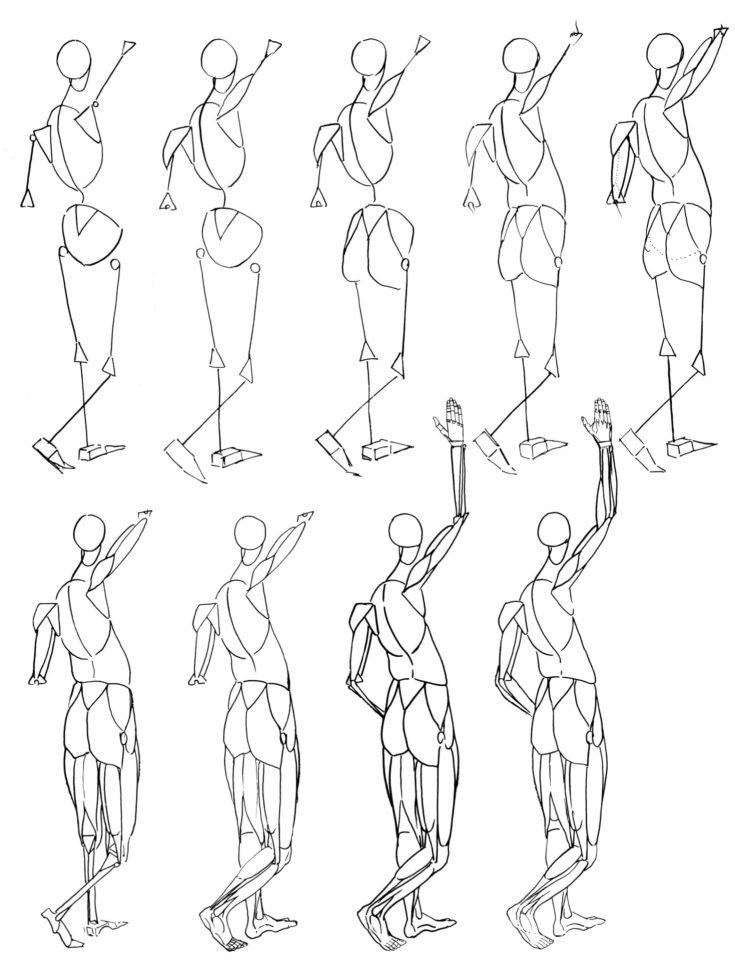

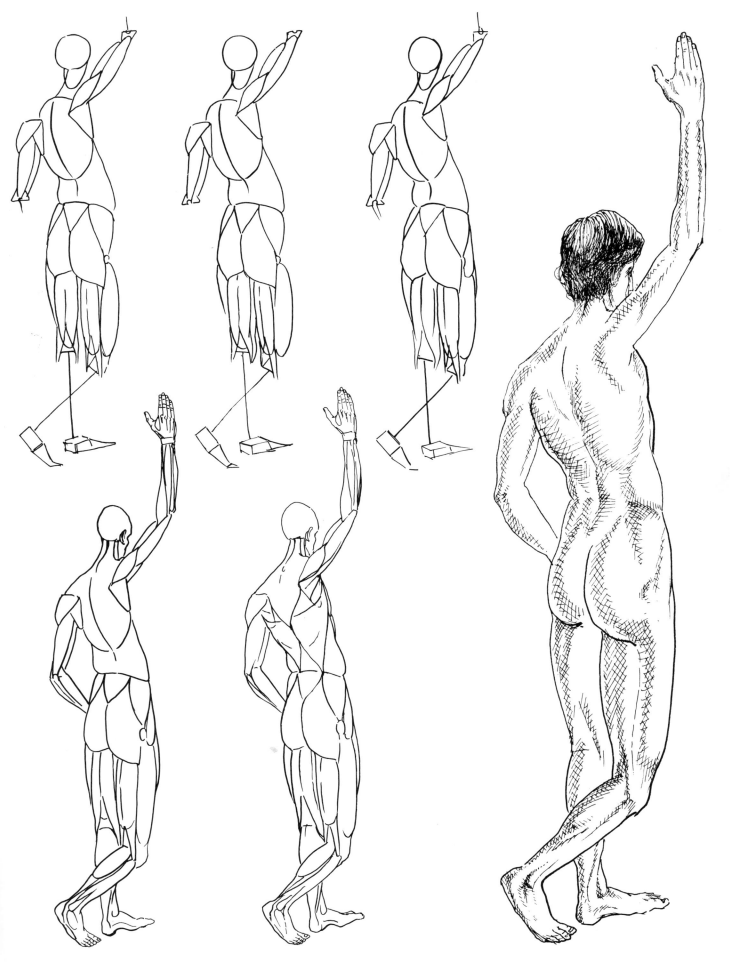

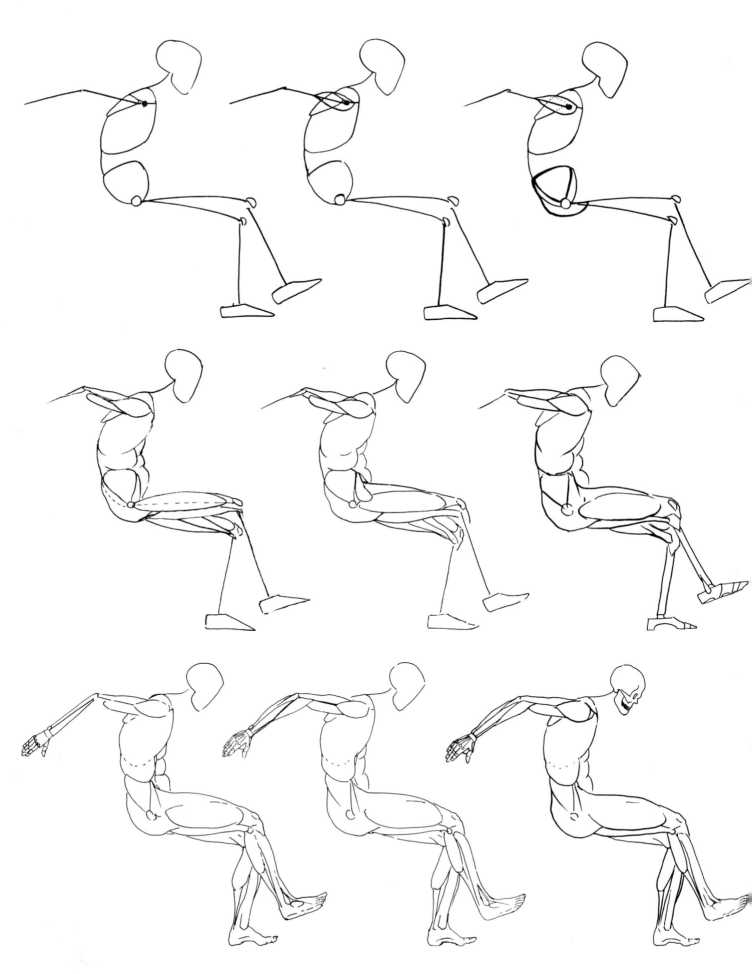

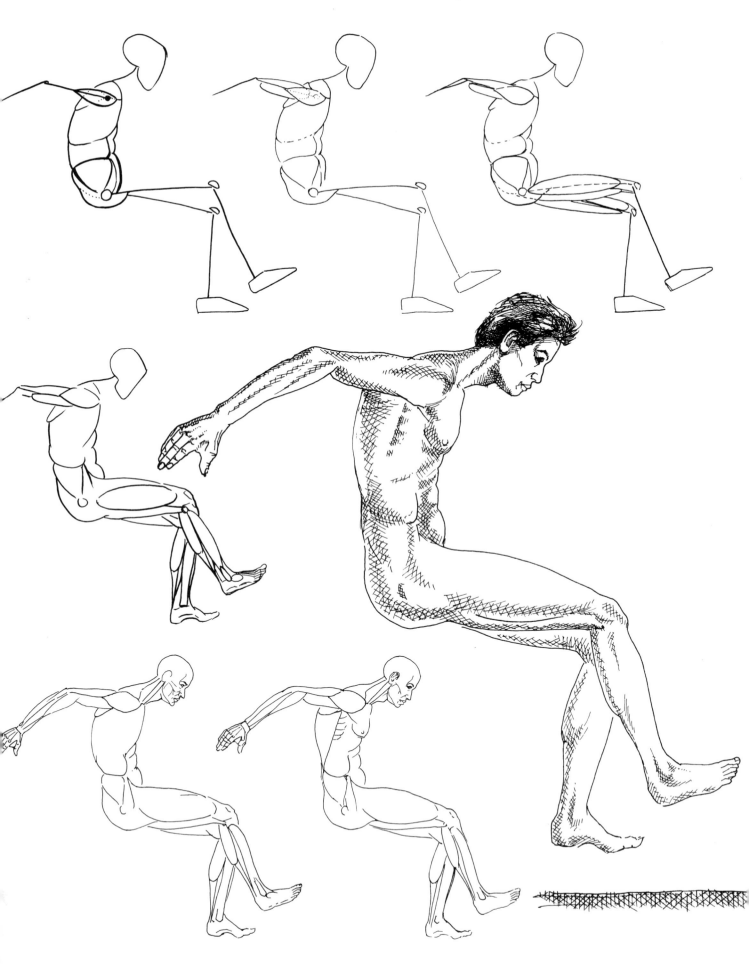

Senior Editor: Marian Appellof
Associate Editor: Carl Rosen
Designer: Bob Fillie, Graphiti Graphics
Production Manager: Ellen Greene